PILOTS AND PAINTED LADIES

493rd Bomb Squadron and the Air War in the CBI

LAWRENCE V. DRAKE

CASEMATE

Pennsylvania & Yorkshire

Published in the United States of America and Great Britain in 2025 by
CASEMATE PUBLISHERS
1950 Lawrence Road, Havertown, PA 19083
and
47 Church Street, Barnsley, S70 2AS, UK

Copyright 2025 © Lawrence V. Drake

Hardback Edition: ISBN 978-1-63624-495-2
Digital Edition: ISBN 978-1-63624-496-9

A CIP record for this book is available from the British Library

Printed and bound in the United Kingdom by CPI Group (UK) Ltd, Croydon, CR0 4YY

Typeset in India by Lapiz Digital Services, Chennai.

For a complete list of Casemate titles, please contact:

CASEMATE PUBLISHERS (US)
Telephone (610) 853-9131
Fax (610) 853-9146
Email: casemate@casematepublishers.com
www.casematepublishers.com

CASEMATE PUBLISHERS (UK)
Telephone (0)1226 734350
Email: casemate@casemateuk.com
www.casemateuk.com

Cover image from author's collection.

All images from author's collection unless otherwise credited.

Contents

Author's Notes

Dear Readers,

I have made every effort to portray the events in this book as accurately as I could, relying on the stories recorded by my father Vernon Drake, his friends, and writings of others who served in the China–Burma–India Theater. Vernon was an avid historian and kept a treasure trove of documents, photos, correspondence, and writings concerning his life during the World War II years. He maintained contact with most of his crew and did extensive research into the artwork painted on the aircraft within the arena in which he flew. His library contained many historical books on World War II in which he highlighted passages and inserted notes expounding on his involvement and first-hand knowledge of the events they described. He also recorded hours of oral history for the Commemorative Air Force Museum and wrote lengthy accounts of his experience for the Hump Pilots Association. The photographs contained in this book are from his collection and my personal collection, unless otherwise indicated.

Some names, dates, places, and incidents in this book have been changed, modified, or omitted for a variety of reasons, including but not limited to the security, safety, and wellbeing of the people, places or agencies involved.

I have dedicated this work to my loving father who provided me with guidance, a secure home, and an example of integrity and strength.

Lawrence V. Drake

Prologue

The CBI (China–Burma–India) Theater received little recognition during World War II. War with the Nazis in Germany and the Japanese in the Pacific is well known. Not only had Japan declared war on America, but it was waging an ongoing effort to conquer China as well. The United States and its Allies vowed to stop the Japanese from overrunning China.

Japan's assault on China came on the continent's eastern coast, as well as from Burma to the south. From bases in northern India, the United States' 10th Air Force, 7th Bomb Group, along with the British, flew bombing missions into Burma ranging from Rangoon in the south to Mandalay and Myitkyina in the north. These missions were intended to destroy the Japanese supply lines by taking out bridges, railroads, shipping, staging yards, airfields, and any other targets necessary to halt the advancing armies.

As the Japanese pushed north toward China's southern border, US and Allied forces struggled to hold them back. Supplies for the Allies were shipped from northern India through Burma into China by truck and rail. Eventually, the Japanese cut off those supply lines which set off one of the greatest airlifts in history. Supplies, men, and fuel had to be transported by air over the highest and most dangerous mountains in the world, the Himalayas.

The China Airlift became known as "the Hump" to those brave aviators who risked their lives to cross it. More than 700 aircraft crashed or were shot down, and over 1,200 airmen died.

To provide some personal identity in an impersonal war, aircrews took to painting images of identity on the nose of their aircraft. Ideas for nose art came from girlfriends, wives, posters, calendars, comics, and often the

history of a particular airplane. The Vargas Girls calendars were among the most popular sources. Scantily clad girls with provocative names dominated the nose-art scene.

This story is based on true-life events recorded by Lieutenant Vernon L. Drake and those airmen, no more than boys of 18 to 25, who flew massive machines on dangerous missions against impossible odds, over unforgiving territory against a brutal enemy. Lt. Drake, a gifted artist, not only piloted Consolidated B-24 Liberator bombers into Burma but Consolidated C-109 tankers that were converted B-24s across the Himalayas into China. He put his artistic talents to work in his off-duty hours painting nose art on aircraft at the request of their crews. He flew in the 9th and 493rd Bomb Squadrons, 7th Bomb Group, 10th Air Force. His story is not just about dangerous missions but about the life of a young man pulled into a war half a world away, and all that entails, from family, to dreams and fears, to acts of bravery.

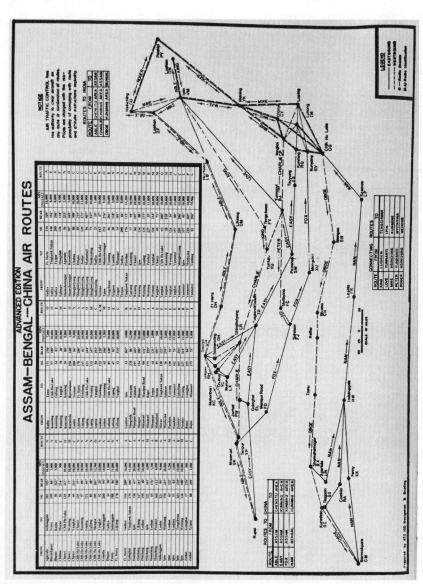

This map shows the Assam–Bengal–China air routes flown over the Hump (Himalayan Mountains) near the end of World War II. (This and other maps were shared by the Hump Pilots' Association)

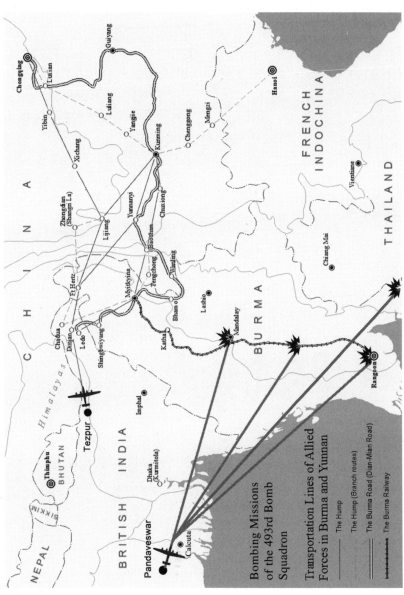

This map generally shows the bombing-mission routes the 493rd Bomb Squadron flew into Burma as well as the routes flown over the Himalayan Mountains into China flown by the 7th Bomb Squadron. (Base map courtesy of Wikimedia Commons)

CHAPTER I

Heavens to Betsy

Numb from the recent swirl of events, Lt. Vernon Drake mindlessly stroked the hard-earned Army Air Corps 2nd Lt. bar on his collar as he gazed through a small passenger window at the endless Atlantic Ocean below. Only a few days ago in Kansas, he had celebrated the arrival of 1945 with his fellow airmen while awaiting his overseas assignment. Now, miles of dark-blue water slowly passed beneath his wings. A shadow cast by the four-engine transport raced across the waves as it growled its way toward the coast of Africa. Initially designed as a modern luxury liner, the gleaming aircraft wore US military markings and charted a course for India filled with fresh, young reinforcements. War would soon become their reality—but not flying bombing runs over Europe. According to the latest news reports, the Germans were in retreat. This plane was headed halfway around the world to a country these freshly trained recruits knew nothing about. Lt. Drake's battlefield would be Burma, and his enemy the Japanese.

The rumble of the powerful engines hypnotized the young officer as he stared out of the window, transfixed by his thoughts of home. He felt 2nd Lieutenant "Chappy" Chapman's head come to rest on his shoulder, momentarily bringing him back from his trance. His crew draped over their seats, exhausted from a night on the town in Natal, Brazil. Most of them partied a bit too hard and had to be rounded up by the Military

Police to get them to the airplane on time. Now they were sacked out, sleeping it off on the eight-hour flight over the Atlantic.

On December 8, 1941, Vernon and his college classmates had gone to Gowen Field airbase in Idaho to enlist after hearing the news of the attack on Pearl Harbor. That was three years ago. A lot had happened since then. His crew had come together in Pueblo, Colorado, in June of 1944 for bomber training. The B-24 Liberators required nine bodies. Vernon got the copilot seat next to the aircraft commander, Lieutenant Goodrich, on the flight deck. Trained as a navigator, Chappy worked from a built-in table in a cubbyhole in the nose of the aircraft behind 2nd Lieutenant Froula, the bombardier. Sergeant Stinson, the engineer, and Private Coogan, the radio operator, took up positions behind the pilot and copilot. Sergeant Kardell, Sergeant Mandula, and Sergeant Barry were waist and tail gunners. For now, they were passengers along with 30 others headed for a world for which they had no point of reference.

The Douglas C-54 Skymaster transport plane carried two B-24 crews who had gone through training and graduated together, a few other officers, plus 20 nurses. Where they were headed, no one knew. Lt. Goodrich had noted that winter gear had been loaded on the plane in Miami. They travelled under secret orders, so speculation ran wild.

They had just departed Parnamirim Airfield in Natal, Brazil, a base with the reputation of being one of the busiest in the world. Thousands of military servicemen passed through in transit to the war. President Roosevelt dubbed Natal the "Trampoline to Victory" for keeping Allied troops in Africa supplied. Goodrich managed to get the crew overnight passes during their stopover. How he pulled that off, he wasn't telling, but the guys didn't waste any time learning about Brazilian hospitality. All the crew members got fitted with fine Natal leather boots. After a steak dinner costing about 30 cents each, they discovered the Wonder Bar where beer flowed freely, and the local girls didn't look too bad in dim light. An evening of drinking, dancing, and plenty of laughs had taken its toll on a number of the crew. They had already sullied their reputation during the Miami layover where the enlisted men, all but Stinson, had been court-martialed and busted to private for skipping out of KP (cleaning up the kitchen) for a night on the town. This unceremonious return to base in Natal didn't do the crew's reputation any good either.

Lt. Drake hadn't fully participated in the festivities but as part of the crew, found himself guilty by association. Considered "the old man" of the bunch at 22, he shouldered the burden of being the responsible one. The only sober airman at the time of their apprehension, his rational and sincere pleas kept the group from spending a few nights in the brig instead of boarding this transport over the Atlantic. Adding the reprimand to their record proved they had had a good time in Natal.

With a gentle push, Vernon righted Chappy who grunted as his head sagged into his chest. With the weight off his shoulder, Vernon shifted in his seat and leaned nearer the window to continue his gazing. Home lay far beyond the horizon. *Would he ever see it again?* he wondered as he drifted off to sleep to the drone of the engines.

★★★

Vernon's life before the war had been simple and uncomplicated.

"Come on, Vern," his brother Dave yelled. "Knock it into the trees."

Vernon cocked the bat over his right shoulder, dug his feet in, and bounced on bent knees, ready for a mighty swing. Dust rose from the

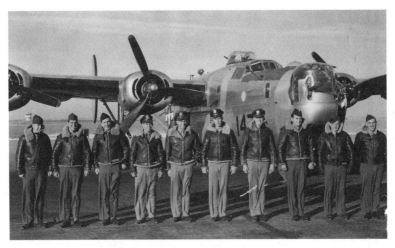

Sgt. Ralph Stinson (engineer), Cpl. Jim Barry (tail gunner), Sgt. Berry Walsh (top gunner), Flight Officer Ralph Chapman (navigator), Lt. Vernon Drake (copilot), Lt. Ralph Goodrich (pilot), Lt. Jim Froula (bombardier), Pvt. Jim Coogan (radio operator), Cpl. Albert Mandula (waist gunner), Sgt. Harry Kardell (waist gunner).

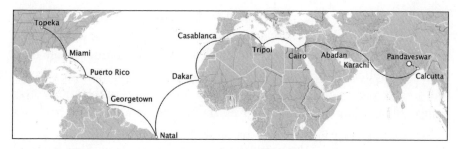

Lt. Vernon Drake and crew travelled via train from Topeka, Kansas, to Miami, Florida, then by air transport to Calcutta, India, and finally to Pandaveswar, India, by train.

dry, yellow Montana grass of mid-summer as the Nazarene Church team faced off against a feared rival, the Presbyterians. Their pitcher wound up and fired the baseball at the plate. Swish.

"Strike one," yelled the umpire.

Vernon's eyes narrowed as he loaded his bat for another swing. *Concentrate*, he thought, but he couldn't help glancing toward the picnic tables where he had spotted a new face. He knew the moment he saw her she was special. He and his older brother Ray were home for the summer from college to help on the farm. Some new families had joined the church while they were away. When he forced his focus back on the pitcher, the ball was already on its way.

"Swing and a miss!" came bellowing from someone behind him.

"Strike two." The umpire, Mr. Thurman, who also led the choir on Sunday mornings, thrust two fingers up in the air.

Okay. Settle down. You can do this. I hope she isn't watching. Vernon tensed in his stance, ready to swing.

The third pitch came right over the plate, waist high.

Crack!

He sent the ball flying, flung the bat, and took off running as fast as his well-worn black Converse athletic shoes could carry him. He rounded first base.

"Slide—slide!" the Nazarene crowd yelled. Vernon hit the dirt feet first, skidding toward a small flour bag filled with sand. The second baseman, with one foot on the bag, fielded the ball.

"Y'er out!"

"Yeah, yeah," Vernon said as he picked himself out of the dirt and dusted off his already-soiled denim trousers. He looked back at the gathering to see if he could pick out the pretty, petite brunette who had interrupted his concentration. He scanned families around the picnic tables as he walked the line back toward his team, but she was not there. Maybe he could find her after the game? Of course, as shy as he was, the chances of actually meeting her were pretty slim.

"Batter up!" the umpire called out.

The Nazarenes lost four to six, but they seemed to take it well. There was always next Sunday. Besides, they may have lost the game, but they knew where the Presbyterians would end up. They would be pitching balls of fire and brimstone. The Nazarenes had the corner on the spiritual market. All others were lost souls.

Vernon found his way to the picnic tables placed end to end in the shade of the huge cottonwood trees. Checkered tablecloths covered the weatherworn tables under bowls of green beans, potato salad, fresh-baked rolls, and plates heaped high with fried chicken. Mrs. Stall's fresh apple pie sat enticingly close to the hand-cranked ice cream maker. The wonderful sight and smell made sitting through Reverend Anderson's morning sermon worthwhile. One more thing made the tables even more attractive. A pair of beauties had been added, the brunette and a redhead standing alongside two adults he assumed were their parents.

"Come over here, boys," Vernon's mother called as she set down a pitcher of iced tea and smoothed out her dress. "I want you to meet the Ross family. They just moved here from Nebraska."

Vernon and brother Ray shuffled up shyly, removed somewhat worn cowboy hats, and shook the outstretched hand of Mr. Ross.

"These are their daughters, Fern and Bettie. Their son, Delmar, is around here somewhere pitching knives with a few of the younger boys."

Vernon absentmindedly kicked at the dust as he flashed a nervous smile at the girls. "Pleased to meet 'cha," he mumbled, suddenly aware of how rumpled his clothes were.

The sisters were dressed in their Sunday best, clean and sparkling. Fern's dark auburn hair framed her fair, lightly freckled face. She had eyes that danced with confidence and energy as she smiled back at the

boys. Likely a year older than her sister, Vernon got the sense right away that she was a force to be reckoned with.

On the other hand, Bettie appeared quiet and demure. He found himself gazing at her a bit too long.

"Nice to meet you, too," she almost whispered as she shifted uncomfortably.

Their brief meeting got interrupted as his father and Grandpa Williams joined the group at the table. "Are we ready to eat?" Father asked, receiving a nod of approval from his wife. "Mr. Ross, would you like to do the honors of saying grace?"

The boys backed away and found their places at the picnic table as all bowed their heads. Mr. Ross did an admirable job of blessing the food and everyone in attendance. He obviously had plenty of previous experience. Vernon didn't hear much of the prayer as he found himself sneaking several peeks at Bettie, now sitting near the other end of the table. He hoped God would forgive him for such a sacrilegious act during a time of worship.

Between the sweet potatoes and chicken wings, Vernon was sure he caught Bettie glancing his way a couple of times. Normally, he would have gobbled down a heaped plate of food and been off to the races, but he took his time.

"Come on, we're up again." Ray tugged on Vernon's shoulder. "We gotta go."

Vernon grabbed his last half-eaten drumstick and shot one last look at the other end of the table as he swung around to leave. Bettie and Fern were helping the ladies pick up dishes. Maybe he would see them again after the games?

Across the Atlantic

As evening twilight settled in, a narrow tip of land appeared on the darkening horizon.

North Africa, Vernon thought as he pressed his nose to the window for a better look. Slowly, Dakar came into view perched on a point that seemed aimed back toward South America. The young lieutenant felt a rumble of excitement welling up inside. *Whoever thought I would see Africa?*

He poked the sleeping Chappy in the ribs with his elbow. "Hey, wake up. We're coming into Dakar."

Chappy's eyes blinked open, momentarily questioning where he was. "What? Where?" he slurred.

"There. Look. There's Mallard Field." Vernon pointed out the window as Chappy half crawled over his lap to get a view.

"Well, I'll be damned," Chappy crooned. "Hey, guys," he called over his shoulder, "we're in Africa."

The growl of the engines that had rumbled through the big Douglas C-54 Skymaster for eight hours softened as bumps and hydraulic motors grinding away indicated flaps and landing gear were being lowered. A few minutes later, tires squealed as they contacted the pavement. In the dim remnants of day, runway lights rushed by. The shadows revealed transport and military planes scattered around the field with trucks busily loading and unloading cargo. The crew taxied the big plane to its assigned slot in the lineup on the tarmac and shut down a long way from any terminal or building.

"Relax, boys," the captain called out as he poked his head from the cockpit. "You're not getting off here. We're just picking up some fuel."

An audible grumble rose from the cabin.

"Sure doesn't look like Africa to me," Chappy quipped. "Just another military airfield." He folded his arms and sank back into his seat. "Sure could use a beer about now."

The sky had grown dark with only a sliver of a moon when the ground crew finished fueling the aircraft. As the big bird broke ground and climbed out over the city, Vernon watched the twinkling lights fade and disappear below a cloud layer. Next stop, Casablanca.

How unreal it all felt, sitting in that time capsule tube while, somewhere out in the darkness, the coast of Africa slid by. Vernon peered into the black sky, hoping for a glimpse of the Dark Continent. An occasional twinkle of lights way off in the distance broke the vast emptiness. He imagined there were bonfires with natives dancing around them like the pictures he had seen in National Geographic.

"Another banquet, compliments of Uncle Sam." Chappy took a tray from the steward and slipped it on to Vernon's lap and then one for himself. "Ah, SPAM the ham that failed the physical." He leaned down to take in the aroma as though he were enjoying steak and lobster. "Dig in, lieutenant, you're not going to see anything out there."

"Y'er right. It's just a shame to come this far not to get a look."

Vernon downed the rectangular hunk of composite meat, lukewarm reconstituted mashed potatoes, and beans, all disguised under a layer of brown gravy. He washed it down with KLIM, a white liquid loosely referred to as milk, spelled backward. Having grown up on a farm with fresh eggs, real milk, and homegrown ham, army food wasn't too exciting.

In the dim cabin light, guys played cards, smoked army issued Lucky Strike cigarettes, wrote letters, and nodded off to pass the nine-hour flight. Chappy found one of the nurses willing to listen to his exaggerated tales of amazing accomplishments. Vernon went back to staring out at the void now gently lit by a small slice of moon and a sky full of twinkling stars. His mind wandered back to the moonlit nights in Montana.

★★★

"Do you like college?" Bettie asked after taking a small sip from her straw submerged in a tall glass of chocolate milkshake. Drawn to this shy young man with a winning smile, from the first time she met him at the picnic, she found his gentle demureness hid confidence she felt she could trust. His handsome face with a slightly oversized nose and thick, black hair, combined with a six-foot-two frame, completed the attraction.

"Yeah. It's great," Vernon perked up. "I've made some swell friends. A couple of courses are pretty hard, but I don't mind."

He had finally gotten up enough nerve to ask Bettie to go out for ice cream with him that evening. He picked the Luzon Cafe since it was the most popular eatery in town and it had a soda fountain. He figured he could afford a couple of sodas. His only income came from a part-time job at the hardware store. He and his brother Ray had almost made enough money to pay for a year of college by hauling wheat to town for the farmers when their trucks broke down, bringing their businesses to an abrupt halt. Every penny went toward college, but Vernon figured the ice cream date was a worthwhile exception to the spending rule.

As Nazarenes, his family and friends didn't go to dances or movies. Those places were Satan's dens of temptation. That limited the dating prospects. He had briefly dated a couple of girls in high school and his first year in college, but nothing serious. He definitely had a few crushes but felt awkward around girls. It seemed girls preferred him as a friend. Besides, he had ambitions and girls were a distraction ... a pleasant one ... but a distraction just the same.

Bettie's soft brown eyes and dainty face, framed by hair that swept up on the sides to a crown of curls that spilled down to her shoulders, sent Vernon's heart into a flutter. Her voice flowed like sweet cream and made him want to drink in her every word.

"I don't think I will go to college." She slowly stirred her milkshake with her straw. "We can't afford it, Dad's just starting to get work here."

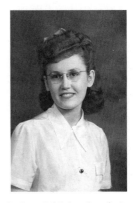

Bettie Ross's high school picture, Vernon Drake's future wife as she was when they first met in Billings, Montana.

She had Vernon pick her up at the church because she was embarrassed to have him see where she lived. The Great Depression and Dust Bowl of the 1930s hadn't been kind to the Ross family. They hoped a move to Montana would improve their situation. Her father bought two old grain bins, hauled them to a lot he purchased, put them together, added a pitched roof with an attic, and converted them into a house. A bricklayer and building contractor by trade, he had the skills, but the structure remained a work in progress.

"Besides, I didn't really enjoy school that much." Her face brightened as she turned the conversation to her new companion. "What are you studying?"

"You know, general courses. The first couple of years are pretty set. I do like math. I might study to be an engineer or something. I sort of wanted to be a cowboy but Mom and Dad didn't think too much of that idea."

"A cowboy?"

"Yeah, I love horses. I even spent last summer working on the Lazy-Y Dude Ranch up near Big Timber as a ranch hand."

All the while they talked, Vernon compulsively doodled on his paper napkin to avoid starring too long at the beautiful face across the table. Sketching often helped to fill the awkward moments in his life. The activity had not gone unnoticed.

"What's that you're drawing?"

"Oh, sorry." Vernon quickly laid his pen down and covered the artwork with his arm. "Sometimes I'm not even aware I'm doing it."

"Let me see." Bettie reached across the table with an open palm.

"It's nothing, really."

"Come on, I want to see," she pleaded.

He reluctantly handed her the napkin but not without exposing a little pride.

The young lady's eyes grew large with surprise as she erupted with glee. "Why … it's me!" The napkin contained a line drawing of the girl who had captured Vernon's affection. "It's beautiful. You didn't tell me you were an artist."

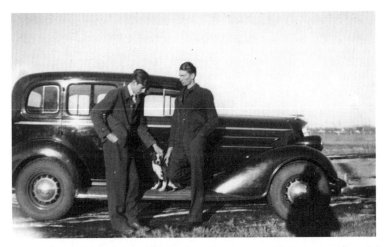

Vernon Drake, his brother Ray, and their dog Pepper with the family's Oldsmobile prior to leaving for college in Nampa, Idaho.

"I wouldn't say I'm an artist," Vernon protested. "I just like to draw. Been doing it as long as I can remember."

"But this isn't just good, this is really good." Bettie tenderly stroked the napkin. "Can I keep it?"

"Sure. Maybe I can do a better one to replace it sometime."

From that moment on, the tension between the two melted away. They chatted on about college, friends old and new, and life.

"It's getting late. I better be getting you home. I sure don't want your father mad at me."

Vernon mashed down on the starter of the '34 Oldsmobile. The well-used car rattled like a tin can as the engine reluctantly came alive.

"It's okay. Dad and Mom will still be at a prayer meeting," Bettie said quietly, slightly embarrassed by her boldness. "Can we drive around a little bit?"

"Sure can. Where would you like to go?" Vernon eyed the gas gauge creeping just below the quarter tank mark. The gas had to get him to and from the farm for the next week. It would be tight, but worth the risk.

"I don't really care. I just like to see the city lights at night." She didn't want the evening to end.

CHAPTER 3

Casablanca

Engine rumble subsided as the transport began its descent from the skies above Morocco. Far below, azure-blue water turned to white froth as it rolled onto bleached-sand beaches. A patchwork of small green and brown rectangle farms spread inland held together by a spider web of dirt roads. Up the coast, Vernon could see a city hugging the shore with an airfield to the south.

Lt. Goodrich called out from the seat ahead, "Look out Bogie, here we come," a reference to the hit movie *Casablanca*.

Most of the guys onboard only knew about this part of the world from watching the movie with Humphrey Bogart and Ingrid Bergman. Vernon had gone to see it in the theater with his buddies in San Antonio during advanced flight training. The guilt of participating in the forbidden activity of movie watching haunted him but the film had its intended effect. The intrigue of Rick Blaine, Bogart's character, helping refugees escape occupation by the Nazis in French Morocco, hit home. When *Casablanca* premiered in 1942, the movie changed many Americans' minds about remaining isolationists and staying out of the European conflict. For some reason, seeing the plight of refugees at the hands of the Germans in the movie, along with the associated newsreels, made the war personal.

Vernon thought back to the headlines last June when D-Day made the front page of the papers. General Eisenhower announced the landings

of American and Allied forces on the southern coast of France. Now, Vernon and his crew were about to land at another scene of a significant battle, although the difference was stark.

Two years had passed since US troops drove the Nazis from Casablanca and were welcomed by the French. The city served as the springboard to liberating all of North Africa and a stopover for allied military personnel heading for India, China, and Burma to fight the Japanese Imperial Army.

"I hope I can find a Bergman," Chappy retorted. "Now, there's a swell dish."

Ignoring Chappy's levity, he remarked, "Kinda makes you think, doesn't it?" Looking down on the historic city, Vernon not only felt the great distance from his family; he felt the war getting closer. His stomach tightened and his jaw tensed. "We're a long way from home."

"Yeah," Chappy whispered to himself. "But, hey," he perked up, "we'll whip those Japs in no time and be back home by the Fourth of July."

After the big plane rolled to a stop, the captain stepped through the cockpit door and addressed his passengers. "You boys can get out, stretch your legs, and find some chow in the mess. We'll be here overnight so try and stay out of trouble."

A ground crew rolled a metal stairway up to the door of the aircraft and the airmen filed out into the pleasant 65-degree Fahrenheit air, filled with the smell of the ocean, spices, and aviation fuel—a far cry from the Montana winter where Vernon had received leave to spend time with family before heading overseas. Any remaining feelings of detachment as a result of droning away for hours were swept away by the near Mediterranean climate.

As the group reached the bottom of the stairs, Chappy called out, "Hey guys, we're standing in Morocco!"

An army-green jeep pulled up carrying a sergeant who jumped out with a clipboard in hand and saluted the officers. "Welcome to Berrechid Airfield. Form 'em up here boys. Shout out when I call your name. Wouldn't want to lose any of you." He ran through the roster of names and checked them off. "Okay, all present and accounted for. Follow me to the chow hall. I don't want nobody wandering off."

The smell of fried food increased as they approached a long, flat, block building.

"Officers to the right, enlisted to the left," the sergeant barked, getting pleasure from ordering around officers above his rank.

A cafeteria-style meal offered plenty of selection. No one would go hungry.

"Sure beats SPAM." Vernon picked out a nice plump chicken breast and dropped it in one of the compartments of his metal tray.

"Hey, they even have apple pie," Lt. Goodrich called out as he neared the end of the line. "Where's the couscous?" he jived the private on the server-side of the counter.

"Gotta go to town for that, lieutenant."

"What's goose-goose?" Vernon asked, confused by the foreign word.

"Hell if I know," Goodrich quipped. "I just heard that's what Moroccans eat."

After a hearty meal, the crews were transported to a dumpy hotel on the edge of the city with no heat to temper the cold nights and no warm water. A fellow passenger, Captain Rousch, had attached himself to their group as they headed out to explore Casablanca. He had been to the States on leave and was now on his way back to his duty station.

"You guys gotta be careful with these Moroccan fellas. They know every trick in the book to separate you from your dough," Cpt. Rousch boasted with the confidence of experience.

He led them through crowded back streets of shops and vendors until he found what he was looking for. His pockets filled with Parker pen and pencil sets brought from the States, he found his mark. After a brief discussion with a vendor in a barrel-shaped brimless red hat and rumpled white suit, the two disappeared into a dark alleyway where the transaction would not be observed by the authorities. A few minutes later he emerged with a satisfied grin on his face.

"And that's the way it's done," he said as he pulled out a large roll of bills from one of the pockets that had been loaded with pen and pencil sets.

As he began to unroll his prize his face fell. "What the …?"

The top 1,000 lira bill covered the rest of the roll of 100 lira notes cleverly folded to expose three zeros. His head swiveled around as

he searched for the man in the red hat who had disappeared into the crowd. Gone with him were his dreams of a quick road to riches. He had unintentionally given his naive companions a lesson on caution in foreign countries.

The brief excursion into town, a restless night in a cold hotel, and an early departure left the crew with little good to say about Casablanca.

As they strapped back into their seats on the airplane, Chappy frowned with disappointment. "So much for Casablanca."

Minutes later, Vernon was staring out the window once more as the foreign landscape grew small beneath the wing soon to be obscured by clouds … next, across North Africa to Cairo, Egypt.

★★★

"Will you write to me?" Bettie asked. "You won't forget me with all those college girls around?"

"Sure, I'll write. You're my Betsy." Why he had started calling her "Betsy" he wasn't sure, but it seemed to fit and she liked it.

The night air had cooled as they snuggled under the stars in the beat-up Model-A Ford he and Ray had bought to carry them back over the mountains to college.

Vernon and Bettie had been together through the summer of 1941, attending church socials, riding horses on the farm, going to the county fair, and double dating with Fern and her boyfriend. The more he got to know her, the more comfortable he felt. She laughed at his corny jokes, enjoyed his cowboy stories, and encouraged his artwork, but most of all, his heart raced whenever he held her in his arms. He had kissed a few other girls, but with Bettie, the feeling was hard to explain.

"I feel like I'm home," he told her one night as he embraced her at her front door. He never wanted to leave at the end of an evening and he knew she felt the same.

The summer romance ended all too soon when Vernon and Ray packed up the Model-A, ready to head west to Idaho. Good Nazarene boys attended the Nazarene Christian College in Nampa. Their parents were sad to see them go but grateful two of their boys had the opportunity to go to college. Each gave their blessing and advice.

"Remember, boys," their father said, passing on a family tradition, "whatever your hands find to do, do to the best of your ability."

Their mother, with a hug for each and a soft voice, said, "I will be praying for you daily. God is watching over you, and He will take care of you."

Stepping back with his hands tucked into his bib overalls, their father called out, "Study hard and make us proud"

Vernon cleared the lump growing in his throat. "I hope this old bucket of bolts will make the trip."

The Model-A rocked and sagged as each boy mounted the running board and plopped onto the seat. Vernon stepped on the starter pedal as he retarded the spark and opened the throttle. The engine jumped to life with a bang and a pop.

"Forward, ho!" Ray called out as the car lurched ahead. They were off.

The miles crept by with the old Tin Lizzie making 50 mph at best—25 climbing the pass outside Bozeman. Vernon had plenty of time to think and Bettie occupied most of it. He played their experiences together over and over in his mind. As excited as he was to get back to college, things would be different without her.

Pyramids

Letters came faithfully from Bettie, fulfilling her promise to write to Vernon regularly while he attended college. Receiving her correspondence became the highlight of his day. They weren't particularly romantic but hearing of her workweek at the dress shop, the music she liked, and updates on friends, felt special. He wrote back about his classes, his professors, and the baseball games. He always included a sketch, often a cartoon of a professor or someone he found particularly amusing. He could draw horses like no other, too. After all, he had been studying them as long as he could remember. They were the objects of his earliest artwork.

Fall passed slowly and a cold Idaho winter settled in. Vernon enjoyed math and science but found history boring. Even with the war in Europe, recent events like the Germans' push into Rhineland, Austria, the destruction of Czechoslovakia, and Hitler's invasion of Poland were, simply, answers to test questions.

"The European War will be a protracted conflict," taught Dr. Culvar, the history teacher. "No doubt the much larger population of the Allies will eventually gain the upper hand. It certainly would do no good for America to get involved. That is not in our best interest. President Roosevelt has pledged to keep the US out of direct involvement in the war."

The war between Japan and China taking place half-a-world away barely warranted mentioning. Besides, the US government was in negotiations to put a diplomatic end to Japan's aggression.

Between classes and homework, Vernon began planning his return to Billings for the holidays. He and his brother Ray talked about taking the Model-A back over the mountains, but slick tires and a questionable engine made the winter trip dubious at best. They would take the bus. Each found small part-time jobs to help finance the upcoming trip home.

Bored by Reverend Strand's Sunday sermon, Vernon sat on the hard chapel bench doodling caricatures of cowboys on his bulletin dated December 7, 1941, when Dr. Culver entered and interrupted. "Can I have your attention? I have some very important news. President Roosevelt just announced on the radio the Japanese have attacked Pearl Harbor by air."

Vernon looked at Bob, a fellow student sitting next to him, and they both shrugged. "Pearl Harbor?" He figured it must be somewhere of importance in Europe otherwise Dr. Culver wouldn't have taken it so seriously.

A boy in the second row raised his hand, "Dr. Culver, where is Pearl Harbor?"

I'm glad someone was brave enough to ask, Vernon thought.

"It's in Hawaii, son. The Japanese have attacked our navy in Hawaii."

"I thought the US was in peace talks with Japan."

"We were. That's what makes this surprise act of war so unsettling."

"Are we going to war?"

"Unfortunately, it certainly looks that way."

The faces of the students appeared stunned and confused but within seconds the class erupted in questions.

"Did they sink one of our ships?"

"Do you think they will attack California, next?"

"Did they bomb the island too? I have a brother in the army there."

"Isn't Hawaii a US territory?"

Dr. Culver raised his hands to silence the onslaught. "I'm sorry, that's all I can say for now. Listen to the radio for more information. That's what I will be doing. For now, I would like us all to bow our heads in prayer for our nation."

A hush came over the students as he prayed, not his normal practiced prayer, but a truly passionate one filled with emotion and concern. He

had no doubt God was in charge but felt the great need to petition Him for His grace in the days to come.

Rev. Strand ended the service early. That afternoon and evening, Vernon, Ray, and their friends gathered around the radio in the Student Union building as the horrifying reality of the bombing unfolded. Hundreds of Japanese fighters and bombers swarmed over the island of Oahu raining down death and destruction. Most of the Pacific fleet had been sunk or severely damaged. Thousands of lives had been lost, no one knew how many. War had suddenly become real. America was under attack and the students were fighting mad.

"Okay, boys," Vernon's friend, Kenneth stood up facing the group with his clenched fists on his hips. "I'm going to join up tomorrow. Anybody with me?"

"Count me in," Vernon shouted out.

"Me too," Ray echoed.

Nobody wanted to be left out as boy after boy chimed in. The next day, the group headed out to enlist at Gowen Field in Boise 24 miles away. Once there, they found the enlistment office overwhelmed with men of all ages, anxious to do their part. There were men in business suits, farmhands fresh off the field, clerks, salesmen, old geezers in bifocals, and more. The crowd rumbled with excitement and a singular focus, to join the fighting forces and protect home and country.

"I'm sorry men," the rattled recruiting officer yelled over the crowd. "We just aren't able to handle you all. You men will have to come back later, say in a few weeks. The war ain't going to be over anytime soon."

"Come on, *sarge*," Vernon yelled. He called anybody in uniform, *sarge*. "We've come all the way from Nampa."

"Can't take you right now, son. Go on back to school."

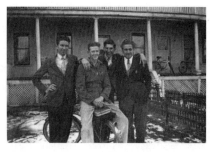

Raymond Drake (left), Vernon Drake (back), and friends attending Northwestern Nazarene College in Nampa, Idaho, where they heard the news about Pearl Harbor.

Dejected, the boys piled into their cars for the return trip to the campus.

"Geez, I was all set to fight some Japs," Ronald gruffed. "I'll be back. You bet I'll be back."

Vernon pictured home and Bettie, and secretly felt relieved they had been turned away. He needed some time to think.

★★★

As the C-54 climbed eastward out of the clouds into the morning sun, the Moroccan mountains were left behind and barren desert stretched out over the horizon into Algeria. The vast parched emptiness added to Vernon's feeling of dreaded things to come. Mile after mile, hour after hour, desolate sand dunes broken only by occasional rocky outcroppings slid silently under Vernon's window.

"So this is North Africa," he commented to Chappy. "How could a war be fought here?"

"Well, you keep wondering," Chappy quipped as he clapped Vernon on the shoulder and rose from his seat. "I'm going to give Nurse Baker another try." Chappy had his eye on one of the nurses traveling with them, although she didn't seem too interested.

An hour from Tripoli, Vernon began seeing abandoned airstrips with wreckage strewn around. Tracks in the sand made by war machines, scarred the earth with metal carcasses where they ended life and littered the landscape. Then, signs of civilization began to emerge—first a few remote settlements and then larger villages. The azure blue of the Mediterranean Sea appeared on the horizon as the villages grew into cities. The engines of the Skymaster reduced their rumble, signifying their descent into Tripoli. A quick stop for refueling and the four engines again pulled the transport into the air enroute to Cairo.

"Hey guys, look, it's the pyramids!" Vernon pressed his nose against the window as half the airplane's passengers piled into the right-side seats to get a look.

"Well, I'll be danged," Chappy crooned.

From above, Cairo looked like millions of children's building blocks, brown and tan, overtaking the narrow, green landscape between the wide Nile flowing to the sea and unending sand dunes. Just at the edge,

where the city meets the desert, stood symbols that defied the ages—the pyramids of Egypt.

"Hot damn!" Lt. Goodrich remarked, "Did you ever see such a sight? Boy, I'd like to give them a buzz job."

"There's the Sphinx," someone cried out.

"Right," Chappy chuckled. "How can he tell? It looks like a pile of rocks and sand down there."

"There, see that line coming out from the smaller pyramid. The Sphinx is at the end, there, by the road."

"Hot diggity dog! You're right. I see it."

Dozens of eyes strained through the portals to get a glimpse of history coming to life.

As the four-engine transport banked to the northeast toward the Ismailia Airfield, the pyramids disappeared while the city of Cairo spread out below. Tires squealed as they gave up rubber to the Royal Air Force Base runway. This would be a two-day layover … a welcome break from days of droning through the skies.

The Sheppard Hotel, famed for its grandeur, welcomed the B-24 officers while the enlisted crews were billeted in a nearby hotel. It didn't take Lt. Goodrich and the others long to find the famous "long bar," so named because of the long wait to get a drink due to the crowds.

Vernon found Lt. Froula in the plush hotel lounge. "Hey, do you believe this? A bit better than the dump in Casablanca wouldn't you say?"

Ironic as that seemed, neither one had ever experienced anything like the worlds they had encountered in the last few days.

Lt. Froula held up a brochure. "They have a tour of the pyramids. You wanna go?"

"You bet your boots. When do we leave?"

The next two days were filled with sights of the Great Pyramid, Sphinx, Napoleon's cannon balls still embedded in the walls of temples, stage shows featuring belly dancers, acrobats, and jugglers, and the River Nile. At night they watched the movie *Best Foot Forward* with Lucille Ball and June Allyson projected on the blank exterior wall of the hotel. The war was going great.

A crush of humanity built on top of a long-gone rich civilization, Cairo overwhelmed the country boy from Montana. Vernon marveled

at how such a cramped and dirty city held millions of people in obvious poverty yet dressed in pure white, clean and pressed clothing.

"I've found a guide who will take us to the off-limits bazaars," Lt. Goodrich announced.

"Is he legit?" Vernon asked, remembering their recent experience with the pens.

"He's an employee of the hotel. That's good enough for me."

A trip to the bazaars netted each officer a bottle of Chanel No. 5 perfume for their wives and sweethearts back home … a great acquisition at an even greater price … that is until they discovered what they had actually purchased was camel piss in a fancy bottle. So much for Cairo.

On the morning of departure, five of the 10 crews and some nurses were routed to Russia. That explained the winter gear on board which now took its place in the hold of another transport heading north. Vernon's crew continued their journey east. The big bird again rumbled down the runway and lifted off into the warm Mediterranean air. In minutes, the green Nile Delta fell behind and the stark desert of the Sinai Peninsula stretched out ahead. The Suez Canal connected the Red Sea and the Mediterranean, separating the fertile from the parched.

"This is where it all happened," Vernon breathed.

"What's that?" Chappy's voice startled Vernon, unaware his friend had leaned over his shoulder to get a better look out the window.

"Oh, I was just thinking about all those Sunday School classes and sermons on Moses and the Egyptians. I never thought I would see where all that stuff took place."

"Keep your peepers open, lieutenant, you might see some lost Jews wandering around down there in the desert."

Barren hills, mountains and valleys passed under the wing, hour after hour. Vernon tried to imagine how anyone, let alone a multitude of people, could live 40 years in that barren emptiness. *It certainly would take a miracle*, he thought.

Eventually, the parched earth reluctantly gave way to the blue water of the Persian Gulf off in the distance. The C-54 banked for a landing over the oil fields of Abadan and a quick refuelling stop.

Back in the air, the sun cast long shadows on the sterile hills and wadis, Vernon drifted off to sleep. Karachi remained a long way away and the plane would be droning its way through the darkness for many hours to come.

Karachi

Christmas 1941, and home from college, Vernon and Ray had to give up on taking the bus. They weren't able to raise the fare and still buy presents for the family and friends back home. Ending up hitching rides, at one point they feared they were going to freeze to death outside Dillon, Montana, thumbing for a lift in blowing snow and single-digit degree °F temperatures. But now, they were safe and warm at home with their parents, and brothers. Even the eldest, Norman, made it from Minneapolis where he worked as an aircraft mechanic.

"When are you going to see Bettie?" his mother asked with a twinkle in her eye. "You know, she always asks about you at church."

Vernon tried to hide his blush and brushed off the question as though he was indifferent. "Oh, I'll get around to it."

"Get around to it," Ray blurted. "She's all he talks about."

Vernon shot back an icy stare. "Is not."

"Yeah, he's pretty sweet on her alright."

He contemplated whether to tackle his tall, lanky brother and muffle him, or leave the scene. "Aw, nuts to you," he said as he chose the latter. The truth was, he couldn't wait to see Bettie again.

The next afternoon, he put on his Sunday suit, borrowed his father's car, and drove over to the Ross house. They didn't have a telephone even though they lived in town. The farm had a phone, but it only connected nearby neighbors. He had with him the flower-shaped brooch

he purchased as a Christmas present for Bettie. The clerk at the Five & Dime store had wrapped it nicely.

"I hear jewelry is the way to a girl's heart," Ray had teased, knowing full well that the church frowned on such showy things.

Vernon didn't know much about jewelry, but the sales lady at the store said it was very nice and not too gaudy. "Your girlfriend will love it."

Too bad he wasn't on any athletic team or college club that had a class pin. The brooch would have to do. He walked up the board sidewalk to the door and knocked, both nervous and excited. Bettie's mother answered the door. Vernon snatched his cowboy hat from his head and held it over his heart.

"Hello, Mrs. Ross. Is Bettie at home?"

Mrs. Ross was a stern lady—stout of build and a face that wasn't used to smiling. She had on her customary apron, white with flour. He could smell the wonderful odor of fresh-baked bread emanating from her kitchen.

"Land sakes alive, if it isn't Vernon." She gave a quick look, up and down. "Your mother said you were home from college. Bettie and Fern aren't here. They're at the church practicin' for the Christmas program." Her eyes penetrated his. "You're going to be there, aren't you?"

He shuffled uncomfortably, "Yes, ma'am. I'll be there for sure."

She straightened up, arms folded over her broad bosom with an approving look. "Good. You can probably catch her at the church. They should be done soon."

"Thank you, ma'am." Vernon gave a tilt of his hat as he placed it back on his head, and made a hasty retreat back to the car.

The late afternoon sun reflected off a thin layer of snow that had dusted the church lawn the night before. Too cold to melt, it stayed as a reminder that Christmas day wasn't too far off. Vernon leaned against the sedan as he watched the choir members file out of the double-wide doors of the small white church and down the steps.

Fern spotted him first, giggled, and whispered something to Bettie. Her face immediately went flush as she pulled her scarf over her ears and half her face, supposedly to ward off the chill of the day. She gave a timid wave to Vernon as the two walked toward him.

Vernon stood up straight and tipped his hat. "Hi, Bettie. Gee, you look swell." He gave a side-glance at Fern. "You, too, Fern."

Fern pulled her collar up around her neck and smiled knowingly at the two.

"Can I give you a ride home?" Vernon reached for the car door.

"You go ahead, Bettie. I'm riding with Shirley."

Before Bettie could answer, Fern turned and walked off toward the small group of young people waiting down the block.

"Looks like I'm riding with you," Bettie said, her lips trying to hide a delighted smile. "I'm glad you came by. I was wondering when I would see you."

Vernon opened the door, removed his hat, and made a slight bow. "Your coach awaits, my lady." The class in English literature wasn't completely lost on him.

"Why, thank you, sir."

Bettie slipped into the front seat, he closed the door and strutted around to the driver's side.

Tires slipped on the soft snow as the car pulled out into the road. Bettie gave a little shiver and scooted closer to her handsome chauffeur. Conversation came a little awkward at first as the two renewed their relationship but quickly eased into the comfortable affection they had felt when he left for college.

"Mind if we pull in here for a minute?" Vernon asked as they approached South Park. "I have something for you."

"Oh, okay," she shivered.

They pulled into the gravel parking lot of the small municipal park. By now, the car heater had taken off the chill. Vernon reached into his pocket and pulled out the small, nicely wrapped box with an attractive red ribbon.

"This is a Christmas present for you but you can open it now, if you want?"

Bettie's eyes shined with surprise. She carefully removed the ribbon, twirled it around her finger into a small roll and stuck it in her purse. Next, she gently removed the tape from the printed wrapping paper and folded the paper.

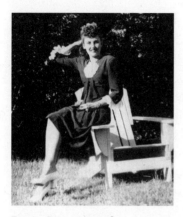

Bettie Ross poses for a picture to send Vernon Drake while he was away at college.

Vernon fidgeted with anticipation, hoping she would like it but at the same time, fearing that she would be disappointed.

Come on. Hurry up; he wanted to say but kept quiet.

Slowly, she opened the small white box to reveal the flower brooch lying on a bed of cotton.

"Oh, Vernon, it's beautiful." Bettie caressed the little hunk of metal and glass as though it were made of gold and diamonds.

"It's not much. Glad you like it. I don't have a class pin, but I was thinking, maybe you could wear it to sorta, you know, be my girl."

Bettie threw her arms around his neck and pulled him close. "Of course I'll be your girl."

The smell of her perfume, the tickle of her hair on his neck, and a kiss on his cheek sealed the deal.

<p style="text-align:center">★★★</p>

More hours in the air … the sun began to peek over the horizon as the transport touched down at Karachi Airfield. Taxiing in, Vernon became overwhelmed.

"Wow, Chappy, cast your peepers on this!"

A huge multistory terminal building, flanked by monstrous hangars, took center stage whilst scores of military buildings spread out in all directions. Rows of bombers, fighters, and transports seemed endless. In the distance, yards full of military vehicles of all kinds were lined up in rank and file. Vehicles and people were swarming around in a flurry of activity.

"I think we found the war," Chappy responded.

After parking and securing the aircraft, the captain addressed his passengers. "This is as far as I go, men. You'll get orders for your assignment here. I wish you all the best of luck."

By the time the ground crew got the stairs in place, the sun beat through the windows, heating up the plane. Expecting to step out into cooler air, the airmen were met, instead, by a hot breeze. Several trucks waited at the bottom of the steps with an officer and some enlisted men. Toting their olive drab B4 garment bags at their left side, each man saluted the officer upon reaching the last step.

"Welcome to Karachi, men," the officer announced. "These trucks will take you to the administration office."

Vernon, Chappy, Goodrich, and the other young airmen climbed aboard and found places on the hard wooden bench seats for the short ride across the tarmac to an official-looking wing of the terminal building. A separate transport was provided for the nurses.

"Hey, Lt. Goodrich, sir, do you know where we are going from here?" asked gunnery Private Kardell, formerly Sgt. Kardell.

"Nope. This is as far as our orders take us."

Everyone piled out onto a small grassy area in front of the building while Lt. Goodrich and the other aircraft commanders went into the administration office. A few minutes later, he came out with papers in hand.

"I got our orders. We've been assigned to the 10th Air Force, 493rd Bomb Squadron, 7th Bomb Group. We'll be stationed at someplace called Pandaveswar in India."

"Where the devil is that?" Chappy barked.

"Damned if I know. We depart here at eleven hundred hours tomorrow and arrive in Calcutta at around nineteen hundred tomorrow tonight."

A notable groan arose from the crew.

"That's clean to the other side of India. Another eight hours in the tin can," Pvt. Kardell grumbled.

"The good news is, we got a two-day leave coming in Calcutta," Goodrich responded.

"Yeah, I'm gonna need it," Chappy sighed.

After stashing their belongings in their assigned barracks, Vernon, Goodrich, Chappy, and Froula rented bicycles to explore the base and found their way to the Officers' Club. The place hopped with live music, a crowded bar, and a busy dance floor.

"Hey," Chappy perked up, "there's Lieutenant Baker.

The attractive blonde nurse that he had been flirting with all the way from Miami was dancing with one of the base officers. She and the other nurses had found the Officers' Club as well. Chappy pushed his way through the crowd and tapped the base officer on the shoulder.

"Sorry, Captain, I'm cutting in."

He forced his way between the couple, wrapped his arm around Lt. Baker and swept her away.

Vernon watched in amazement as Chappy and Lt. Baker swirled through the crowd like Fred Astaire and Ginger Rogers. Lt. Baker didn't look too happy about it though.

Goodrich leaned into Vernon to be heard over the band. "Wow. I know Chappy's a navigator but who would have guessed he could navigate his way around a dance floor?"

When the music ended, Lt. Baker turned on her heel and began walking away. Chappy grabbed her arm to stop her. She turned toward him and began giving him an earful. Vernon, Goodrich, and Froula couldn't hear what was being said but they could tell it wasn't going well for Chappy. As she marched off, Chappy stood looking dazed and dejected. He shuffled over to the bar and ordered a drink as the guys joined up with him.

"What's the deal?" Vernon asked.

"Aww … the dame thinks she's too good for me. I figured we were doing pretty good on the flight over. Yeah, maybe I was being a bit too cocky but now she doesn't want anything to do with me."

The boys left Chappy to drown in his sorrows, which he proceeded to do quite handedly. He eventually left and disappeared into the night. When the rest of the crew ended their evening and were returning to the barracks, they found an inebriated Chappy peddling his bike in a fast frenzy around the dark parade ground cursing at the top of his lungs. The rejection by Lt. Baker had obviously hit him a lot harder than any of the guys understood. Eventually, they were able to coax him into the quarters where he dug into his duffle bag, produced a bottle of Scotch whisky, and sat on the doorstep challenging the mosquitos to give him malaria.

Lt. Goodrich sat down on the step and tried to console him. When that didn't work, he figured he would share the bottle in an effort to consume most of it, thereby preventing Flight Officer Chapman from drinking it all and killing himself. An ill-conceived plan, it was quite a sacrifice for a teetotalling Mormon boy from Utah. Soon there were two loud voices keeping the whole BOQ (Base Officers Quarters) awake.

When morning arrived, Chappy stayed in his bunk too sick to eat while the rest went to breakfast. When they returned, they found him showered and badly hungover. They packed up their gear and headed for the airstrip.

After hanging around the terminal with a hundred other guys for a couple of hours, Vernon's crew climbed the steps of another C-54 transport.

"Welcome to the army," Lt. Goodrich grouched as he entered the wide door. "Looks like we're roughing it from here on in."

Canvas sling seats hung from the sides of the army-green, bare-metal superstructure. Crates of cargo filled the center aisle.

Vernon shoved his garment bag in the overhead netting and claimed a seat beside a window in front of the wing, although he would have to look over his shoulder to see out. The transition from the airline luxury they had been traveling in, to this troop transport, left him with a queasy feeling. Like it or not, he was being sucked toward the war.

As the big ship growled into the air, he twisted around to get a view of the shrinking city. "Well, I guess I can say I've *been* to Karachi but I haven't *seen* Karachi."

CHAPTER 6

Across India

Once at cruising altitude, Lt. Drake reached into a side pouch of his B4 garment bag, pulled out a small 5" × 8" sketchbook and began leafing through it. The history of his military experience was captured there in pencil images. The little book had become a pictorial diary, more expressive than any written log. Cartoon caricatures of bumbling, newly enlisted soldiers tripping through Basic Training drills filled the first dozen pages. They were captured learning how to march, do push-ups, make beds, salute, fire machine guns, and run obstacle courses. More than one image contained a drained recruit sacked out in his bunk.

Then came slightly more sophisticated images of cadets at the San Antonio Aviation Cadet Center in Brooks Field, San Antonio, Texas. These illustrated classroom stuff—confused students overwhelmed by E-6B slide rule flight calculators, navigation charts, aircraft systems and such. He drew perspiring young men hunched over desks with manuals, formulas, and dials, dancing overhead.

By the time he reached Primary Pilot Training at Ballinger, Texas, his sketched cadets wore parachutes and struggled under the pressure of hollering, overbearing flight instructors and uncooperative, open cockpit aircraft. Young aviators began to emerge on the pages depicting the Advanced Training at Pampa, Texas. Sketches of tempting shapely girls being whistled at by cadets were interspersed with flight training.

Exaggerated images of screaming instructors chronicled the fear students had of washing out.

"Say, you're pretty damn good," a young officer sitting next to Vernon commented as he watched the pages turn.

"Aw, they're just scribbles."

"No kidding, you could be a pro."

Vernon had honed his talent as a cartoonist for the Cadet Class Book and worked on the base newspaper in his spare time. A lot of his ideas first found life in his little sketchbook.

A finely crafted jackass, the animal, behind the controls of a twin-engine Cessna AT-17 Bobcat, not so affectionately known as the "Bamboo Bomber," illustrated how he felt the first time he sat in the multi-engine trainer.

Time in the seat built his confidence in both flying and drawing. With the new-found freedom of weekend passes, more fine-figured females and off-base hijinks found their way to the tip of his pencil.

"Boy, those sure bring back some memories," his observer said.

As Vernon turned the page, a well-drawn portrait of a girl with dazzling eyes and flowing hair swept up at the sides with tortoiseshell combs, teased from the paper.

"Wow, what a dish!"

"That, lieutenant, is my bride," Vernon replied with a bit of pride for both the model and his artwork.

"No kidding? She's swell."

Vernon drank in the image, lost in the lines of her soft face and the memories of a time that seemed so far away. The rumbling of the aircraft engines faded to the background as his thoughts slipped into the past.

★★★

Bettie's high school graduation picture had found a safe place in Vernon's wallet but there were more important things on his mind. He finished the college semester and enlisted in the Army Air Corps in March 1942. Being placed on reserve status meant he could be called up at any time. To do his part for the war effort while waiting, he and Ray took

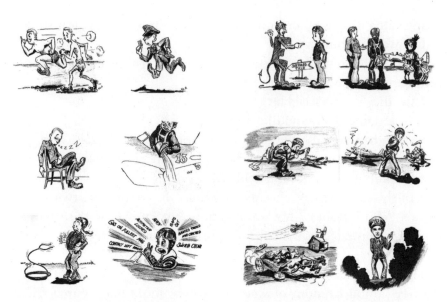

Cadet Vernon Drake drew these illustrations for the class book while at Pampa, Texas, for Basic Training.

Illustrating basic flight training, these drawings by Cadet Vernon Drake were also included in the class book.

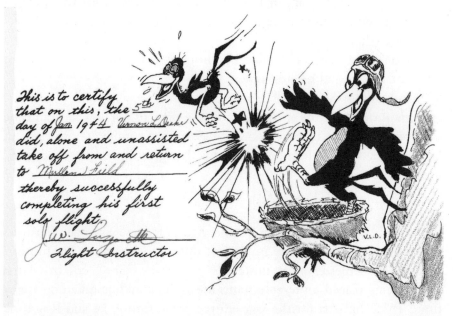

Cadet Vernon Drake created his own solo certificate, which was adopted by other student airman as well.

As an exhausted airman, Vernon Drake's dreams were haunted by gruff flight instructors and the constant pressure of training. The threat of washing out was ever present.

As was the case for young GIs everywhere, girls were always on their minds even though encountering them was rare. Vernon Drake captured their antics well enough to get several full pages in the Pampa Army Air Field Class Book, Class 44F "The Gig Sheet."

Night was the time for dreaming of the future as Basic Training came to an end.

The author never learned what the significance of this illustration was, although it can be surmised Major Hap was the big dog at the training school and the "Dodos" were the students.

A full-page drawing illustrates base life of the Class of 44F at Pampa, Texas, for student pilots.

After completing Primary Training, Cadet Drake was sent to Goodfellow Field in San Angelo, Texas, for advanced multi-engine training. From there he went to Ballinger, Texas, as a multi-engine checkout pilot.

Even though training took most of a cadet's time, girls were still a major distraction when the opportunity arose.

summer jobs as carpenters building the Japanese Relocation Camp at Heart Mountain in Wyoming. People of Japanese descent were being rounded up all over the country, particularly on the West Coast, and moved to these camps as a precautionary measure. Swinging hammers kept him busy during the day but Bettie filled his dreams at night. By mid-summer the call was too great, so he returned home.

"Do you know when you will go?" Bettie asked as she snuggled in Vernon's embrace.

"No, they don't tell us that. It could be in a week or even months. I know some guys who waited six months before they were called."

"What are you going to do until then?"

"Mr. Depner said I could work at the grocery store."

"I'm really scared for you. I see so many service flags in windows—especially those with gold stars. Too many are dying." She gave a quiet sigh. "I hate war."

"Don't worry, Betsy. I can take care of myself. Shucks, the war will probably be over by the time I've made it through training."

Bettie stroked Vernon's hand as she looked up into his strong face. "Maybe, but what if it isn't? I can't bear the thought of you going over there."

"I know, but what kind of coward would I be if I didn't? You wouldn't want a guy like that."

"You could ask for a job in the states."

"I don't think I get a choice. I go where they send me."

Bettie fidgeted with the pleat in her skirt. "What if you forget about me?"

"Ah, Betsy, how could I do that? You know you're my girl."

She sat quietly for a few minutes, enjoying the warmth of his chest. "You know, Cal and Ed kept coming by the house while you were gone, honking their ooga horn to get Fern and me to go out with them."

Vernon perked up. "Is that so? And did you?"

"Well, Fern did. I thought about it. Mom sure got mad at them. You could hear that horn two blocks away."

If Bettie intended on making Vernon jealous, it had the proper effect. He knew Cal had eyes for her, and she knew he knew.

"So ... are you going to go out with him?"

"Him?"

"Yeah, Cal."

She silently chuckled to herself. "You're back now. Why would I do that?" She knew her test had worked.

"Let me see if I got this straight, you're worried I might forget you while I'm away, but you might go out with Cal if I'm not here?"

"No, no. That's not what I meant, Vernon." She sat upright, put her hand on his chest, and looked him sincerely in the eyes. "You're the only one I want to go out with—really."

If there ever was a time for a kiss and fond embrace, that was it, and Vernon took full advantage.

In the weeks that followed, Vernon and Bettie spent most of their spare time together. It wasn't as much as they would have liked because, besides working at the grocery store and tending chores at the farm, Vernon took on classes at the Billings Polytechnical Institute. Bettie could be found many evenings helping Vernon's mother prepare supper for the boys when they got home from the farm.

"The Thompsons got a telegram this morning," Vernon's mother sadly announced at supper. "Ronny was killed in a place called Midway. That's the third boy this week."

"Where's Midway?" Vernon asked.

"An island somewhere in the Pacific."

"He got it by the Japs, then." Ray piped up. "Poor Ronny. I didn't know him well, but he was a good egg."

"We'll get those Japs. Just wait and see," Vernon said as he spooned in a mouthful of mashed potatoes.

"Oh, I hope this whole horrible thing is over before you boys have to go," Vernon's mother said, fighting back tears.

Bettie had been sitting silently beside Vernon when she suddenly erupted into sobs, pushed back her chair and excused herself. Vernon gave his family a puzzled look and then excused himself to follow her. He found her on the porch wiping tears from her eyes with the dinner napkin. He walked up behind her and gently wrapped his arms around her shoulders and pulled her close.

"I'm sorry," she spoke softly. "I didn't mean to embarrass you in front of your family."

"You didn't embarrass me. It's fine. Really."

"I just can't stand the thought of you going off to that awful war. Why do you have to fight battles halfway around the world anyway?" She blew her nose into the napkin.

The couple stood at the porch rail, gazing up at a bright, peaceful night sky. "We didn't start it, you know," Vernon said. "If we don't stop them, next thing you know, the Germans and the Japs will be in our backyard. They want to take over the world."

"I know, but it's so unfair. I don't want you, or Ray, or your brothers, or any of my friends to go."

"Somebody has to do it. If not us, who?"

"But what if you get killed. I couldn't bear that."

"Me? Don't worry about me. I'll be fine. Besides, all the heavy fighting will be over by the time they call me up."

Bettie pulled Vernon's arms tighter. "But I am worried. I'm worried you won't come back to me. I'm worried the war will take you away and I'll never see you again."

"Ah, my Betsy, nothing is going to keep me away from you." He gave her a squeeze and nuzzled her neck. "Let's go finish supper. I haven't been called yet. We'll cross that bridge when we come to it. For now, we can enjoy the time we have."

When they returned to the table, Vernon's father was reading the newspaper to the family, something not normally permitted.

"According to the news, the Midway battle is a great victory for the United States. It says here, *Japs thrown for loss at Midway as the United States forces, operating like a smart football team, keep major force to block smash through center.* They got a diagram here showing how we stopped 'em."

Vernon looked at Bettie. "See, it'll be all over soon. Maybe I won't even have to go."

Karnani Estates

"Karnani Estates?" Chappy piped up. "Sounds like a resort. Maybe we can play a few rounds of golf or lounge in the shade with a cool Schlitz."

He and Vernon peered out of the window of the transport as Calcutta slipped beneath its wings.

"Whatever it is, the army is putting the officers up there for *cultural orientation*, for a few days." Lt. Goodrich chimed in.

Pvt. Coogan elbowed Sgt. Stinson. "I wonder what wonderful accommodations they have for us enlisted guys?"

Lt. Froula pinched his nose and yelled out, "Phew, who let the cheese."

As a stench filled the cabin, Vernon replied, "That's no cheese, that's Calcutta."

Tires squeaked as the plane gave a slight jolt, announcing their arrival.

Taxiing in, Vernon could see lines of B-24 Liberators waiting their turn to depart for bombing runs over Burma. Some had caricatures and slogans painted on the nose just below the cockpit. Excitement welled up in his chest as he pictured himself at the controls, followed quickly by a pang of apprehension. Only the Plexiglas window separated him from that reality.

"Welcome to Dum Dum Airport," the captain announced as the transport door opened, anticipating the snickers and joking remarks.

"I was pretty dumb-dumb to sign up in the first place."

"Looks and smells like a dumb dump to me."

Ignoring the obvious retorts, the captain stood at the exit directing his exhausted passengers. "Grab your luggage, men. Your transportation awaits."

As Vernon descended the stairs, the long, low terminal building across the tarmac greeted him with its gleaming white roof and "CALCUTTA" spread out in huge black block letters. An arrow at one end pointing east, indicating New York lay 11,089 miles in that direction, and another pointing west to San Francisco 10,924 miles the other direction. He had literally arrived at the opposite side of the world from home.

Several 6 × 6, olive-drab-green army trucks with canvas enclosures on the back, idled at the bottom of the stairway.

"Officers in these trucks and enlisted men over there … nurses, you get the sedan," the lieutenant in charge barked.

Vernon and the other officers piled into their assigned trucks and bounced off toward the US Army Air Force, 7th Bombardment Group headquarters.

"Let's see your orders, lieutenant," the orderly requested.

Vernon handed over the two sheets of paper that had brought him as far as Calcutta. The clerk briefly looked over the forms, ran his finger down a list and stopped at 2nd Lt. Vernon Drake.

"You've been assigned to the 493rd based at Pandaveswar. You'll report there after a two-day leave in Calcutta. You will be billeted at Karnani Estates during your stay here. Travel instructions are attached. Try and stay out of trouble." He handed the papers back to Vernon. "Next."

Vernon had no idea what or where Pandaveswar was. All he knew was that he would be going there to fly B-24 bombers with his crew.

The men loaded back into the trucks heading for the place they would call home for the next few days. Passing through the base gate took them into a strange new world viewed through white clouds of dust raised by the trucks. Canvas flapped in the wind as women in colorful saris carrying baskets on their heads and men driving horse-drawn carts piled high with grain, trailed off behind the passing vehicle. The air hung heavy with heat and humidity, sticking his khaki uniform to his back.

He expected to see farms and open country as the transport made its way toward Karnani Estates. The excited airmen anticipated rolling

manicured lawns with quaint cottages surrounding a swimming pool. But with every mile, the streets became more crowded, edged with stark-white concrete buildings, shops, bars, and apartment buildings. Dark-skinned Indians dressed in white, many on bicycles or carts, cluttered the road. Groups of servicemen in uniform leisurely strolled among the crowds stopping to inspect the exotic goods displayed in open-air shops. A bewildering mass of billboards of all sizes and colors, lettered in strange characters intermixed with English, added to the apparent chaos of a bustling metropolis.

The trucks turned onto Lower Circular Road near the center of the city and ground to a halt in front of a mammoth five-story hotel that took up an entire city block. Vernon jumped off the truck, caught his bag as it was tossed after him, and stared up at the huge rectangular slab-sided building consisting of row upon row of windows. A few planters surrounded the ground floor exterior, apparently to give a slightly softer look.

"This is Karnani Estates?"

"Welcome to the high life, boys," a passing airman called out as he strolled by giving a mock salute.

The lobby of the massive hotel bespoke of grander days gone by. Richly tiled in colorful, old-world India style, it greeted its new arrivals with tasteful upper-class luxury in a country where a strict caste system existed for centuries.

"Wowee," whistled Goodrich. "Would you look at this place."

As he gazed at the ceiling, walls, and columns covered in colorful ceramic and paintings, Vernon shuffled through the lobby toward the check-in counter, pushed along by 15 other guys. "This is a long way from the farm," he muttered to himself, feeling the weight of being removed halfway around the world from all he knew.

A half-dozen Indian clerks immaculately dressed in white, stood behind the check-in counter busily tending to the new arrivals.

"Welcome to Calcutta, Lieutenant Drake." The clerk's bright white teeth offset his dark complexion as he greeted Vernon with a big smile and a singing cadence to his voice. "You and Lieutenant Harris will be in room 316. Leave your bag with the boy. He will show you to your room. Have a most pleasant stay."

2nd Lieutenant Harris had been on the flight over but Vernon barely knew him. Tall, slender, corn stalk hair and a Southern drawl, Harris trained as a navigator.

"Shucks, ain't this the life. Servants and everythin'," Harris called back over his shoulder as they followed the bellboy to the elevator.

"Hey, Drake," Goodrich shouted from the counter. "Meet us in the bar when you get settled in."

"Yeah, okay."

The elevator operator slid open a collapsible gate to let his new passengers in as the bellboy said something to him—presumably the floor number.

A spacious room with two single beds, an ornate dresser with a water pitcher and bowl, closet, and split doors opening onto a small balcony greeted them. The bellboy set their bags next to the dresser, flipped on the ceiling fan, and politely backed toward the door, bowing several times with his hands clasped together.

"Welcome, sahib," he said with a small side-to-side wiggle of his head. "Please tell me if there is anything I can do for you. I am called Arjun."

Vernon gave Lt. Harris a quick glance and got a puzzled look back. *Was he supposed to tip this guy?*

"Thank y'all, Arjun." Harris handed the boy a quarter and gave a half salute. "We'll let you know."

"*Dhanyavaad,*" Arjun replied as he bowed again and backed out the door.

"Durn you vad to you too." Harris turned to Vernon and gave a big shrug. "Funny little feller."

Vernon laughed and flopped back onto the bed, exhausted from all the events of the day.

"Well, I'll be. Lookee here." Harris opened a small door next to the closet. "We even got indoor plumbin.'" The door led into a small bathroom containing a toilet, sink, and shower all tiled in white from the floor to the ceiling. Another small door on the opposite side apparently opened into the room next door. "We gotta share."

"Sure beats the barracks latrine. Let me at it." Vernon sprung from the bed. The long, bouncy ride from the airport and a couple of cold sodas were making themselves known now that all the excitement had died down.

Relieved and clothes put away in the closet, Vernon and Harris made their way down to the bar to meet up with the rest of the gang.

Since Karnani Estates housed only officers, the bar served as an official Officers' Club. Stepping through the door, Vernon immediately felt out of place. Not because of the bar atmosphere but because of the richness within. Beautiful mahogany columns reached up to a vaulted ceiling of glass chandeliers. Deep red leather overstuffed chairs and stools, looking too stately to sit in, surrounded inlaid tables polished to perfection. The place made the restaurant at the Northern Hotel in Billings look like a dump. The opulence overwhelmed his senses.

"Hey, Drake, over here." Lt. Goodrich, with a beer in one hand and a cigarette in the other, waved from the bar.

Vernon made his way through the small crowd of officers while Harris peeled off to join his buddies.

"Would ya get a load of this place." Goodrich waved his drink in the air. "They say it's the most elaborately decorated bar of any Officers' Club in the CBI. I think I'm gonna like this."

A junior officer leaning on the bar next to Goodrich lifted his glass. "Enjoy it while you can, boys."

Vernon didn't care much for beer but he had a glass with Goodrich, Chappy, and the others to celebrate their arrival. The day had been long and a real bed called to him. His internal clock had not reset but his body knew that the time had come for some serious shuteye.

In his room, he found an orientation brochure placed there by the command. It listed shops, restaurants, recreation, and sites to visit while in Calcutta. The pamphlet listed what to do and what not to do. Indian women were off-limits!

Brigadier General Leyland added, "It is part of your job to cultivate a lasting relationship with India." He went on to write about presenting a good front. "In any permanent plan for peace that includes (and must include) Southeast Asia, India must and will assume a prominent role. You are a practical person from a practical nation. You can see that it makes common sense for anyone to cultivate a lasting friendship with India. Go to it then. YOU—you're the one who is going to do it."

In one final comment, he added, "Incidentally, the people here like us. They think we're all right. Thanks to the good behavior of the American soldiers who preceded you, a friendly welcome from these folks awaits you. If you behave equally as well, a similar welcome will await your buddies who follow you in here. *Theek hai?*"

What the heck is theek hai? Vernon fell back onto his soft pillow and began to drift off as the busy sounds from the street wafting through the balcony doors, mixed with the gentle swirling air of the ceiling fan. Sleep came easily.

CHAPTER 8

Calcutta

Morning light woke Vernon to sticky, limp sheets from hours of sweat in the steamy humidity of India. He wondered how he had managed to sleep through the night. Texas had been hot and humid but nothing like this. For a guy who spent his life in the high, dry plains of Montana, the feeling of always being hot and sweaty didn't come easy but he had been exhausted. That trumped discomfort.

"Hey there, sleepyhead. Decided to join the living, did ya?" Harris, wrapped in a towel, brushed his hair in the mirror over the dresser. "A cold shower sure feels good. Ya gotta try it."

Vernon sat up, stretched, and rubbed the sleep from his eyes. "I could use one."

"What d'ya say you and me hit the streets for some sights after we put on the feed bag this mornin'?" Harris dropped the towel and slipped into his army-issue boxer shorts. "They say this place has some pretty good grub."

"Yeah, sounds okay to me." Vernon eased out of the bed and shuffled toward the bathroom. "Anybody in there?"

"Nope. It's all yours."

After he showered and dressed, the pair headed down to the restaurant where they found a buffet of real eggs, bacon, hash-brown potatoes, pancakes, and just about anything else a guy could want for a good ol' American breakfast.

"Doesn't look like we'll go hungry," Vernon said as he piled his plate high. "Reminds me of breakfast on the farm—without all the fancy trimmings of course."

A captain reached in for a scoop of scrambled eggs. "Eat up soldier, you'll be back to living on SPAM in a few days."

The pair sat down to enjoy their feast and talk over plans for the day.

After swallowing a mouthful of eggs, Vernon spun his fork in thought. "A guy told me last night that we should head over to Free School Street. There's a lot of shops over there. I wanna get something for my wife."

"Yeah, yeah. We can do that. We could hop on one of those trolley cars I seen comin' in and check out the city."

Harris and his folksy ways began to grow on Vernon. He looked forward to spending the day with this lanky Alabama boy. He seemed like a good companion for an exploration adventure in a totally foreign land.

"So, you got a girl back home?" Harris asked, interested in learning more about Vernon's wife.

"Sure do. The sweetest, prettiest girl you ever want to meet." Vernon reached for his wallet. "Do you want to see a picture of her?"

Vernon flipped open his wallet to a picture of Bettie. Harris's eyes widened.

"She's a real looker."

"Thanks. I think so." He returned the wallet to his pants pocket.

A year had passed since Vernon had married Bettie when he transferred to Ballenger, Texas for Primary Flight Training. He had a new daughter he had seen for only a few days. Bettie left six-week-old Lana with her mother, rejoined Vernon at Ballenger, and once again found a small apartment off base where the two could spend time together on weekends. Along with Vernon's meager army

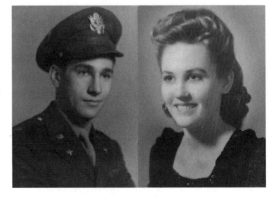

The newlyweds, Vernon Drake and Bettie Ross.

pay, Bettie found a job in town to help cover the expenses. December and January came and went as Vernon learned to fly trainers.

In February, they moved to Goodfellow Field in San Angelo, and then to Pampa Air Corps Base in Amarillo, Texas for Twin Engine Advanced Training. By that time, being married was no longer a secret. Bettie made friends with the daughter of a local judge who invited the couple to dinner. When they arrived, they found the other guests were Vernon's commanding officer and his wife. At dinner, the officer asked Bettie where she would like Vernon to be stationed after graduation.

She didn't hesitate. "Could he stay here and be a flight instructor?"

That was how he ended up at Randolf Field as an instructor and then Fredrick, Oklahoma as a check pilot. Bettie, happy that her husband wasn't being shipped off to war, returned to her mother to take care of baby Lana.

The job of instructor and check pilot lasted only a few months before he was assigned to Topeka, Kansas for copilot training. This time Bettie and daughter joined him. They had become a family for the first time. Summer came and went with Vernon flying and studying hard. Again, he excelled at both. By fall, he finished copilot training and received his orders to report to Pueblo, Colorado for crew assignment on B24 bombers. Now, he sat across from a new friend in India. "You have a girl?" Vernon asked.

"Naw." Harris gave a shy shake of his head. "I did but she broke it off before I left for training. Said she didn't want to worry about me coming back. Next thing I know, she's gone and got herself engaged to a captain."

"Tough break." Vernon didn't know how else to respond.

"Hell, that's enough of that talk. Let's hit the trail and see what we can find."

As they rose from the table to leave, Goodrich and Chappy walked in.

"Hey, Drake," Goodrich greeted. "You gonna join us for a tour of the hot spots?"

"Naw. Harris and I are just heading out to do some sightseeing. Maybe I'll catch up with you later today."

"Okay. But, you don't know what you're missing."

Vernon had some idea of what he would be missing. Those two made them almost miss the plane back in Natal, Brazil with their tour of the hot spots.

The streets of Calcutta blazed in the morning sun—a strange mix of British colonial influence and old-world mystical India. Cars, trucks, ox carts, wagons, bicycles, and streetcars merged into a blur of activity. Open front markets displayed everything from dead chickens hanging in rows to finely crafted beadwork and colorful fabrics. In contrast, stately multistory buildings housed upscale shops inviting the wealthy class to browse. Dark-skinned people dressed in white squatted around cooking pots on the sidewalks, deformed beggars sat cross-legged with hands outstretched while people ignored them. The smell of rotting garbage and human refuse mixed with aromas of spicy cooking and incense burning.

2nd Lt. Vernon Drake tours the temples of Calcutta during a two-day layover at the Karnani Estates on his way to Pandaveswar.

The scene confounded the senses and would have seemed completely foreign to Vernon except for the hundreds of servicemen in uniform roaming the streets. American, British, French, and Dutch soldiers from all branches made the city seem somehow friendly and welcoming. Calcutta served as R&R (rest and relaxation) for soldiers taking a break from the war as well as cultural orientation for men like Vernon and Harris.

"Hey, Drake, take a look at this."

Harris joined a ring of soldiers surrounding an Indian man draped in white with a turban on his head, sitting with legs crossed in front of a woven basket. He had a long elaborately decorated flute-like instrument on which he played a haunting warble of strange notes. The head of a snake slowly appeared rising from the basket. As it coiled upward, the man taunted it with the flute until the snake's head spread into the recognizable diamond of a deadly cobra.

"Can't do that with the rattlesnakes back home," Vernon quipped.

The two spent the day wandering through the shops, bazaars, and markets in wonder at the variety of handmade trinkets, jewelry, and novelties displayed.

"What are you going to get for your girl?" Harris asked.

"I don't know. The more I see, the more confused I get. She doesn't wear much jewelry."

As they strolled among the shops, they came upon a small narrow boutique that had display cases filled with finely carved boxes.

"Now, that's something she would like."

Vernon picked through the boxes of all sizes and found a small one made from tortoiseshell with detailed elephants and flowers carved in bone and inlaid on its top and sides. Each corner had a five-toed lion's foot in white. A red velveteen lining said luxury.

With a bit of haggling over price, Vernon left the store with the beautiful little box wrapped in *The Calcutta Chronicle* newspaper. Somehow, the purchase made him feel closer to Bettie as though she had already touched and treasured it. When he held the box, he could feel her hand touching his. He could imagine the joy in her eyes when receiving the gift.

Stepping out into the street, the reality of being in a country foreign from anything he had experienced, shook him from his brief connection with home.

"Now, I'm ready to do some real sightseeing. Let's hop on one of those trolleys."

Dirty yellow and covered with colorful advertising, electric narrow-gauge trolley cars rumbled through the city in all directions along rusty rails while sparks flew from the maze of wires overhead. At each stop, people surged in and out of the narrow doors and climbed through windows to find space inside.

The two made their way through the mass of slow traffic moving at a bullock cart and rickshaw pace, with car horns honking and trolley bells clanging. A convoy of US military trucks inched its way along the crowded street while a policeman dressed in an official white uniform and an impressive turban, stood on a pedestal in the middle of the street attempting to direct the snarl of traffic. Two sacred cows occupied a street

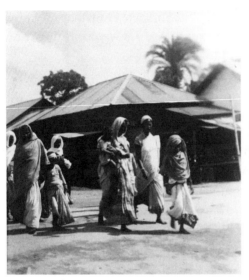

A two-day stay in Calcutta before going to Pandaveswar was the army's attempt at "cultural orientation" for military personnel coming straight from the States. Lt. Drake found the extreme poverty unsettling, although people seemed happy for the most part.

corner, content to be surrounded by throngs of pedestrians, bicycles, and pushcarts.

Vernon led the way as they elbowed through the crowd to the nearest tram stop. "I don't know where it's going but I guess we'll find out."

They squirmed up the step and through the door into the densely packed car, each grabbing onto the overhead well-worn brass handrail as the trolley lurched forward. They were off on an adventure.

For the rest of the day, Vernon and Harris crisscrossed the city, riding trolleys, rickshaws, and walking miles of crowded streets. They saw elaborate temples, painted elephants, stunning official buildings, and poverty. The contrast of a city widely split between the wealthy and the destitute, under siege of war, and invaded by Western military might, permeated every corner. By the time they returned to Karnani Estates that evening, exhaustion drove them to their room for a much-needed rest.

A knock on the door woke Vernon from a deep sleep into which he had collapsed in his clothes. He rolled off the bed and stumbled to the door. As he opened it, Goodrich and Chappy pushed in.

"What the hell are you sleeping for?" Goodrich chortled. "There's a whole night ahead of us. We heard there's some real action down on Park Street. Ya gotta come with us."

"Yeah," Chappy joined in. "We're going to hit Trincas first."

Vernon glanced at his watch—nine-fifteen.

"It's early." Goodrich gave a disapproving look. "Gotta take advantage while we can."

Vernon knew that a night on the town with these two probably meant trouble but he couldn't say no. After all, they were a team.

"Okay. I gotta hit the john first and then I'll meet you in the lobby."

Goodrich shook his cap at Vernon, "But you better hurry soldier. Time's a wastin.'"

CHAPTER 9

Cultural Orientation

"First stop, boys—The Great Eastern Hotel." Lt. Goodrich drooped an arm over the shoulders of Vernon and Chappy. "We're gonna dine like kings tonight. The Casanova Restaurant awaits."

The Karnani Estates' lobby teemed with soldiers coming and going as the three set out on their evening adventure.

"I hear they got everything over there—music, dancing, shows—and we're gonna do it all."

"I guess you know how to get there?" Vernon asked.

"Not a problem. We'll grab one of those wagon taxis over there."

A line of well-worn horse-drawn coaches came and went at the curb of the hotel, picking up and dropping off servicemen in various stages of revelry. Some had been taking full advantage of the bars that day; others carried bags of paraphernalia purchased while sightseeing.

"There's one." Chappy pointed to a slightly tattered, black carriage with a canvas top and a sleepy-eyed horse, expelling its rather inebriated passengers. "Come on."

The three airmen piled in as Goodrich barked at the driver, "To the Great Eastern Hotel my good man."

Without a word, the driver gave a slight flick of the reins from his high perch and they were off at a slow clickity-clack pace of an animal bored with the monotony of dragging soldiers around the streets of the city. The old horse picked its way through the hordes of traffic,

completely unaffected by the honking of horns, cars inching by, and trolleys screeching on metal tracks. The city was in blackout so cars drove with headlights having only a small slit of light, servicemen walked the streets with flashlights, shops and bars had their windows covered.

"Our plow horses back on the farm would spook and run like the blazes in traffic like this," Vernon said as he marveled at how passive the coach horses were. "Ol' Dan would tear up the place."

"You still plowing behind horses out there in Montana?" Chappy asked.

"Naw, we got a tractor, but sometimes the team does a better job."

The evening sky passed through shades of purple as it grew darker. Indian folk music with stringed-sitars and tabla drums competed with popular swing and jazz music emanating from bars as the carriage rolled past. Groups of poor street people sat around small fires by the side of the road while servicemen strolled along looking for the next bar offering entertainment.

The massive four-story Great Eastern Hotel sat with its impressive, curved front festooned with Roman columns, a grand staircase, and promenade balcony overlooking the wide Old Court House Street and Maidan Park. In a true blend of British influence and Indian wealth, it had shops, restaurants, bars, ballroom, and rooftop courtyards to accommodate the elite of society, which in these times of war, included officers.

"Now, this is what I call cultural orientation," Goodrich quipped as he casually flipped the cab driver a few coins. "We're movin' uptown."

Chappy stood gawking at the moon-lit, stately building. "This place looks swell."

"Sure is a long way from the farm," Vernon added.

The trio entered the hotel past exclusive boutiques and climbed the grand staircase leading to a rooftop Italian restaurant. Big band dance music drifted down from above along with wonderful aromas of culinary delights. Again, Vernon would have felt completely out of place except for the crowds of uniformed men and women who dominated the scene.

"Hey, buddy, can you tell us where the Casanova Restaurant is?" Goodrich asked an Aussie officer descending the stairs.

"Sure, mate. Top of the stairs on your left."

A distinguished maître d' in a black tuxedo greeted them in the now-familiar English of East India. "Welcome to the Casanova gentlemen. Do you have reservations?"

Goodrich cast a quick look back at his companions and then slipped a bill into the hands of the maître d'.

"Ah, yes. Please enjoy our bar. You will be seated when a table becomes available."

Indian men attired in black suit and tie accompanied by ladies in evening gowns, mixed with military uniforms from all branches. Waiters dressed in white with black sashes and red turbans pushed through the crowd, carefully balancing trays of food and drink above their heads. A 10-piece orchestra played at the far end beyond a crowded dance floor as a sequin-drenched songstress serenaded a blues tune with a noticeable Indian accent.

"This place is a killer-diller," Chappy voiced over the hum of the crowd. "I'm headed for the bar."

"Right behind ya," Goodrich added.

Vernon followed, jostling through the patrons with a polite "Excuse me," as he went.

Goodrich ordered drinks. "First round's on me boys. And keep an eye open for a table."

"Table at three o'clock," Vernon shouted out when he spotted a group of four standing up to leave.

Seeing a couple of British officers had spotted the vacancy at the same time, Chappy immediately charged forward. "Battle stations, men." He beat the British to the table and held his ground until his two crewmates joined him. "This is US Army Air Corps territory," he said to the agitated departing Brits who gave way to the uncivilized Americans.

The three claimed their prize and sat down to enjoy the atmosphere. Having been raised in a conservative home, Vernon still felt uncomfortable on the town with the boys. He couldn't help thinking about Bettie's reaction if she knew he was out like this. After all, both their families struggled just to keep food on the table.

"More drinks?" Goodrich popped up from his chair and squeezed out of sight before Vernon could say anything.

When the waiter came to the table, Vernon asked to leave three menus, one for his missing friend. Twenty minutes passed before Goodrich returned with more than drinks.

"Look what I found. This is Lieutenant Julie Barnes and Lieutenant Emily Parker. They are with the Women's Transport Service called FANY." He gave a wink.

Two dark-haired girls in their forest green British uniforms, including a set of wings under the lapel, trailed in behind Goodrich.

Vernon turned to Chappy. "How does he do it?"

Ever since they met, Goodrich possessed the uncanny ability to find and attract women. "I'll bet there aren't two other available women in this whole place."

He rose to his feet and offered a chair to Lt. Barnes. "Hello. I'm Vernon and this fellow over here is Chappy. Won't you sit down?"

The girls joined them at the table as Goodrich hailed a waiter. "What would you ladies like to drink?"

"Thank you." Lt. Parker took charge. "We'll each have red wine."

"A bottle of your best," Goodrich directed the waiter.

"Are you ladies stationed here in Calcutta?" Vernon asked.

"No, we just arrived yesterday," Lt. Barnes answered, a bit nervous. "We haven't been assigned yet."

Vernon thought Lt. Barnes seemed shy and somewhat embarrassed. She was rather plain but not at all unpleasant. Of course, that could have been the uniform. On the other hand, her friend jumped right into a conversation with Goodrich and Chappy wearing a big attractive smile on a finely sculptured face. She had a look that attracted notice and would wear any uniform well. He knew right away that she was used to men's attention, and attention she got.

By the time the waiter returned with drinks, everyone had decided on dinner. A look at the menu convinced Vernon of two things, he had never paid such high prices for a meal in his entire life, and he didn't know what most of the dishes were. Having never been to an Italian restaurant before, the menu could have been in Hindi.

Cannelloni, fettuccine, linguine, ravioli … what is that? Lasagna—Mrs. Lombardi brought lasagna to the church social. Not bad—lasagna it is.

"You ladies ready to cut a rug?" Chappy asked.

Both gave him a confused look as he stood up and extended a hand to Lt. Parker.

"Cut a rug?" She replied with a wrinkled brow.

"Yeah, you know. Trip the light fantastic."

Another blank stare.

"Dance ... Would you like to dance?"

Both girls looked at each other with a "these crazy Americans" giggle.

"Sure, soldier. Let's cut a rug." Lt. Parker rose and slipped her arm into Chappy's.

Goodrich leaned over the table and extended his hand to Lt. Barnes. "May I have the honor?"

Vernon watched the couples disappear into the crowd as he stood guard over their claimed territory. In truth, Vernon never learned to dance. His church upbringing didn't believe in such things. Now, he regretted his lack of education in that area. No doubt his companions would view him as a killjoy, but he preferred that to admitting he couldn't actually dance. Besides, he felt a tinge of betrayal even thinking about the possibility of dancing with anyone other than Bettie.

Dinner arrived and the lasagna didn't taste anything like Mrs. Lombardi's. Perhaps the heavy cloud of cigarette smoke permeating the place dulled his taste buds. Goodrich and Chappy dominated the conversation with the girls, leaving Vernon with a definite third-wheel complex. After dinner and an hour of watching couples dancing from his lone seat at the table, he had enough.

"Well, boys, I'm calling it a night. This old fuddy-duddy is heading back to the barn. Got some serious sightseeing to do tomorrow since it's our last day."

Chappy and Goodrich didn't appear too upset with his leaving although Lt. Barnes gave a look that meant she would have liked him to stay.

Arriving in his room at Karnani Estates near midnight, he found Harris sound asleep.

Good, maybe he will be up for another day of exploring Calcutta. I doubt Goodrich and Chappy will.

CHAPTER IO

Train to Nowhere

The new day began with the same heat, humidity, and city noises of the previous one; only this would be the last day in Calcutta. Tomorrow, Lt. Drake and his crew would board a train bound for the war.

"Rise and shine," Vernon said to Harris as he swatted the large Southern bare foot hanging over the edge of a much-too-short bed. "We've got some sights to see."

Harris mumbled something unintelligible as he rolled over and rubbed the sleep from his eyes. "Watcha got in mind, cowboy?" he said through a yawn.

"How about hitting Chowringhee Street first. I still want to get a couple of things to send the family."

"Y'all wanna fight that crowd again?"

"Just for a little while. Then, I got this list of temples we gotta see. There's the Kali and the Jain. And then there's the Palace. I've never seen a palace before."

Harris scratched his sleepy head as he yawned again, "Whaddya mean? We've never seen any of this stuff before."

"Yeah, and now's our chance."

After another great American breakfast, the two dove into the Indian culture once again—this time with more confidence than the day before. The streets packed with roadside vendors, trams, carts, cars, and people, felt more familiar. They knew how to get around, how to barter with the merchants, and how to avoid the beggars.

The two strolled through temples with spires and columns displaying intricately carved patterns—impressive structures consisting of mirror-inlaid pillars, windows of stained glass, and floors paved with marble and floral designs. Water gushed from fountains surrounded by an amazing variety of flowers. Ponds had fish of all sizes and colors. Monkeys roamed free trying to steal any bit of food they could. They saw statues of many gods with names they couldn't pronounce, some had four arms, some heads of animals, others were entirely blue wearing flower leis and beaded necklaces. Oil lamps burned and the smell of incense permeated the air.

"I don't think my mother would approve of me being in a place like this," Vernon said as he watched Indian natives bowing and praying.

"Why is that?" Harris asked.

"We went out of our way to avoid Catholic churches because she said they were run by Satan. She'd have a cow if she saw this."

"What d'y'all think?"

"Don't know. Things aren't so simple. The world's a whole lot bigger and more complicated than I ever imagined. Who'd ever guess I'd be in India to fly four-engine bombers a couple of years ago, let alone visiting temples?"

The day ended back at Karnani Estates for a late fried chicken dinner, mashed potatoes, and green beans. The trucks would be at the hotel at 0700 hours in the morning to take them to the train station. Sleep would not come easy with thoughts of the unknown in their future.

"Where is the Pandaveswar base?" Vernon asked Goodrich at breakfast the next morning.

Their bags were packed and stacked in the lobby under the watchful eye of a porter. Goodrich and Chappy both looked like they had been partying all night and sounded like it too.

"Oh, about 120 miles northwest," Goodrich scratched out a reply. "We go most of the way by train."

Chappy propped his head on his hand as he scooped up a full fork of scrambled eggs. "And I'm planning on sleeping the whole way."

"Seventh bomb group, Pandaveswar?" A clerk interrupted. "Sirs, your transport is here."

The group downed the last bite of breakfast and gulped the last drop of coffee as they left the table.

"Looks like we're off to fight the Japs," Goodrich croaked.

Sgt. Stinson and the rest of the crew were already in the truck. They had been picked up from their hotel earlier.

"How was your leave, boys?" Vernon asked.

Judging by their appearance, they found some late-night entertainment too.

Sgt. Stinson, elbows on both knees and chin in hand spoke slowly. "We polished off a few bottles of sunshine, lieutenant."

As the truck bounced through the streets, everyone else drooped on the transport benches, feeling the effects of around-the-world travel and a two-day leave.

At the train station, they presented their passes, received tickets to Asansol, and were directed to their platform. They made their way through the crowds of uniforms and turbans to where their train was waiting. The cars were packed with Indians carrying chickens, bundles, produce, food, etc. and hanging out of the windows. A few cars were reserved for servicemen heading for somewhere in the Assam Valley in Northeast India at the base of the Himalayan Mountains.

"Over here, boys." Lt. Goodrich waved as he stood next to an army sergeant with a clipboard. "This is our car."

With bags slung over their shoulders, they filed up the stairs and into the coach.

"Hey, whaddya know, padded seats," Chappy said as he threw his bag in an overhead bin and plopped down on a bench.

Others found their place as the car filled up with US Army personnel.

"Anyone know how long it will take to get to Assan … anso … anis … you know, the last stop?" Vernon asked.

"Asansol … about six hours," a voice yelled out from somewhere behind him.

"Don't wake me until we get there," Chappy said as he leaned up against the wall and pulled his cap down over his eyes.

With a jerk, the ancient narrow-gauge train slowly pulled out of the station as the powerful locomotive spewed billows of black smoke.

Vernon watched the city fall behind with its noise, congestion, and confusing blend of British Colonial influence, Indian aristocracy,

Hinduism, Buddhism, extreme wealth, and unbelievable poverty, all overshadowed by war. The city melted into small towns of shacks and shanties, and then onto farms, some no bigger than his mother's garden.

The smell of burning coal mixed with that of cow dung and freshly turned soil, flowed in through the open windows replacing the stench of the city as the country sped by. The conductor collected tickets while moving up and down the train on a plank walkway mounted externally on the cars. Clickity-clack of steel wheels on rails in a constant rhythm faded into the background as Vernon drifted off into thoughts of home.

★★★

Driving down Montana Avenue in the evening with Bettie on his arm, Vernon passed the feed store, some warehouses, and grain silos backed up against the railroad tracks. Now sleeping, they awaited rail cars to receive their tons of golden wheat. How many times had Vernon convinced his Dad's old farm truck loaded with the latest harvest to climb the ramp to the weigh-scale? Tonight, he had an even more valuable cargo on board. He slowed the car, turned in, and chugged up the ramp and into the covered weigh station.

"What are you doing?" Bettie sat up straight as Vernon's car came to a stop.

"I wanted to talk to you … in private. This is about as private as it gets."

Bettie looked around at the walls of the barn-like building with two big doors, one on each end. A dark office stood off to one side, hidden in the shadows. The large harvest moon cast an eerie light through the door of otherwise dim surroundings.

"Really? Here?"

"Well, I hadn't planned it. I've just been thinking about stuff for a while and when I saw the weigh-station, I thought, why not?"

"So …" Bettie asked slowly, not quite sure what to expect, "what did you want to talk about?"

Vernon, toying with the steering wheel and shifting nervously in his seat, mumbled, "You know I got my orders to report to Texas A&M (Agricultural and Mechanical). I'm hoping to be a pilot."

Bettie's mind began to race. *Is he going to break up with me? Am I going to lose him?*

"Well ..." Vernon seemed to choose his words carefully. "I'm going to be gone for a long time. As a pilot, there's no doubt I'll be shipped overseas to the war. Who knows where that will be?"

That's it. He is going to break up with me. Bettie's head dropped as she felt tears welling up in her eyes. *I shouldn't have teased him about Cal and Ed wanting to go out with me.*

"I have no idea when I'll see you again, so I was thinking ..."

Here it comes.

Vernon turned to her and found her hands with his. She looked up, her face bathed in the moonlight streaming through the huge open doorway—her eyes glistening with tears. He had never seen her looking so beautiful.

"What do you say we get engaged?"

"Engaged?" Her face froze somewhere between distraught and elated. "You mean—like engaged to be married?" she stammered. "You're asking me to marry you?"

Vernon searched her face for an answer. "Yep. That's what I'm asking. Will you marry me?"

Long seconds passed as Bettie drank in the full meaning of the request. "Are you sure?" she asked softly.

They both knew of friends who married quickly before the war whisked the soldier away to an unpredictable future. They had even talked about how crazy it seemed when Kelly and Nancy got married the day before Kelly left for Boot Camp. Just out of high school, the couple had only known each other for a few months.

Vernon looked intently into Bettie's eyes. "Well, I know I don't want to lose you and I know we don't have much time until I leave for Texas."

She knew the answer well before he asked. She had been thinking about it for weeks. "Yes! Oh, yes I'll marry you," she exclaimed as she threw her arms around his neck.

"You know, we have to get our parents' permission."

"Oh, my. You're right. Do you think that will be a problem?"

"It's crazy. I can go off to war but we're not old enough to get married, plus cadets aren't supposed to be married either."

He felt Bettie's arms around his neck slacken. "Well, we will be engaged for now and talk to the folks tomorrow. I've got to admit though, your parents have me a little worried."

Bettie pulled back slightly and gave him a pixie look. "Engaged is good." Being engaged was a welcome alternative considering she thought she might have lost him.

"I didn't get a ring." In truth, he couldn't afford one. "I thought maybe you could have my class ring for now."

Vernon pulled from his finger the cast silver ring with the college emblem on its face. He slipped the ring on Bettie's finger.

"I know it's kinda big, but if you wrap some yarn around the bottom, it might fit."

She gazed at her hand as though it bore a golden ring with a huge diamond.

"It's perfect," she whispered. She knew how hard he had worked for the privilege of owning such a ring. "Leave it to a farmer to propose in a grain shed."

<p style="text-align:center">★★★</p>

Screeching brakes of the railroad car woke him from his trance as the train slowed to a crawl before a small station. A brightly lettered sign identified the rural city as Bardhaman. It seemed that Indians used vivid colors to make up for their meager means. A mob of local vendors hawked their wares as they ran alongside the train, which eventually slowed to a halt.

Many miles of flat farmland, small villages, and sparsely treed plains had passed by his window. He could have been crossing Nebraska except for the occasional palm trees, water buffalo pulling wooden plows through miniature fields, and the heat—that ever-present, oppressive hot wind that blew through the open window of the train.

"Halfway to the end of the line," Goodrich announced as he walked down the aisle. "If you want something to eat, here's where you get it."

That got Chappy and Froula's attention. Lt. Froula patted his stomach. "Food. It's about time. I'm starvin'."

Chappy sat up from slouching against the window where he had been napping, yawned, and scratched his head. "Wonder if they got beer here? Sure could use a cold one."

Pandaveswar

The strong odor of curry and other spices filled the air as the boys seated themselves in a booth. A waiter dressed in white with a red sash and the familiar turban poured a cup of tea for each of them.

"Tea?" Chappy stared at the steamy brown liquid. "Can I get a tall glass of beer instead?"

"So sorry. No beer sahib. Assam tea is very good."

"I'm melting and they give us hot tea."

A typical Indian meal arrived with chapati bread, stir-fried vegetables with some sort of meat on rice, well disguised in a thick sauce of various spices, accompanied by a long, narrow pastry called *khaja* for dessert.

As Vernon took a bite of the stir-fried dish, a heavy dose of curry went to work. The stuff didn't taste too bad, but it burned all the way down and kept burning. He reached for his cup of tea.

"Hot tea to wash down hot stew," he coughed. "Don't think I'll ever get used to this stuff."

After lunch, a few more hours were spent watching the scenery drift past; more tiny villages, farmland, dirt roads, and large stretches of nothing but brush, trees, and an occasional glimpse of the Damodar River—and there was that always present earthy, musty smell mixed with the coal smoke from the engine. With every mile, Vernon felt home slipping farther and farther away. He didn't want to think about how impossible it might be for him to ever get back.

As the train approached Asansol, it passed through mile after mile of dense forest and thick jungle where farms became sparse. People

and homes appeared to be stuck in a past long gone. Brown men in nothing but a turban and white, skirt-like bloomers that looked like a wrapped-around bed sheet, walked behind water buffalo pulling wagons. Overloaded donkeys laboring under huge bundles, kicked up dust on the road. Occasionally, a pack of jackals, strange deer, or a cluster of monkeys, appeared.

The clickity-clack of the wheels slowed as the whistle on the steam engine announced the train's arrival. A town appeared through the forest and then a covered railway platform with a small building. Two Command cars sat waiting next to the station in the late afternoon sun.

"Looks like we have arrived, boys," Lt. Goodrich announced as he stood to pull his bag from the overhead rack.

"Talk about being out in the middle of nowhere," Vernon commented, looking out at the conglomeration of mud, concrete, and thatched buildings. "They put an airbase around here?"

"Our good times are definitely over," Chappy spouted as he threw his bag into the trunk of the car and climbed in.

"How far to the base, sergeant?" Lt. Goodrich asked the bearded Ghurka soldier behind the wheel.

"About two hours, sir." The sedan lurched forward with a growl. "That's if we don't get stuck or break down."

Once out of town, the forest gave way to open areas of patch-worked farm fields. Dust bloomed up behind the vehicles and filled the cars as they made their way along the rutted road. Still intensely hot, at least the sun now hung low in the sky.

In and out of forested and jungle areas, through open farm country and small villages, the convoy bounced along juggling its passengers like bowling pins in an earthquake. Sleep was impossible but Chappy found a way.

Passing through a small village with thatched huts, mud buildings, and a few concrete structures, the cars eventually halted at a fenced area with a guardhouse.

As the sun sank to the horizon, the driver announced, "Welcome to Panda, sirs."

Vernon couldn't see much in the dimming light but he could hear the rumble of aircraft operations. Several bombers crossed the small patch of darkening sky viewed through the car window. Excitement began to well up in his chest and his heart beat a little faster.

The convoy jostled along for several more long minutes as it passed rough brick buildings and pole sheds with thatched roofs scattered in seeming disarray. Soldiers moved here and there in jeeps and on bicycles, most wearing khaki shorts, some without shirts, sweating in the sinking sun.

"Things look a bit on the casual side here," Vernon commented.

"Can't wait to get out of this uniform myself," Chappy chimed in.

A long runway came into view in the distance with a line of B-24s taxiing in from the far end. They weren't the shiny aluminum models the boys flew in training. These were olive drab silhouettes in the fading sunlight. Flat grassy areas, interspersed with stands of trees and palm groves, made the base feel more like a ride through the country than an airfield. Sculpted banks of dirt stretched out in the distance forming three walls of widely spaced revetments providing protection for airplanes and supplies.

The soldiers in the transports rode silently, drinking in the strangeness of their new environment. Eventually, the cars pulled up in front of the dilapidated ruins of a factory, complete with a towering brick smokestack. A building with a covered portico extended off one end.

"Admin headquarters," the driver announced. "Check in here and then I'll take you to your squadron."

"Boy, my butt cheeks hurt after that ride," Chappy complained as he picked up his bag.

Lt. Drake stepped out and stood, hands on his hips, slowly panning the landscape of his new home. His heart sunk just a bit as stark reality overwhelmed him.

Check-in took only a few minutes and they were back on the cars headed for the 493rd Bomb Squadron, 7th Bomb Group headquarters.

A long, low building with a thatched roof served as squadron head-quarters. Leaving their bags in the car, the boys filed into the briefing room filled with wooden chairs on a concrete floor and a wall map at one end.

"Attention!" the orderly yelled out.

Everyone popped up and assumed the position.

A tall, lanky officer in his early 30s with a slight mustache and ears that appeared one size too large, strode to the front of the group.

"Welcome to the 493rd, gentlemen. The home of the Flying Cobras.[*]
I am Colonel Dodson, your squadron commander. Please be seated."

The commander stood erect with an air of confidence. His speech
was firm but familiar, like he spoke to friends.

"I know you are tired and hungry from your trip, not to mention
recovering from your time in Calcutta."

That raised a few knowing chuckles.

"Sergeant Rogers, here, will see to it that you get to the mess hall
for some of our fine dining. Unfortunately, your housing assignments
are not yet ready. You will be issued folding cots and mosquito netting
for tonight. It's a nice night to sleep out under the stars. I'll see you
tomorrow morning at 0800 for an orientation briefing. Good to have
you with us."

"Attention!" Sgt. Rogers barked.

Everyone jumped to as the commander left.

"Sleep under the stars?" Lt. Froula griped. "What about the jackals we
saw coming in? And I hear there are tigers roaming around here, too."

"Buck up, Froula," Lt. Goodrich needled. "You're a big boy now. You
can handle it. Can't let a little old thing like a tiger make you sweat."

Vernon doubted Goodrich or anyone was too comfortable with
sleeping outside in this wilderness.

The next stop, the officers' mess.

"Fried SPAM, beans, and bread." Lt. Froula chided the private heaping
piles of the brown stuff on his tin tray, "What will they think of next?"

Chappy peered over Froula's shoulder for a look at what was coming.
"Hey, I'll eat anything right now. It's been a long time since lunch."

When he reached the end of the line, he lifted a can of beer in the
air, "Hey, look what I found fellows. Now, I'm a happy airman."

The light of day had almost departed by the time the group finished
eating and were dropped at their billet for the night. It consisted of a
row of cots under a long, thatched roof held up by skinny, twisted poles.
A slight breeze could send the whole mess tumbling. Each leg of every

[*] The Flying Cobras of the 493rd Bomb Squadron are not to be confused with the
Flying Tigers Fighter Squadrons flying P-40s based in Kunming, China, although
the Flying Tigers were often present at Pandaveswar.

cot was set in a tin can filled with oil to keep crawly things out, and a mosquito net hung from a pole overhead.

"We haven't hit the monsoon season yet," the driver said. "Just keep the mosquito net over you or you'll wake up as one big bump. Those little buggers are pretty friendly around here. Not to mention the fact that they carry malaria."

Vernon and Chappy glanced at each other with a look that asked, "malaria?"

Stripped down to his shorts, his B-4 garment bag slipped under his cot, and a sheet pulled off to one side, Vernon lay sweating in the hot and humid night air. He could see the stars through the mosquito net and the dark outlines of the surrounding buildings. Off in the distance, the dim lights illuminated mechanics doing maintenance on returned bombers as they sat silent in their earth-bermed revetments. Occasionally, the rumble of aircraft could be heard as they approached the field and landed. Jeeps and trucks with slits for headlights, passed in the night. Strange birdcalls and unfamiliar jungle sounds filled the silence in between. Thoughts of jackals, tigers, snakes, and insects roaming around in the dark, made sleep difficult.

Vernon tried to get his mind off the day's events and the night's unknowns. He had no idea where life would take him when he joined up, what now seemed like decades ago. He certainly didn't imagine this. He and Bettie had married just weeks before leaving for Boot Camp at Sheppard Field in Wichita Falls, Texas. She had fallen ill with pneumonia and ended up in the hospital. Instead of a nice big church wedding, she struggled out of her bed to marry him in a small ceremony on Christmas Eve after which she immediately returned to the hospital. It took weeks for her to recover from her illness before they could thoroughly enjoy their newlywed status but it all came to an end way too soon. They had only a brief couple of months before he made the trip to Texas. He wouldn't see her again for 60 days.

His brother Ray had enlisted the same time as Vernon. He was called up shortly after Vernon and ended up one class behind. On rare occasions they would have a brief meeting but the army kept them both very busy.

He remembered the day Bettie joined him at College Station, where he began his Cadet Training at Texas A&M. Again she was ill but this

time morning sickness plagued her. He had to live on campus while his secret wife found a small, lean-to room to rent by a polo field and survived on odd jobs. She developed a talent for mending nylon stockings that helped provide an income since nylons were in short supply. They had Sundays together, often watching polo matches from her tiny yard while munching on watermelon, one of the few entertainments they could afford.

After two months of hard study and far too little time with Bettie, he was transferred to Brooks Field in San Antonio to begin flight training. Another tearful goodbye and Bettie went back to Billings to live with his parents. How hard it was to see her go, knowing he wouldn't be there to comfort her as she carried their child.

Four months and many letters later, on the day he received his assignment to Advanced Officer Training, he also received an urgent telegram. Bettie had been experiencing a difficult pregnancy and had been in labor for a week. He had become a father but Bettie's condition was critical. Frantic attempts at telephone calls failed to get through. Telegrams from the Red Cross requesting leave piled up undelivered at the Western Union office. Finally, he got emergency leave and after four days of rail travel, arrived in Billings to find, to his relief, mother and child doing well.

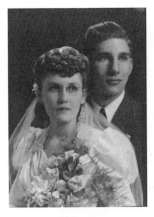

Vernon Drake and Bettie Ross's wedding.

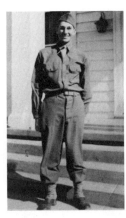

Cadet Vernon Drake as a student at Texas A&M.

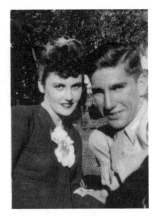

Vernon and Bettie Drake in Texas during training.

Three days at home with his new family wasn't nearly enough. The train ride back to San Antonio passed slowly, tearing him from the ones he loved and a baby girl he didn't get a chance to know.

As he lay there, soaked in the humidity of this foreign environment, the images of those days remained only briefly and then an ominous howl floated out of the dark, bringing him back to India. Hours passed slowly as though the darkness would never end but eventually, he drifted off to sleep from sheer exhaustion.

Lt. Vernon Drake gets leave after finishing B-24 training to meet his new daughter.

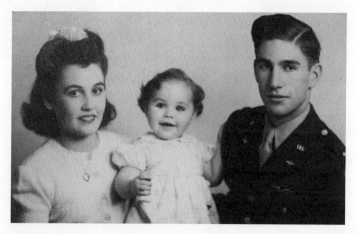

Lt. Vernon Drake, Bettie, and their baby Lana prior to Lt. Drake's leaving for India.

CHAPTER 12

Introduction to War

Bettie's warm body snuggled in under Vernon's arm as the couple gazed up at a sky full of stars. They had managed to sneak away from the church social to find a secluded patch of grass under a large oak tree. Reclining up against the massive trunk, Vernon had never felt so peaceful yet excited, all at the same time.

"Did you meet many girls while you were in Texas?" Bettie asked quietly.

"Naw. We hardly ever left the base." He knew that wasn't entirely true, but it was the answer she wanted to hear. "Besides, Betsy, you're my girl."

Bettie snuggled in a little closer and looked up into Vernon's eyes, searching for confirmation. He couldn't resist and met her with a warm kiss. Just as he felt her return his affection, a convoy of farm trucks and tractors with headlights beaming, came charging at them across the field, shattering the magic of the moment. As the brigade of vehicles was about to overrun them, he awoke to find noisy jeeps and trucks rolling by, one after another. Confused, it took a few moments to realize the Tezpur ruckus of the passing motorcade had invaded his dream. He felt as though he had fallen asleep only minutes before. He propped his head on his elbow and with sleepy eyes searched for the luminous hands on his watch.

Four-thirty? What are all these guys doing up at four-thirty in the morning?

He watched taillights peel off toward squadron headquarters while others headed for the bomber revetments.

Too groggy to care, he lay back down and tried to find a comfortable position on the canvas cot, as if that were possible.

Maybe I can get another couple of hours of shut-eye—if I can get back to sleep. He hoped he could return to the oak tree.

What seemed like only a few minutes had passed when the cot came alive with the vibration of several dozen 1,200 horsepower Pratt & Whitney radial engines warming up. The growl rumbled across the airbase as planes, one by one, left their banked sanctuaries and joined the line of barking monsters marching to the end of the runway. The taxi lights of each illuminated the tail section of the one in front as their brakes squealed with stops and starts, each aircraft jockeying to keep in step with the pack.

A faint glimmer of morning hid just beyond the eastern horizon in an otherwise dark sky. Vernon checked his watch once again.

Five-thirty?

He rolled over to look down the row of cots. Everyone seemed to be asleep, but he doubted many were. Of course, Chappy could sleep through anything. Draped over his cot, one leg dangling to the ground, Vernon had no doubt he was dead to the world.

With little chance of getting back to sleep, Vernon slowly sat up and scratched his belly. A flying T-shirt hit him on the back of the head.

"Ready for some breakfast, Drake?" Lt. Froula called, seeming way too chipper for early reveille.

"Think you can find the officers' mess in the dark?" Vernon chided.

A few more bodies stirred on their cots. Soon all the guys were yawning, pulling on pants, and bantering about the not-so-great first night in Pandaveswar.

As the dark sky began to lighten, the mess hall wasn't difficult to find—just a short walk away.

"What the hell is that?" Chappy asked as the server plopped a mountain of greasy, sort-of yellow, mash onto his metal tray.

"They're eggs, sir."

"Eggs?" He poked a fork at the pile. "Looks like someone took a crap on my plate."

"They're reconstituted eggs, sir, and here is your reconstituted bacon."

The server dropped a slice of fried SPAM in the next compartment on his tray.

"And some good ol' reconstituted hash-browns." He scraped up a flat cake of browned dough-like substance that had been bubbling on the greasy grill and flipped it onto Chappy's tray.

"You can get a glass of lukewarm, reconstituted milk over there." He pointed to a large, corrugated cylinder with a spout near the bottom. "All compliments of Uncle Sam."

Chappy surveyed the contents of his tray. "What, no homemade buttermilk biscuits?"

"Biscuits at the end of the line, sir, fresh out of the oven."

He picked up a couple of light brown pucks off the cooking sheet, took a bite, and nodded his head. "Whaddya know. Not bad."

Back at the cots after breakfast, they found young Indian boys had brought a few water basins and hung mirrors on the poles. The men washed up and shaved in preparation for their morning briefing.

Returning to the Ready Room, the base commander addressed the new recruits. "I hope your first night with the 493rd wasn't too unpleasant. The work crew will be finishing up your quarters today so you will have an assigned basha this afternoon."

He then took on an official air as he moved to the map of the Bay of Bengal. "You might be wondering what we are doing so far from the war in Europe and the Pacific you have heard so much about. Our China–Burma–India Theater doesn't get much coverage. In fact, we often get overlooked but we are a highly strategic and important piece of the war effort."

With a pointer, he outlined the southern two-thirds of Burma on the eastern side of the Bay of Bengal. "The Japanese currently occupy all this territory and are pushing north toward China. We, along with our Allies, are fighting a hard jungle battle to hold them back. The enemy's primary source of supply comes through Rangoon by ship." He pointed to a city near the southern tip of Burma.

"From there, supplies and troops are moved north by this rail line, which the Japs have built, all the way to Myitkyina. Our job is simple but critical. We must stop the flow of supplies. Cut off their supplies and the Japanese army can't function. That means we hit bridges, marshaling

yards, ships, and any other targets of opportunity that cripples that supply line. The job of the 7th Bomb Group is to get there, drop your bombs accurately, and get back safely. We are a long way from our targets so our missions are long, typically eight to 14 hours in the air. We have very little fighter support but your planes are heavily armed and the B-24 can take a whale of a lot of punishment and still bring you home."

The commander stepped forward and confidently swung his pointer behind his back to grip it with both hands. "I know each of you came here as a member of a highly trained crew. You will eventually be flying together but first, each of you will be sent on several missions individually with experienced crews. That way, you will receive the training and orientation you need to work together as a team effectively.

"I know you will make your country proud."

With that, the commander turned the meeting over to squadron commander, Col. Dodson, to complete the briefing, including the details of what life would be like on the Pandaveswar Airbase.

After a lunch of SPAM, rice, and tea—"Get used to it!" the cook said—Staff Sergeant Travis took them to their new quarters.

"Lieutenant Goodrich, Lieutenant Chapman, Lieutenant Froula, and Lieutenant Drake, you will be bunking together," the sergeant announced. "Hop in the jeep, sirs. I have your bags."

Built on a concrete pad, the basha consisted of mud and grass walls, and a thatched roof. It had a covered porch and two rooms. Each room barely provided enough space for four wooden cots with woven rope mats slung tightly in the frame.

As the jeep pulled up to the basha, several Indian women in white saris wrapped around their torsos and over their heads were lashing down the last of the thatching on the roof in the glaring sun.

"Home sweet home," Chappy chuckled.

They unloaded their bags and crowded into the hut hoping for relief from the heat. A slight breeze penetrating through the door and window gave the impression of being a degree or two cooler but sweat rolled down their backs just the same.

Vernon eyed the cots. "Hey, where's the mattress?"

"Well, sir, we're a bit short on supplies here. You can buy a straw-filled mattress and sheets in town for a couple of bucks. The army supplies a blanket, pillow, and the mosquito netting."

Women thatchers finishing the roof on the basha hut for the crew in Pandaveswar.

Vernon threw his bag on a cot under the window—an open-air rectangle in the wall with a grass-covered flap. The others claimed their cots as well.

Sgt. Travis stood in the open doorway. "Shower is the barrel on stilts behind the basha next to the latrine. It gets filled by basha boys several times a day, so time it right and don't ask where the water comes from."

An Indian man who appeared to be in his 40s, dressed only in the typical white diaper looking affair, and black from a life in the sun, stood behind the sergeant. He pushed the man through the door into the crowded room.

"This, here, is Abdula. He is your basha boy. He will take care of your quarters, shine your shoes, do your laundry, bring boiled drinking water, and keep the rats out of your stuff, compliments of Uncle Sam. One of the perks of Panda living."

Abdula, with hands together as though praying, and a wide smile, bowed several times to his new charge.

"Sure isn't Karnarni Estates," Goodrich said as he plopped down on his cot and tested the stiffness, "But it'll have to do."

"Well, I'm not puttin' up with you mugs," Chappy said as he tilted up his cot on its edge and began dragging it toward the door. "I'm sleepin' on the porch, tigers, or no tigers."

Lt. Vernon Drake in front of his basha hut with his basha boy Abdula, who took care of his quarters, shined his shoes, did his laundry, brought boiled drinking water, and kept the rats out of his stuff.

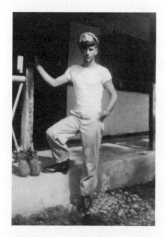

Lt. Vernon Drake on the porch of the basha hut in Pandaveswar wearing his leather boots bought in Natal, Brazil, in transit to India.

Sgt. Travis backed out of the doorway as Abdula picked up one end of the cot. "I'll help, sahib."

With one cot on the covered porch, Sgt. Travis again addressed the men. "A runner will let you know your schedule. Contact dispatch whenever you need a jeep to get into town. We'll send over a driver. That's about it for now."

The sergeant gave a salute and left.

Lt. Goodrich propped his bag up on the end of the cot and leaned back on it. "I'm just itchin' to get my hands on a flying machine and take out some Japs."

I just want to get home safe to Bettie, Vernon said silently to himself, feeling lost and alone, far from the life he knew.

CHAPTER 13

Rookie

"Ignition switches, on?" Copilot Lt. Drake called out reading from his laminated checklist.

"Ignition switches ... on," aircraft commander Lieutenant Henderson answered as he flipped the toggles.

"Booster pump on and fuel pressure?"

"Booster ... on." He watched the gauge's needle climb. "We have pressure."

"Energizer, on?"

"Energizer ... on."

The pitch of the inertia starter rose to a whine, ready to engage and force the big radial engine to wake up.

"Spin number four."

Lt. Henderson lifted the starter switch for the number four engine, watching out the window for puffs of black smoke indicating it had come alive. Slowly, the engine cylinders fired one at a time until the propeller blurred and a rumble vibrated through his seat in unison with the other three engines.

Vernon tried to appear calm and professional, the veins in his neck throbbed from an excited heartbeat. More than nervousness, he wanted to make a good impression on his first mission. The new guy on the crew, he had met them only an hour before at the early morning mission briefing. This aircraft, a B-24D Liberator, felt different than the old worn-out B-24A models he flew in training. All the instruments and

switches generally occupied the same position as in the trainer but with enough variation to make things seem slightly unfamiliar.

Vernon moved the mixture control to Automatic Lean and scanned his copy of the checklist. He didn't want to make a mistake. No time to think of anything but the tasks at hand, and there were many.

The sky had barely given up its darkness when Lt. Henderson advanced the four throttles, forcing the heavily laden Liberator to creep out of its embankment. The big bird seemed reluctant to fall in line with the other bombers headed for the runway departure end in the early morning dawn.

"We got a milk run," Henderson had said earlier when they were pre-flighting the aircraft. "Our target bridge is unprotected. No flak or fighters today."

That made Vernon only slightly less apprehensive about his first mission. A rookie copilot, he simply wanted to get up and back without any screw-ups on his part.

As the aircraft crawled toward the takeoff point, Vernon could feel sweat running down his back. His flight suit made escaping the 90-degree heat of the morning impossible but soon they would be at 5,000 feet where temperatures would be in the 70s with lower humidity.

The lineup of eight bombers came to a halt at the end of the taxiway where the crew went through their pre-takeoff checklists. With controls and instruments checked, engines run up to 2,700 rpm, and superchargers set at 49 inches, flaps lowered to 20 degrees—the beast was ready to take to the air.

Rolling onto the runway, things felt strangely familiar to Vernon even though halfway around the world from the last time he sat behind the controls.

"Let's go. Give me full throttle," Lt. Henderson commanded.

He held the brakes while Vernon advanced the four levers slowly but firmly. The big engines shook the airframe as they surged with power. Once they reached full rpm, the commander released the brakes. The plane, heavy with bombs, labored forward.

Vernon called out the airspeed as the Liberator slowly accelerated down the runway. "Fifty … sixty … seventy … eighty." *Come on, girl, get goin'. The end of the runway is coming way too fast.*

As the aircraft in front of them clawed its way into the air, barely missing the lights, Vernon looked quickly at the commander who had a firm grasp on the controls and a steeled expression.

"Ninety … one hundred" Vernon called out. *We're way past the abort point.*

Lt. Henderson eased back on the wheel. "Gotta lighten the nose until we hit a hundred and thirty,"

"One fifteen … one-thirty." *I don't think we're gonna make it!* Vernon felt his body brace for impact.

The rumbling of tires on pavement suddenly stopped as he watched the end of the runway pass uncomfortably close beneath his window.

The commander glanced over at Vernon, "Gear up, lieutenant."

Still unnerved by the seemingly near disaster of overrunning the end of the runway, he reached for the gear lever. "Gear up."

After setting the turbochargers, engine rpm, and raising the flaps, Vernon sat back, realizing how tense he had become and felt the pool of sweat collecting around his midsection.

Henderson trimmed the controls for a climb at 150 mph, and relaxed. "These old birds were designed to fly at 45,000 pounds. We're at 65,000 with our bomb load. Makes getting airborne a little tricky. You'll get used to seeing the end of the runway up close."

Vernon doubted that would be the case. At 5,000 feet in length, Panda's runway fell almost 300 feet short of the mile minimum required by the operation manuals.

The lights of the airbase and village disappeared below as the aircraft windows turned grey from entering a layer of clouds. Both pilots concentrated on the instruments, keeping the aircraft level, climbing, and on course. A few minutes later they popped out into a clear morning sky with remnants of stars still sparkling behind them and a slowly glowing horizon ahead. Other aircraft broke free of the clouds and fell into a loose formation with the leader.

A carpet of white stretched out ahead obscuring the land below. *Somewhere down there is India*, Vernon thought, *and over 500 miles to our target.*

Scattered holes in the clouds gave a quick glimpse of green farm fields and dirt roads that could have been almost anywhere in the world seen

from this height. Vernon felt the air getting cooler and dryer as the bomber made its slow climb through 4,000 feet. It felt like a Montana fall day, a welcome break from the constant heat, morning, noon, and night, on the ground. Vernon's mind drifted to the cool mornings on the ranch. He would have had breakfast and headed out to do chores. Thoughts of those chores he once hated now brought comfort.

By the time they reached 5,000 feet, he welcomed the balmy fresh air although sweat had soaked much of the fabric of his khaki uniform. Time passed as slowly as the creeping terrain below.

"An hour and a half to target, lieutenant. You take 'er for a while. Just hold this position on the leader. You've got it."

With hands on the control wheel, Vernon focused on the four-engine brute flying forward of his right wing. He had done hours of close formation flying with Lt. Goodrich during training. In fact, Goodrich often got chastised for being too close. He liked to push the envelope.

The commander pulled out his charts and grainy black and white recon photos of the target bridge. Occasionally, Vernon heard the crew chatting back and forth over the interphone. They seemed unconcerned about the mission ahead.

"I'm freezin' my ass off back here," came a call from the tail gunner.

"It ain't any warmer up here," a waist gunner replied, "but I got hot coffee. Come on forward and grab a cup."

The gunners had little to do on the way to the target. The chance of running into enemy fighters this far out was almost nil.

Lt. Henderson checked in with the navigator through the interphone. "How we doing, Pappy?"

Pappy enjoyed the status of being the oldest member of the crew at 24. Every crew had its Pappy or a similar nickname.

"Right on course and chewin' up the miles. Sixty-six minutes out. A-flight should be breaking off to the south any minute now."

Vernon leaned forward to take a quick look out and back through his side window. Four of the flight of eight were drifting off to the right, headed for their target leaving only four in Vernon's formation. The lead aircraft cruised along above and to the right while the other two bombers trailed off under Vernon's left wing.

Lt. Henderson and Lt. Drake sat quietly, lost in their own thoughts as the minutes wore on. Conversation passed briefly among the crew.

The constant deafening rumble of the engines resonating through the airframe reduced communication to a yell unless on the interphone.

Wisps of clouds parted and melted away to reveal a vast stretch of endless water—the Bay of Bengal. Hours spent over the Atlantic during Vernon's trip to India increased his apprehension of flying over water. Large expanses of liquid were nonexistent in Montana. The thought of ditching meant a watery grave. Sure, the crew had life vests and a lifeboat, but he didn't figure they would be of much use if they cracked up in the water and couldn't get out. He tried to put all thoughts of that possibility out of his mind.

"You can clear your guns now," the commander announced over the interphone.

"You got it, sir," came the reply. "Yes, sir."

The airframe shook with the loud rata-tat-tat of .50-caliber Browning machine guns blasting away at thin air. Tracer shells left trails through space as they hurled their way toward imaginary targets. The barrels of the top turret guns positioned over the top of the pilot's heads were deafening when fired.

White cotton puffs of clouds far below left dark shadow footprints on the gently rolling sea. A thin brown line appeared on the horizon above the azure-blue water.

"Burma," Vernon heard Lt. Henderson almost whisper through the headphones over the drone of the engines. "Set to climb to 12,000."

Up to this point the war, with its dreaded Japanese enemy, existed on maps, in newspapers, and military briefings. With that single word, it suddenly became real.

The heavily loaded bomber slowly struggled upward to reach bombing altitude. Temperatures dropped to below freezing. Little conversation took place. Oxygen masks and the interphone made casual chats cumbersome. From 12,000 feet, the earth seemed to stand still as the aircraft churned through the air at just over 200 mph.

Vernon forgot about his frozen toes, the chill of an ice-stiffened flight suit, and his oxygen mask rubbing heavily on his nose. In the next few minutes, the enemy would be beneath his wings. He would be entering Japanese held territory where fate would decide whether he lived or died.

Bettie's last words haunted him. "Come back to me. Please come back to me." He had every intention of doing so.

A Time of Testing

The thin brown line on the horizon slowly grew into a green outline of hills sloping down to delta country and onto white-sand beaches as the B-24 made its way along the coast of Burma. Narrow rivers broadened to miles-wide as they emptied into the sea around small islands. He wondered how such beauty could be the home to war.

"Myengu Island coming up, commander," Pappy announced over his headset. "Take up heading zero-niner-six … 23 minutes to target."

"Roger, Pappy," Henderson acknowledged. "Shorty, arm your bombs. The rest of you stay alert."

"Yes, sir," Shorty, the bombardier, answered.

Shorty had already positioned himself on the narrow catwalk between the bomb racks. He attached a thin cable to the pull-pin in the nose of each bomb. When the doors opened and the bombs released, each pin would be jerked out of the arming mechanism as they fell free.

Looking down the narrow stairs behind his seat on the flight deck, Vernon saw Shorty making his way back through the crawlway into his cramped nest in the nose of the aircraft. From there, he would squint through his Norden bombsight, that top-secret device that he guarded with his life, which allowed the Americans to do precision bombing from such great altitudes. He would control the aircraft in the last few minutes of the bombing run and trip the toggle switch to release their deadly cargo.

Far below, Vernon could see boats in the harbors, villages, and farm fields laid out in a colorful patchwork. The fields climbed up the slopes of the heavily wooded coastal mountains as the bomber flew eastward toward its target and emerged over the wide plains of central Burma.

What must life be like down there? Are the Burmese people going about their normal business or are they in hiding?

One thing struck home, he couldn't see any Japanese from 12,000 feet.

"Yaw Chaung Bridge in seven minutes," crackled over the headset.

A spider web of small rivers and creeks carrying water to the plains from the low mountain range merged into one where they escaped from the hills.

Lt. Henderson looked at his photos. "That's our target," he said to Vernon. "The bridge is just up that valley."

"Two minutes to target," Pappy announced.

"Shorty, you have control," Lt. Henderson commanded.

Shorty peered intently into his Norden bombsight, tweaking the control of the airplane as he directed the big bird precisely toward the target. "Bombay doors, open," he announced.

Slowly, the thin line of a bridge over a mile below crept into view. With proper calculations and exact timing, the bombs would fall in trail, hopefully hitting their mark. Many considered the bombardier the most important job on the aircraft. After all, the purpose of every other position was to get the bombardier to this moment.

As the bridge crossed the center of his scope, a flick of his thumb released twenty, 500 pounders. "Bombs away."

Vernon felt the big bird sigh as it relieved itself of half its load. He looked out his window to see the bombs falling, shrinking away behind the aircraft. Fifteen seconds would pass before they hit.

Lt. Henderson put the aircraft in a wide arcing turn to the left. The bridge came into view just as the last bomb exploded only yards away from a center pylon. All the others had fallen short of their mark and done nothing but create large plumes of water as they exploded.

"No dice," the commander chided over the interphone. "You'll have to do better on the second run, Shorty."

All this time, Vernon's job had been to watch the gauges and keep his hand on the throttles to respond to Lt. Henderson's commands.

"You take it for this run, Lt. Drake."

"Yes, sir," Vernon answered in his most professional voice. He wrapped his fingers around the control wheel. With headings given by Pappy, Vernon maneuvered the ship back into position for a second attempt.

"Bombardier, you have control," Vernon announced.

"Yes, sir. I have it," came the response.

After bombs away, Vernon took back the controls to make a slow turn. Pilot and copilot watched two explosions on the first third of the bridge that sent planks and trusses flying.

"Well done, Shorty," Lt. Henderson complimented over the interphone. He turned to Vernon. "Take us home, lieutenant."

Vernon sat a little taller in the seat. He felt he had earned his wings as a true bomber pilot. "Give me a heading, Pappy. We're going home."

The miles seemed to pass quickly and soon the rolling blue carpet of the Bay of Bengal dominated the horizon once again.

"Let's get down to some warmer air," Lt. Henderson said as he dug into his flight bag, producing a thermos of coffee and a bundle wrapped in paper. "How about a sandwich?" He handed Vernon two slices of white bread with SPAM trapped in between.

With one hand on the control wheel and his oxygen mask hanging to the side of his leather helmet, Vernon bit into the offering. It tasted surprisingly good. Maybe the thin air affected his taste buds or the simple exhilaration of recent events dulled his senses.

A high afternoon sun shown down into the cockpit through a cloudless sky filled with smooth air as the bomber rumbled its way westward. All seemed good with the world. Vernon's first bombing mission came off without a hitch.

The two pilots sat relaxed, the autopilot keeping the plane on course, when an urgent voice came over the interphone.

"We've got an oil streak on number four, lieutenant."

Engineer, Sergeant Kuchinski doubled as the top turret gunner, a position that allowed him to monitor the four engines. He knew more about the airplane than anyone on board.

"How does it look, Kuch?" Henderson shot back.

"Not good, sir. She's losin' oil fast."

Vernon quickly focused in on the gauges. "Oil pressure dropping and cylinder head temperature rising."

"Crap!" The commander strained to look beyond Vernon at the number- four engine. "Feather number four." He needed to get that engine stopped and the propeller turned 90 degrees to the wind before all the oil departed or it would over-speed and come apart.

Vernon pulled back the throttle and mixture levers, turned off the fuel booster and ignition, closed the cowl flaps, and flipped the feathering switch. Both pilots watched intently as the propeller slowed to a stop.

"One dead but we still have three," Lt. Henderson said in a confident tone.

Vernon looked down at the rolling sea a mile below and hoped the commander's confidence was genuine. Pandaveswar Airbase now seemed much farther away.

They had rejoined the other three bombers for the flight back but now lagged behind. Even though Vernon practiced engine failure in training, the real event over open water unnerved him a bit. He found himself watching the needles on the gauges a little longer than usual as he panned across the instrument panel. A small fluctuation that would have normally gone unnoticed demanded more attention.

With the aircraft trimmed up to counteract the yaw tendency of dragging a dead engine through the air, Lt. Henderson sat back, relaxed. Vernon marveled at his seeming complacency as he took the emergency in his stride. Evidently, an engine out was a small price to pay for a milk run.

The rest of the flight went without incident. Lt. Drake performed his copilot duties without error. Lt. Henderson seemed pleased. As the coast of India came into view, the commander called for a slow letdown. Descending over the farms and villages, the interior of the plane began to warm and Vernon's insulated flight suit became uncomfortably hot. He traded an oxygen mask for the humid air of lower altitudes. Once the airbase came into view, he breathed a quiet sigh of relief.

Vernon followed his learned procedures for an engine-out landing. All went well and the injured machine touched down easily and rolled out safely to the end of the runway. Back at the revetment with the engines shut down, Vernon sat silently as the crew began disembarking.

"Well done, lieutenant," Lt. Henderson gave Vernon a pat on the shoulder as he lifted himself out of the commander's seat. "Time for a drink."

On the ground once again after almost 11 hours in the air, Vernon's ears continued to buzz as though the engines were a recording in his head. The debriefing went quickly and the traditional shot of whiskey helped bring him down. He wondered again what his mother and Bettie would think if they saw him take a swig of alcohol, the Devil's brew but it seemed right.

"Back in time for supper," Lt. Goodrich commented as Vernon joined him and Chappy at the table. "How was it?"

Tempted to spin an exciting yarn about fighting off Jap planes and dodging exploding flak, instead he simply said, "Aw, it was okay. Hit our target but lost an engine on the way back. No big deal."

He didn't mention the milk-run aspect. He'd let their imaginations fill in the blanks. Goodrich and Chappy would get their chance tomorrow. For now, Lt. Drake had the prestige of being the only mission veteran at the table.

"Canned beef and powdered potatoes. Believe it or not, I was looking forward to this meal." Vernon let the statement lie with all its connotations. He dug into his supper like he hadn't eaten for days. The truth was, it did taste pretty good.

Dreaming

Throaty radial engines sent a rumble through the cockpit as Vernon put the huge plane into a steep bank. He looked over at his copilot, surprised to see Bettie sitting there, smiling back at him. Somehow, it felt comforting. The cockpit melted around him and transformed into his '36 Dodge Coupe. White mist and grey skies transformed into rolling hills of golden wheat bathed in sunshine. He recognized the road to the farm. Bettie sat at his side on the slightly tattered bench seat. His car kicked up a cloud of dust as the washboard road bounced the two around and made her giggle. He loved to hear her giggle.

"We're almost there," Vernon assured her. "It's just over that hill." He pointed across a wide valley to the rise beyond where the road disappeared over a crest.

Descending into the valley, they passed a small one-room clapboard church, weather-beaten from too many winters, with an aging swing set looking lonely on the yellow grass.

"That's where my brothers and I went to grade school. We rode old Dolly from the farm on most days."

"You all went there at the same time?"

"Yep. We had one teacher, Mrs. Stevens. She taught all the grades. We each got assignments for the grade we were in. Mom was a schoolteacher when she met Dad, so she helped us a lot with homework."

The car bounced across the valley and labored up a steep incline on the other side. As it crested the ridge, an old Chevy farm truck came rumbling past, loaded to the brim with grain. Vernon gave an enthusiastic wave.

"Hey, that's Ray heading with a load for the granary."

Up ahead, a small single-story farmhouse came into view. Bare-board siding, dark brown from the sun, made it stand out against the yellow fields of grain and blue summer sky. As they grew closer, a couple of lean-to sheds and fenced pens for farm animals became clear.

"Nobody lives there now," Vernon said. "But Dad and Grandpa keep the farm up and we all put in time working it. They bought another farm out on the bench so there's plenty to do. We moved into town a couple of years ago but I still like to come out and spend time here."

Bettie gazed out over the rolling hills, almost devoid of neighbors. Off in the distance the lonely silhouette of another farm nestled into a ravine.

"Is that what you want to do—be a farmer?"

"I don't know. I sure don't think I'd make it as an artist. I thought maybe I could be a cartoonist, y' know, like Al Capp and Li'l Abner." He shook his head, realizing that wasn't going to impress her. "I know farming but I'd like to think I could finish college and maybe get a job designing buildings." His brow wrinkled. "Do you think that's crazy?"

Bettie gently slipped her arm around his and nestled in closer as he wrestled the steering wheel jerking at each rut in the road. "No, that's not crazy. You're a good artist. I think you can do anything you want."

"Well, we gotta get this crazy war over first anyway. Dad thinks we'll have it won by Christmas. Sure would be great, then I wouldn't have to go."

As the car pulled past the gate and up the two-track driveway, Bettie began shaking his arm. His vision blurred and things went dark.

Why is she shaking me?

"Up and at 'em." Bettie's voice seemed strange. "It's 0300 hours, lieutenant."

"Huh? It's what?"

"If you want breakfast before the briefing you better get a move on."

Vernon forced his eyes open to be greeted by the blinding beam of a flashlight. "Turn that thing off," he gruffed. "I'm awake."

He rolled over on his cot and pulled the pillow down over his head, desperately wanting to return to the farm and Bettie. Too late. The early morning darkness, heavy with heat and humidity, invaded his thoughts.

The duty sergeant had moved on to Lt. Goodrich, giving him a good shake on the shoulder.

"Yeah, yeah. I'm up." Lt. Goodrich sat up on the edge of his bed, stretched, and yawned. "Come on, Drake, time to go blow up some bridges."

Vernon slowly rolled over and reluctantly sat up. He fumbled for his flashlight on the stand beside his cot and focused its beam at his boots. Grabbing one by the bottom, he turned it upside down and gave it a good shake. His sleepy eyes watched for any critters that might fall out. A repeat on the second boot, a reach for socks hanging on the wire stretched from thatched wall to thatched wall of the basha, now dry from the sweat-drenched day before, he pulled them on and slipped into his boots. Dressed only in his olive-drab boxer shorts and boots, he stumbled for the door and the path that led to the latrine behind the hut.

The moon, almost full, lit the way along with a few other shadows bearing flashlights. The latrine became a busy place this time of the morning. A few muffled conversations, some groans, and grunts, mingled with the sounds of crickets, frogs croaking, and night birds chirping.

Back to the front of the basha, Vernon found the covered stand with pans of clean water placed there by Abdula their houseboy. He splashed water on his face and toweled it off; thankful he couldn't see the water clearly. No telling where the houseboys got it. Better not to know. He would shave when he got back from the mission.

Lt. Goodrich dipped into another water basin. "Hope we get an easy ride this time. Fourteen hours bouncing around yesterday in those thunder-bumpers wore me out."

"You got that right. I'm all for some smooth air for a change." Vernon threw his towel over a hook on the post and headed back into the basha. He slipped on his khaki pants and shirt. Goodrich, Chappy, and Froula did the same, and the four made their way across the compound to the mess hall where the smell of breakfast cooking wafted through the air and lightened their steps. A beacon in the darkness, the mess hall glowed.

The sounds of clinking utensils and crews of airmen, trading stories of previous missions filled the air.

Vernon's crew fell in line, pushing their trays along the counter, piling on scrambled powdered eggs, fried SPAM, pancakes, and whatever else the cooks had concocted for the morning crowd. Coffee urns stood at the ready for the gallons of the black pick-me-up consumed by young men going off to battle.

"I hear your buddy, Harris, had a rough time of it yesterday," Lt. Froula's fork clicked against his metal tray as he scooped up a heap of eggs.

"Yeah? What did you hear?"

"They were saddled with ol' 204 and got into a mess of flak over Goon [Rangoon] at noon. They went in at 26,000 feet, tail-end Charlie, so you know they got the worst of it. That bird's a bucket of bolts to begin with but number three got hit and caught fire. They feathered the prop and put the fire out but got shot full of holes. The waist gunner took one in the leg and the bombardier got hit in the shoulder."

"No kidding?"

"Not only that, but the damn bombs settled down on the doors and they wouldn't open. They had to salvo the whole stinking mess right through the doors."

"They made it back okay, didn't they?"

"Barely—with all that drag and only three cranking they were skimming the water just to stay in the air. They made it back but it's gonna take some doin' to put that crate back together again."

"If we're lucky, 204 will hit the scrap pile for parts. I sure don't want to sit in that seat again."

Lt. Goodrich had been stirring his powdered eggs in contemplation. "Well, to be fair, that old tub brought 'em home. You gotta give it that."

The table went silent for a few moments while four airmen counted their good fortune so far.

Back at the basha, the crew gathered their flight suits, survival gear, and side arms, and boarded the jeep headed for the morning briefing. Vernon sat silently thinking about what had happened to Harris and his crew. He couldn't help but wonder and worry about what today's target might bring. Hopefully, it would be another run at remote bridges with

little or no resistance. If they were lucky, thunderstorms wouldn't build over the Bay of Bengal on the way back and the universe would be void of Jap fighters out hunting.

The night sky fought back as morning began to lighten the far eastern horizon. Jeeps full of airmen rolled up to the Operations building, their passengers piling out and streaming into the open door. Inside, rows of chairs faced a large wall map of India, China, and Burma, all bordering the Bay of Bengal. Vernon and his crew filed in and settled onto open chairs, shoulder to shoulder with a dozen other crews. Here, they awaited their fate. Within minutes, their future would be revealed. Always a tense time, some sat quietly, others threw jokes around, and a few studied the map on the wall as if they already knew what the target would be. Vernon thought of Bettie and the wonderful dream he had to leave to be here. Hopefully, he could return to it in another 16 hours or so … if he were lucky … a good time to say a prayer.

Goon at Noon

Col. Dodson stood before the wall map, pointer at the ready. "Intelligence has spotted several large Japanese freighters escorted by a battleship entering the Rangoon River. We can't allow those supplies to be off-loaded. Your target for today will be those freighters and the loading docks."

A noticeable murmur of discontent rolled through the ranks. Rangoon ranked near the top of the list of least favorite targets. Heavily guarded with antiaircraft guns and fighters, the city claimed more than its share of downed Allied planes. The gateway for Japan into Burma and eventually China, made it strategically important. Whoever controlled Rangoon, controlled Burma. Right now, the Japanese army held the region.

"A-flight, you will concentrate your drop on the freighters as primary targets. The battleship is secondary. B-flight, your target will be the docks." Col. Dodson tapped the tip of his long wooden pointer on the wide river harbor at the southern end of Burma.

Chappy sank a little in his chair. "Ugh, another 14-hour mission. A long way to sack time."

"Is that all you can think of?" Vernon sounded annoyed. "Knowing you, you'll find a way to sack-out between here and there."

Col. Dodson continued the briefing with bearings, altitudes, armament, and such. "Lift off is at 0700 hours. We will rendezvous with Charlie Baker at 0900 and form up in staggered formation with four elements of three aircraft."

The briefing continued for another 20 minutes covering the finer details of the drop including reconnaissance photos and loading dock

schematics pinpointing the exact areas where a hit would be most effective, and which crews were to target which areas.

With the briefing over, the airmen loaded back into the jeeps and headed for the airfield where the rest of the crew waited patiently for news of the day's mission.

"We got Rangoon," Lt. Goodrich announced.

The crew groaned.

"Gee wiz," Sgt. Barry sighed. "Another 10 hours in that stinkin' tail."

"Aw, stop your griping, soldier," Chappy shot back as he threw his parachute up through the access hatch. "You got one of the best seats in the house. Besides, you'll get some action on this trip. You know the Japs will be waiting for us."

"Thanks a lot, lieutenant. I feel much better now," Sgt. Barry chuckled.

No question they would see some action. Too many of their friends had not come back from Rangoon.

"We're number three in the lead element," Lt. Goodrich continued. "It's low and slow to save fuel until we're 100 miles out and then we'll climb to 21,000 for the run."

"Translation," Lt. Froula added, "That means 12 hours of hot and sticky and two hours of frozen toes and fireworks."

The armament crew loaded the last of the 500-pound bombs. Lt. Froula squeezed down the catwalk checking the rack for security. He didn't want any bombs hanging up.

Vernon strolled around the aircraft looking into hinges and scanning the airframe for anything out of the ordinary. "How's she look, Skipper?" he asked Sergeant Skip Morrow, the chief mechanic.

"We were up all night changing out number four. Everything checked out on run-up this morning. She'll get you there and back." Pride in his accomplishment crossed his face with a knowing smile and a wink as he wiped his hands on an oily rag. "Just keep an eye on the oil temp and manifold pressure for a while. She's got four new jugs on that engine."

Lt. Drake had a healthy respect for his maintenance crew. His life depended on them. They didn't face the dangers of combat, but they knew the consequences if they didn't do their job and they took the responsibility seriously.

"Thanks, Skipper. Get some shut eye and we'll bring 'er back in one piece."

"I put my name on one of those pounders. Get a few Japs for me."

"You got it."

Once in the cockpit, the crew went through the routine startup and taxi out. Lt. Goodrich checked in with every crew member over the interphone. Sgt. Stinson, the flight engineer, confirmed all systems were in the green on run-up. The aircraft slowly crept toward the runway behind the line of bombers ahead until it became their turn came to take off. Balancing the throttles to assist the turn, Lt. Goodrich taxied out onto the runway and held in position waiting for the airplane ahead to lift off and a green light from the tower to start their roll.

Vernon watched in the dim morning light as the four-engine bomber before them struggled into the air, barely clearing the trees. Instead of a slow climb following the rising line of aircraft on the horizon, the big bird sank out of sight. Seconds felt like minutes as Vernon held his breath hoping to see it climb back into view. Instead, a ball of flame and a mushroom cloud of smoke rose from the rice paddies beyond.

"My God, they bought the farm!" Froula whispered over the interphone.

Vernon sat stunned at the sight. He didn't hear Lt. Goodrich calling for throttles.

Goodrich barked to get Vernon's attention, "Green light … balls to the wall, lieutenant."

Vernon had his left hand on the round knobs of the throttle levers, ready to push them forward for takeoff.

"Come on Drake, we gotta go."

Suddenly, aware once again, he pressed the levers forward as the heavily loaded machine rolled down the runway. "She's got four new jugs on that engine." Skipper's words came racing back. Vernon's eyes shot to the number four gauges as the bomber labored into the air. All looked good. Below, the burning wreckage reflected off the waterlogged fields as they passed overhead.

That could've been us. The reality of war once again washed over him as he quickly turned his attention to the tasks at hand—get his aircraft safely to altitude and join up with the group. Mechanically moving through the climb procedures helped keep the image of the smoldering mass from his mind.

Flying eastward, Vernon watched as they caught up with the sunrise. The earth below, still enveloped in the grey, early morning dawn, slept while the sun glinted off the wings of the formation. Once at altitude and joined in the formation, time slowed down. A long, boring flight lay ahead chugging along through the heat and humidity, providing too much time to reflect on the war. Images of the burning wreckage faded with the growl of the engines.

Chappy sat, hunched over his charts, keeping track of their position. Even though they were following the leader, he always wanted to know exactly where they were, just in case. More than once in past missions he found the lead aircraft off course and had to correct it. Not the only reason, in an early mission he made an error of his own that put his crew 100 miles to the south of the intended target and well into enemy territory. They barely had enough fuel to make it back. All four engines quit as they rolled off the runway and onto the taxiway after landing ... out of gas. That rookie mistake haunted him. He swore that would never happen again.

Familiar sweat rolled down Lt. Drake's back as the morning sun streamed into the cockpit baking its occupants already overheated from the oppressive Gulf air. Even the substantial breeze coming through the open side windows and swirling through the structure provided little relief. He watched the grey shadows of the aircraft formation dance over the fields below.

What must the farmers down there with their water buffalo in endless rows of rice think as we darken the sky overhead? After months and years of the same scene repeated, are we simply ignored like a flock of birds? Do they realize that some of us may not come back? Do they even care?

Soon, the fields, jungles, and towns gave way to the endless waters of the Bay of Bengal. The aircraft shadows no longer danced over the terrain but seemed frozen on a backdrop of flat, blue sea. Only the occasional fishing boat overtaken by the grey silhouettes gave an indication of the 160 mph progress toward the Burma shores. Low and slow ... those were the orders.

Time stopped over the open water. A blank horizon remained featureless as the formation droned its way toward war. Vernon mused at how safe and connected he felt tucked in among the gaggle of aircraft

outside his window. In truth, they might as well be on the other side of the world when the shooting started. If one got shot down, the others were simply spectators.

"Time to head for cooler air," Lt. Goodrich announced over the interphone after hours of droning over the featureless sea.

Vernon eased the throttles forward as the formation began a gradual climb to 21,000 feet. According to Operations, high altitude bombing somewhat reduced the risk of detection and being hit by flak. On the other hand, accuracy suffered.

Lt. Goodrich yelled over to Lt. Drake, not wanting to broadcast on the interphone. "Why Command thinks we can hit a ship from high altitude is beyond me. I could dive this baby down on the deck and blast that thing out of the water."

Vernon nodded his head in agreement and smiled to appease Goodrich, knowing that the concept of a B-24 as a dive-bomber defied practicality. A fighter pilot in a bomber's skin, Goodrich felt he had been mis-cast and denied his true calling. There were times in training when he pushed the envelope and received a reprimand in no uncertain terms. Today would not be one of those days. Today's mission went strictly by the book.

The air blasting through the open window cooled as the aircraft labored upward. Soon, sweat gave way to chills and the windows were slid shut.

Lt. Goodrich leaned toward Vernon. "You can get into your bunny suit first, I've got the airplane."

Vernon unbuckled his seat belt, worked his way onto the small platform next to flight engineer Sgt. Stinson, and wiggled into his bulky, insulated flight suit. Outside temperatures would soon dip to 20 degrees F below zero. All crew members bundled up for the couple of hours they would endure the intense cold. B-24s had, what comically passed for heaters. At altitude they did little to combat the cold. Some aircraft had electric flight suits that seldom worked.

With fleece-lined gloves, boots, hat and oxygen mask, the crew transformed into a fighting organism as they leveled off high above the Burmese coastline en route to their mission target lying just beyond the horizon.

Next stop, Rangoon.

Hero

A blanket of snow sifted through the screened-in porch, lying heavily on the two boys bundled under a pile of blankets. Vernon peeked out from a small gap to see the first light of morning on the horizon. Cold, fresh air rushed in and filled his nostrils. He loved the smell of pure country air and breathed in deeply, filling his lungs. He then pulled the blanket tightly over his head and returned to the warm darkness, knowing in a few minutes his dad would be at the door.

"Come on boys, time for chores. It's going to be a beautiful morning," Vernon's father called as he pushed the porch door open creating a small snowbank in its path.

Six-year-old Vernon and his older brother Ray preferred sleeping on the porch to the over-crowded bedroom they had to share with three other brothers. His father had yet to finish the addition to their little farmhouse. The annual harvest had not been good. Very little rain on those rolling sun-bleached hills made it a tough year for dry-land farmers. A wooden skeleton of two more rooms stood tacked to the back of the house, waiting on the funds to buy the materials needed to finish them.

"Aw, we're coming Pop," Vernon croaked. "Be there in a minute." He curled up into a ball under the heavy blankets to soak up the remaining heat before he had to sprint through the cold for the door.

The sound of someone rattling the wood stove penetrated the walls from inside the house as Vernon's mother shook out the spent coals from

the night before. She loaded up the firebox with fresh wood, stirred the remaining glowing embers, and got a new fire started.

Ray groaned as Vernon gave him a nudge in the side. "Mom's got the stove going. We gotta get up."

"Okay," Ray grunted as he burrowed deeper under the covers. "You go first."

"Me? Why is it always me?"

"Cause I'm older and I say so."

Vernon wasn't sure why seniority dictated that he should be the first out of bed in the morning, but he had learned the hard way it was best not to argue. Ray had a convincing punch.

As the first order of business, Vernon bopped the blankets from underneath to knock off the layer of snow. Next, he sent an arm out and reached under the bed to locate his shoes and position them at the ready to be slipped on quickly. His woolen underwear and socks kept him toasty warm at night and would keep him warm for the dash to his clothes inside the house. He had left them draped over a chair next to the stove. With luck, the stove had warmed them up.

"Morning, Mom," Vernon called in a cheery voice as he rushed into the kitchen and made for his clothes.

"Good morning, son."

The room was still cold from the long night. Even though his father got up several times to stoke the fire, it had not been enough to keep the bucket of water beside the stove from crusting over with ice. His mother had chipped the layer away and poured some water into a washbasin on the stove and filled the coffee pot. As Vernon dressed, he danced a little to keep warm. The hollow walls of clapboard and plaster did little to retain heat on cold Montana winter nights. As a result, the family gathered around the wood stove in the morning to get ready for the day.

Ray appeared shortly, stomping porch snow from his boots before traipsing across his mother's clean kitchen floor. He joined Vernon by the stove and slipped into his overalls.

Vernon's father came in, bundled up for his routine trip out to the fields to spread hay for the cattle.

"Uncle Chauncey and I are heading into town this morning. If you boys get your chores done in time, you can come along."

Vernon's eyes glowed brightly as he shot a look at Ray. The chance for a trip into town sent excitement through his body. Not only did a trip to town promise adventure, it also meant skipping school for the day.

Ray pumped his fist and gave an enthusiastic thumbs up. "We'll get 'em done Pop. Don't leave without us."

The two boys hurriedly finished dressing and layered on coats, scarves, mittens, and hats. Their mother inspected each of her sons closely, tugging up their mittens and tucking in their hand-woven woolen scarves. They each grabbed a bucket and headed out the door into the rising sun glistening on the fresh snow.

The first order of business meant a trip down the coulee to the spring that seeped water all year round. His father had said that, without that spring, they wouldn't be able to stay on the farm during the winter. He planned to sink a well near the house, but that too had to wait for a better harvest. With luck, the ice wouldn't be too thick on the creek.

The trip down the draw was easy. Coming back up with a bucket of water, particularly with fresh snow on the path, presented a challenge for a six-year-old but Vernon was up to the task. Today, nothing would slow him down. He was going to town.

The last time he went to town with his father was in early September, not long before the first snow. He would never forget that day. Playing in the yard with the goats, he heard a rumble that at first sounded like Grandpa's tractor off in the distance. As it became louder the sound became a distinct growl, not like the puff, puff, puff of the tractor. Looking up, a silver airplane soared low over the house, the sound rattling the windows. It sailed north over the bluffs toward town as Vernon stood in awe. He had heard about airplanes but had never seen one before. Transfixed, he watched the silver wings become smaller and smaller, as they sailed farther and faster away than anything he had ever seen.

For the rest of that day, the airplane was all Vernon could think about. He found a couple of scraps of wood and pounded them together to form a small wing and fuselage that he could lift high above his head, flying it around the yard as he ran, imagining what it would be like to ride in such a machine. The next morning, he arose early, did his

chores quickly, and went to find his new toy to take to the breakfast table. When he got to the kitchen, the rest of the family sat waiting for him to take his place.

After his father had given the blessing, he announced, "We're all going to town today." That got everyone's attention. "We are going to see someone very special, a real national hero."

"A hero?" Vernon asked.

"Yep. We're going to see Charles Lindbergh."

"Who's he?"

Ray wrinkled his forehead and squinted at his little brother across the table. "He's the guy who flew an airplane across the ocean. Don't ya remember Mrs. Halverson tellin' us about it in school?"

Vernon shook his head. He didn't pay much attention to what the teacher said when she taught the older students.

"That's the airplane that went over yesterday … that was Charles Lindbergh," Ray said impatiently. Little brothers seemed so dumb at times.

Vernon didn't know much about oceans. He just knew they were the big blue areas on the map that hung on the wall in the schoolhouse. But he did know what he saw, and that was a wonderful machine that sailed over his house like magic.

"Will we see the airplane, too?" he asked bouncing in his seat.

"I suppose so," his father answered.

That was all Vernon needed to know. He would be the first one in the car when the time came.

The final chores seemed to take forever. His mother had to do the dishes, pack a picnic lunch for the family, and clean up the kitchen. His father and brothers were tending to the livestock. He fed the chickens and then sat impatiently waiting on the porch, flying his model over the distant clouds.

At last, his father rounded the house and called out, "Let's head 'em up and move 'em out!"

That meant it was time to load up the car. The family piled into the big old five-passenger 1918 Buick touring car. Ray and brother Norman took up their favorite spots standing on the running boards. Halfway to town, they would get tired of hanging on and eventually clamber in, stuffing four brothers into the back seat.

Father mashed down the starter and the old car bucked as the engine belched smoke. Off they went, weaving and bouncing down the rutted Duck Creek Road toward town eighteen long miles away

As they drove, Vernon's father explained that Charles Lindberg flew his airplane across the Atlantic Ocean from New York to Paris, non-stop—the first to cross the Atlantic by air. But his father's enthusiasm for that accomplishment increased when he revealed that he had personally met Lindberg five years earlier when Charles was a young guy working in Bob Westover's garage in town. It seems Lindbergh got stranded in Billings after a barnstorming tour went bust. Not a pilot at the time, he had been a mechanic and parachute jumper for the troupe. Charles, known locally as Slim, spent the summer in town and even did some exhibition parachute jumping out of Bob Westover's airplane.

Vernon had no idea his father knew anything about airplanes or had even seen one. He didn't even know that there were any airplanes around let alone one that someone would jump out of and float to the ground. He got so excited as they pulled into the fairgrounds that his stomach hurt.

It seemed like hundreds of cars and large crowds of people would block any chance of seeing that wonderful airplane. Once out of the car, Vernon's father hoisted him on his shoulders and pushed through the crowd. From his high perch, he could see it—that wonderful machine. Not only the silver beauty that had passed so gracefully over their house but two other winged wonders. Vernon's heart pumped with joy.

His father edged closer to the focal point of the throng and eventually made it to a rope separating the people from the stately bird. A tall, slender man in a full-body flight suit and a leather helmet with goggles perched on top of his head, stood next to the airplane along with several people in business suits. Photographers with their cameras on tripods snapped away.

Vernon's father called out, "Hey, Slim. Great job!"

The man glanced Vernon's way and gave a quick, knowing smile of recognition, and turned back to the cameras.

"That's Charles Lindbergh?" Vernon asked. "You really do know him."

Several long boring speeches followed and Vernon's father tired of his son sitting on his shoulders. Vernon was ushered back to his mother where

they walked around looking over the variety of Lindbergh memorabilia that vendors had on display. There were flags and buttons, books and banners, model airplanes painted silver, and even dishes painted with an image of Lindbergh's airplane, the *Spirit of St. Louis*. Suddenly, Vernon spied the one thing he knew he had to have. A small pile of a child's version of Lindbergh's leather helmet, complete with goggles, lay on the corner of one of the vendor's tables. Of course, it was canvas, not leather and the goggles were cheaply made but that didn't matter.

"Can I get it, Mom ... please, please, please?"

Vernon's mother had very little spending money but his birthday was coming up so he used that as an incentive.

"You won't have to get me anything for my birthday ... or Christmas either," he said as he stroked the prize with one hand while tugging at his mother's skirt with the other.

His pleading eventually paid off and soon he was sporting a canvas flier's helmet. No ball cap or cowboy hat for him—the helmet would never leave his head.

Now, on this snowy morning with his Lucky Lindy helmet to keep his ears warm, he would be going to town again. He didn't know what his father had in store, but he was ready for the adventure.

Lt. Drake's sketch of the homestead on Duck Creek Ranch near Billings, Montana, where he grew up.

"TIME TO HITCH UP"

Horses had always been a big part of Lt. Drake's life and a favorite subject in his sketchbook.

Later in life, Vernon Drake sketched a memory of pulling a mired tractor out of the mud with a team of horses. The drawing shows him wearing the Charles Lindbergh flight helmet he got as a souvenir when Lindy visited Billings, Montana.

CHAPTER 18

Bombs Away

"Twenty-one thousand," came Lt. Goodrich's voice over the interphone, slightly muffled by the throat microphone and the oxygen mask. "Time to tighten up the formation."

Vernon had been daydreaming as the flight climbed for altitude, a long, slow process. When he first saw Charles Lindbergh, he never imagined that one day he would find himself at the controls of an airplane. Even now, he had a hard time believing that he had any real control over this monster flying machine. *How was it possible that 60,000 pounds could be rumbling through this thin, frigid air at over 20,000 feet?*

"Stay sharp, boys," Goodrich commanded. "We're coming into fighter range. Oscar will be looking for us today."

Vernon's heart jumped a few beats at the thought. The Japanese Nakajima Ki-43 Oscar, similar to the Zero, could range several hundred miles away from base in search of Allied aircraft to attack. With luck, his flight wouldn't be discovered for a while. At least he hoped not.

Burma lay menacingly ahead in clear view. Low coastal clouds hid the shore but the Chin Hills beyond, rose up green and lush. Across the hills, the Irrawaddy River flowed south where it spread its fingers and emptied into the Andaman Sea near Rangoon. One-hundred and fifty miles to go, they would be over Rangoon in about an hour and 45 minutes—each mile filled with anxiety.

All eyes scanned the skies for small black dots indicating enemy aircraft. The group of bombers had no fighter protection on this mission. Protection would come from the .50-caliber M2 Browning machine guns that bristled from all sides of the aircraft.

Time passed slowly as the bomber formation seemed to inch its way toward the Irrawaddy River Valley. Vernon wanted it to be over and safely on his way back. The more he thought about it, the slower the aircraft seemed to fly. The city of Rangoon emerged in the distance with the brown Irrawaddy snaking away toward the Gulf of Martaban.

"A-flight breaking off to target," Goodrich announced as their formation made a slight course adjustment to the south.

Vernon watched the B-flight formation grow smaller as they separated and headed for the docks. Vernon's flight steered for the river where the freighters were to be found. He could already see a few puffs of black smoke high above the city's shipyards as the Japanese calibrated their 88 mm guns for the incoming bombers. B-flight would have to fly through those exploding shells to their target. There would be no puffs of black where A-flight headed. At 21,000 feet, they were far out of reach of the guns on the ships in the river. Why Command had designated such a high altitude to bomb the small fleet from didn't make much sense to the crew but those were the orders. Vernon was thankful for that.

"Target in seven minutes," Chappy called out over the interphone.

The Irrawaddy spread out before them like a widening highway far below. In the distance, two large freighters flanked by a much smaller battleship steamed toward Rangoon.

"There's our lunch ticket home, boys," Lt. Goodrich said as he shook his finger toward the windshield. "You ready, Froula?"

"All set, captain," the bombardier replied in an assuring voice as he peered through his Norden bombsight at the river below.

"The ship is yours, lieutenant."

Goodrich flipped the switch giving temporary control of the autopilot to Froula. Vernon sat back and scanned the skies for those telltale specs that could be fighters. He marveled at the possibility that the bombs he carried could strike the tiny toy ships so far beneath him. As soon as that thought entered his mind, the knowledge that there were people

on those ships sent a pang of guilt through his heart. Sure, they were Japanese, the enemy responsible for the deaths of so many of his friends and countrymen. Those faceless Japs, fit only for killing, became real people for a moment. For most of his life he heard, *thou shalt not kill*. Now, here he was, about to unleash tons of explosives on ships full of men. Was it right? Was it wrong?

Stop thinking, Drake, Vernon shouted silently to himself. *Just do your job.*

"Bombs away," crackled over his headset as he felt the aircraft levitate in a sigh of relief as it ejected the heavy load from its belly. Through the window he watched the other bombers disgorge their cargos as well.

"I've got the aircraft," Goodrich announced as he returned control to the cockpit and put the bomber into a left-hand turn. The two pilots watched, as the gaggle of black bombs grew smaller on their dive toward the ships. Soon, plumes of waterspouts from explosions paraded toward the floating targets. Then, a series of blasts peppered the deck of one cargo ship. The second freighter erupted in a huge ball of flame, like a volcano.

"Man oh man, must have been a tanker," Chappy chirped over the interphone. "I hope somebody got that on film for the commander."

Cheers could be heard from the rest of the crew as they celebrated a direct hit.

"Let's tighten up the formation," Lt. Goodrich announced to the other three aircraft commanders. "We're not home yet."

Vernon felt his shoulders loosen and drop slightly as built-up tension drained away. At least they were heading northeast, away from Rangoon.

"Fighters at two o'clock high!" Chappy's excited voice boomed over the headphones.

Vernon lurched forward to look up and out of the cockpit window. Three black dots grew larger by the second as the Oscars entered a rolling dive toward the small formation of four bombers. His heart jumped a beat and then took off.

"Man your stations, men. Here they come," Lt. Drake ordered.

As copilot, his Gunfire Control Officer duty made him responsible for maintaining strict interphone discipline as well as supervise the call of attacks. "Keep the chatter down and make every shot count."

Sgt. Stinson climbed into the top turret, Lt. Froula scooted forward to the nose turret, Sgt. Barry already sat in the tail gunner chair, and Sgts. Kardell and Mandula stood poised at their waist guns.

"We're ready for 'em, lieutenant." Sgt. Mandula's voice blasted, charged with energy. "I'm gonna get some Japs today!"

"Ten bucks says I'll get the first score," Stinson injected.

"You're on."

The crew had not encountered fighters before. Today the gunners would be able to test their skill and training against a real enemy. Anticipation filled their chatter.

"They're comin' in hot and high, now three o'clock."

"I got 'em."

"You see 'em, Mandula?"

"There they are. Hold off 'til they get in range."

"Now!"

The aircraft erupted with the ratta-tat-tat of .50-caliber machine-gun fire as Stinson pulled the trigger on his guns in the top turret, swinging to follow the lead fighter as it flashed through the formation spewing deadly projectiles.

"He's yours, Mandula."

The fighter dove past Mandula's guns as he opened fire. At the same time, Stinson swung around to take on the second fighter while tracers filled the air from both combatants marking hits and misses.

Lt. Drake felt helpless. He had become a spectator. He now had to rely on the training of his crew and all the drills they practiced getting ready for this day. An additional duty as Fire Officer made the location of all fire-fighting equipment race through his head. A duty he hoped he would never have to exercise.

Copilot responsibilities briefly overwhelmed him. According to his training, he had to know everyone's job at least as well as they did, including the role of airplane commander should Goodrich become incapacitated. Suddenly, that thought surfaced more real than it ever had before. He glanced to his left to find his commander intent on the controls and focusing on keeping the other bombers in a tight formation. Stragglers made an easy target for the Japs.

Lt. Goodrich's communication with the other aircraft commanders revealed that the fighter's first pass had done little damage. They would, no doubt, now swing around and attack from the rear.

"Comin' in fast, six o'clock high," Sgt. Barry broke through.

The airframe rattled once again as he and Stinson both let loose bursts of fire with their .50-caliber guns. As the fighters bore down, tracers tearing up the sky, the lead plane suddenly burst into flames, rolled over, and headed for the ground.

"Hey, hey! Ballard's crew got one!" Stinson yelled.

The side gunners joined in as the fighters caught up with the bombers. Vernon stretched around to get a view out his side window when the right outboard engine cowling appeared to explode as shells tore into it. The shock of the sight stunned him for a fraction of a second.

"They got number four engine," Vernon announced, trying to sound calm and professional even though the sight of flames beginning to wrap the exposed engine rattled him. "Feathering number four and engaging fire suppression."

Both pilots, tense with anticipation, watched as the flames subsided on the outboard engine and its propeller came to a stop.

"Still got three spinning," Lt. Goodrich said reassuringly as he bumped up the throttles.

Vernon knew that, even with three good engines, they would be hard pressed to keep up with the formation for any length of time. He hoped it would be long enough to escape the fighters. He watched the menacing monoplanes arc off to the right to regroup for another attack.

"They'll be coming back at us from four o'clock," Lt. Drake announced. "Stay sharp."

Stay sharp, he thought—a completely unnecessary comment. He knew everyone on the ship was operating on high alert.

Two Oscars had climbed slightly above the formation and began another run, targeting the stricken bomber. Sgt. Stinson swung his turret around and took aim, waiting for the aircraft to get within range. Sgt. Mandula did the same with his waist gun. Within seconds, tracers from the attacking fighters flashed by Vernon's window as he felt the

aircraft rattle from the machine guns of Stinson and Mandula. The sound pounded through him, being only a few feet away from Stinson's turret.

"I got 'em! I got 'em!" Stinson yelled over the headphones.

Vernon watched the lead fighter burst into flames, shed a wing and began a violent roll toward the earth before it disappeared out of his sight. The second Oscar broke off his attack and banked back toward Rangoon.

"Great shooting!" Vernon erupted over the interphone. He could hear the cheers from the rest of the crew as they celebrated their victory. They had faced the enemy head on for the first time and survived.

Once certain the Japanese had given up the pursuit, Lt. Goodrich reduced the throttles on the three good engines for a slow return to base.

As the tension drained away, Vernon turned to Goodrich. "Wonder how Skipper's gonna feel about the Japs shooting up the engine he spent all night fixing?"

Lt. Goodrich looked back at Vernon with wide eyes and pointed to the cockpit sidewall where, three inches above Vernon's elbow, light streamed through a silver dollar-sized hole.

Vernon felt a chill run down his spine. "This job could be hazardous to a guy's health," he responded absentmindedly.

The Girls

The trip back to Pandaveswar wore on for hours after the formation left its three-engine straggler behind. Lt. Drake closely monitored the instruments, hoping the remaining engines stayed healthy. When the airbase at Pandaveswar finally came into view, he felt a lot like coming home.

How strange, he thought, that this long stretch of concrete and thatched huts could feel so welcoming when, just a few weeks ago, it felt so foreign.

Lt. Goodrich made a textbook landing and turned the controls over to Vernon.

"Take us to the revetment, Drake," he said with a sigh.

Vernon pulled the mixture on the number one engine and used the two inboard engines to taxi to parking. At the sheltered area, he swung the tail around and shut down the remaining engines. As they ticked to a halt, the men sat motionless, relishing in the soothing quiet after 12 hours of monotonous growling.

Goodrich broke the silence. "Time for a whiskey." He and Vernon flipped switches, unplugged their interphone, and seat belts clanked against metal seat frames as the two freed themselves.

"Owww," Vernon groaned as he rolled out of his seat into the narrow space leading from the flight deck. "My legs feel like they're 90 years old and my butt's numb."

Hunched over, he wedged his way through the engineer's station and dropped down through the open bomb bay doors. As he walked toward the waiting jeep, he could hear the excited jabber of his crew as they boasted of their adventure to the ground team.

"Sorry about number four," Vernon said to Skipper as he passed.

"No problem lieutenant," Skipper answered lightheartedly while surveying the blackened hulk. "Just good to have you back in one piece. By the way, how'd my pounder do?"

"She landed square mid-deck and blew that tanker sky high, sergeant."

Skipper broke into a broad grin. "I'll trade that for one burnt-up engine any day."

Back at the Operations shack, the debriefing earned a few, "Well done, men" comments from Col. Dodson and an extra shot of whiskey. Even better, the crew would get a day or two off while Skipper patched up the plane.

As the flight crew enjoyed another evening meal of fried SPAM, Vernon decided the time had come to mention something he had been thinking about ever since he saw bombers lined up in Calcutta.

"Hey fellows, anybody know why we don't have nose art painted on our planes like other squadrons?"

"Hell, I don't know," Chappy chimed in. "Maybe we're so far out in the sticks, the word hasn't trickled down from headquarters yet."

Lt. Goodrich stabbed a fork into a hunk of charred SPAM. "Not sure there is any regulation against it. I don't think anybody here ever gave it a try."

"What would you say about asking the commander if we could paint something on ours?"

Goodrich lit up, "I'm all for that, Drake. And

Lt. Froula and Lt. Drake in Pandaveswar enjoying time between missions.

I know just the guy that can do the painting." He lifted his beer in a toasting gesture. "To Lieutenant Drake ... our resident artist."

The guys got used to seeing Vernon with pad and pencil in hand sketching everything from houseboys to horses.

The others raised their drinks, "To Lieutenant Drake."

"Alright. I'll do it. We don't fly tomorrow. I'll see Colonel Dodson in the morning."

"What'll we name ol' 264?" Froula asked. "Any ideas?"

Enthused that everyone liked the idea, Vernon offered, "We oughta give the whole crew a shot at naming her—including Skipper's bunch."

Lt. Goodrich's fork absentmindedly raked through a mound of brown rice, making sure there weren't any unwanted critters among the grains. "Good idea. We'll make it a contest. Drake can draw something up to match the name ... right Drake?"

"Sure."

Chappy lifted his glass. "As long as it's a dame."

Vernon's mind had already been racing through potential images. A Vargas Girl Calendar hung on every wall in basha huts and army tents on the base. Those enticing and alluring images didn't leave too much to the imagination. Alberto Vargas had become a master at pinup girl paintings. Servicemen treasured his artwork featuring idealized women accentuating every good curve. Those images helped block the not so pretty memories witnessed daily of war and death. They also represented what waited back home, at least in their dreams. Versions of Vargas Girls showed up as amateur paintings on the sides of US Army Air Corps vehicles of all kinds including B-24 bombers. Somehow, the practice had not yet reached Pandaveswar other than teeth painted on the P-40s in the Flying Tiger fighter squadron.

Vernon loved sketching the flow and curves of a woman. They had replaced horses as his most enjoyable subject. Although he didn't have a lot of experience with the real thing, the Vargas Girls fed his imagination. He felt both excited and guilty as he drew. He could feel his mother, Bettie and, most of all, God looking over his shoulder in disgust. He wondered how something so beautiful could also feel so sinful. The pastors had done their job well. But, they were half a world away now.

The next morning, Vernon waited until all the flight crews had departed on their missions before approaching the Operations building.

An orderly sat behind a desk piled high with papers, hammering on a typewriter. He looked up as the screen door banged shut behind Vernon.

"Morning corporal. I'd like to see the commander. Is he in?"

"What's this about, lieutenant?"

"An aircraft maintenance issue."

"Okay. Just a minute, I'll check."

The orderly picked up the phone receiver and pressed a button on the side of his desk.

"Sir, there's a lieutenant …" He paused and looked up at Vernon.

"Drake. I'm Lieutenant Drake."

"Lieutenant Drake here to see you about an aircraft maintenance issue. Shall I send him in?"

He put down the receiver. "You can go in."

Hat in hand, Vernon walked in and stood at attention in front of Col. Dodson's desk.

"At ease lieutenant. What's this about a maintenance issue?"

"Well, sir, it's not really maintenance. It's more about morale."

"Morale?"

Vernon suddenly became aware of how petty his request might sound and began almost as if he were apologizing. "Yes, sir. Some of the guys are wondering why none of our planes have names and nose art painted on them. It seems other squadrons allow it. We think it would boost morale if we could paint our planes too."

Vernon waited for the Colonel to dress him down for such a foolish request and send him packing. Col. Dodson sat for a moment without expression.

"Hmmm, interesting thought. You know, it's against regulations … although it's been done a lot in other theaters, particularly in Europe. I can't see why we are any different. You might have something there, lieutenant. Let me get back to you."

"Yes, sir!" Vernon surprised himself with his overly enthusiastic response. "I know the boys will be excited to hear that. We'll keep our fingers crossed."

Later that morning, several grounded crews in shorts and boots were playing baseball in the parade grounds when the commander's orderly pulled up in a jeep and called Vernon over.

With a salute, he said, "Sir, Colonel Dodson says, concerning your maintenance issue, sometimes aircraft need a little touch-up paint."

"That's all he said?"

"Yep. That's it, sir."

"Okay—great, corporal. Thanks!"

Vernon returned the salute and turned to the guys who had halted their game. Usually, a message from Ops meant reporting to the briefing room on the double.

"Guess what, guys. It's on the QT but we have the go-ahead to paint nose art on our planes."

Chappy threw his glove in the air, "Yahoo! Hip, hip hurray for the colonel."

As the flight crews gathered around, Vernon quieted them down. "Just so you know, the commander said nose art is against regulation so he hasn't 'officially' given us permission. He just said sometimes aircraft need a little touch-up paint."

Bombardier Lt. Froula demonstrates that he is ready for battle should they get shot down in enemy territory.

Lt. Froula in front of their basha named "Little Wheels."

"We'll do a little touch-up alright," Froula piped up. "I can see it now—Betty Grable riding shotgun on the nose of ol' 264."

Lt. Goodrich held up both hands, one with his first baseman's glove holding the ball. "Whoa. Hold on there, partner. We gotta name her first. Let's get the ground crew involved too and make a real event out of this."

"Right," Vernon added. "Those guys were up all night changing out the engine. They're still hard at it. They deserve a say. I think we oughta make a contest out of this. Everybody can submit a name and then we'll take a vote. Whaddya think?"

Everyone agreed, the ground crews needed to be included.

"Great, then. I'll go over and let ours in on the deal."

Vernon commandeered a jeep for a ride out to the revetment where 10 guys in shorts, and brown from too much time sweating in the hot Indian sun, labored on the injured aircraft. Vernon found Skipper standing on scaffolding against one side of the new engine hooking up an oil line.

"Hey, Skipper. You gotta minute?"

"Sure, lieutenant. What's up?"

He gave a final twist on his wrench, stuck it in his back pocket, wiped his hands on a rag, and climbed down the ladder.

With a lazy salute, he said, "What can I do for you, lieutenant?"

"Well, we're gonna need some paint."

"Paint?"

"Yep—paint."

"For what? What kind of paint?"

"Whatever you can get your hands on that will stick to the side of an airplane. And we need all the colors you can find, too."

Skipper tipped back his cap, revealing a brow dripping with sweat. His eyes squinted and forehead wrinkled in confusion. "I don't get it."

"We're gonna paint some nose art on this ol' girl ... spruce her up a bit." Vernon patted the side of the airplane.

Skipper's face lit up in a grin. "Really? They're gonna let us do that?"

"Well, I wouldn't use the word 'let.' Let's just say we're gonna apply some touch-up paint."

"Holy mackerel, lieutenant, that's great. Wait until I tell my boys about this."

"We gotta name her first, Skipper. That's where your crew comes in, see. Lieutenant Goodrich and I want everybody to give a suggestion for a name. Then we will put it to a vote. Once we have a name, we'll come up with the art to match the name."

"I like it!"

"Have your suggestions to me by Thursday. That gives you two days."

"You got it, lieutenant," Skipper said with an exaggerated salute.

Goodrich, Froula, and Drake goofing off in front of their Pandaveswar basha hut. They named their basha crew "Little Wheels" as opposed to "big wheels," which they were not.

War Never Stops

Vernon finished drawing the final curve of the leg on a beautiful bomb-shell of a gal. He sat back studying his handiwork when her appearance slowly took on a heavenly glow and transformed into Bettie's smiling face looking back at him. He could feel her slim waist, her gentle touch, and he melted at the shape of her breasts. Her hair cascaded down to her shoulders, dancing in a slight breeze ...

"Briefing room in 20 minutes, lieutenant."

The stabbing beam of a flashlight penetrated his squinting, sleep-filled eyes.

"Right—right. I'm awake," he mumbled, annoyed at the rude intrusion.

The light moved to Lt. Goodrich's cot as the voice in the dark repeated its announcement.

"Briefing room in 20 minutes, lieutenant."

"Got it, sergeant," came a muffled voice from beneath Goodrich's mosquito net.

A lantern broke the darkness as bodies rolled from their cots and into their army boots for a trek to the latrine.

"There's gotta be a better way to fight a war," Froula complained as he scratched his rear on the way out the door.

By the time everyone got to the briefing room, energy had returned and the morning banter among a bunch of guys in their early 20s filled the space.

"Today's mission, men, is Thedaw Airstrip, an enemy fighter base just 20 miles south of Mandalay." Col. Dodson pointed to the location in northern Burma on the wall map. "Our Chinese, British, and Indian allies are fighting to keep the Ledo Road open to supply our troops out of China and India. They are pushing hard to force enemy withdrawals. British P-47s have hit Mogok, Mankat, Bawgyo, and Konhka with 500 pounders, inflicting heavy damage. British and Indian forces have the Japs retreating and are moving on Mandalay. We need to knock out the Jap's ability to get their aircraft off the ground."

Col. Dodson had everyone's attention. Going after a fighter base meant two things—ack-ack antiaircraft fire and aerial fighter attacks.

"You won't be alone on this one, boys. We'll have 32 aircraft in the air, each carrying 1,000 pounders, and a fighter escort. The 7th Bombardment Group is going in full force. Our 493rd will join up with the 492nd and the 436th."

Vernon looked down at his mission cap hung over his left knee. It had hand-drawn hash marks on its bill, four vertical lines with a fifth diagonal, and four more vertical. This would make 10 missions under his belt. So far he had been lucky. Most missions were bridge busting, and little ack-ack or fighters to deal with. Some near misses, engine problems, spotty weather, and such, but other than long miserable hours aloft, pretty routine. Today would be different.

Col. Dodson and his staff laid out the details of the rendezvous and the mission. Each crew member recorded the data needed to complete their job. Lt. Drake's crew would be the lead element of their combat box so Chappy had to get them to the join-up point. Once there, they would merge with the group in wing formation and follow it to Burma.

"You'll be going in at 6,000 feet," Col. Dodson continued. "You can expect antiaircraft fire but if we can come in fast and low, they may not be able to get fighters in the air before we hit them."

"Right," Lt. Goodrich said quietly. "How does a formation of 32 bombers cross Burma without being noticed?"

"You have 45 minutes to chow down, get your gear, and be at your planes. Departure time is 0530 hours. Set your watches now. It is ... 0442 hours."

The crew made a quick dash to the chow hall for a breakfast of powdered eggs, pancakes, and SPAM. Then they picked up their gear, jumped in the supplied jeeps, and headed for ol' 246 where the ground crew worked at loading the final 1,000-pound bombs.

On his walk-around inspection, Vernon asked Skipper, "You guys come up with any names for this old girl yet?"

"We're workin' on it, lieutenant. Bring this sweetheart back in one piece and we might have something for you by then."

"Estimated chock-to-chock time is about 12 hours. That'll give you plenty of time. What else are you gonna do while we're gone?" Vernon gave a wink.

"Hey, we gotta sleep sometime, lieutenant."

Startup, taxi, and takeoff were pretty routine. Now used to seeing the end of the runway barely slip beneath the wheels of the heavily loaded bomber, Vernon never felt completely at ease until gear up and the establishment of a good rate of climb.

By the time they reached 6,000 feet and made formation, temperatures were in the 90s along with stifling humidity. Missions never seemed to occur at a nice comfortable altitude. The crew either soaked in sweat or froze. Today, in their light cotton khakis, they tried to cool off with the windows and side gunner doors open to get a breeze flowing through the fuselage. It didn't help much as the sun baked down on the flying tin can.

"There's the 436th at two o'clock," Chappy called on the interphone.

Lt. Drake spotted the formation of 10 bombers about five miles off, their shadows dancing over the broken low-level clouds that obscured much of the landscape below. "We got 'em, Chappy."

Pvt. Coogan contacted the 436th formation on the radio as Lt. Goodrich guided his plane toward the rendezvous. Within 30 minutes, the 492nd flight showed up on the horizon as well.

When the morning sun burned off the low-lying clouds, green fields and small villages stretched out before the formation of bombers. A little more than two hours passed when blue waters of the Bay of Bengal filled the windscreen. Once again, Vernon had the uneasy feeling of crossing open water. He paid extra attention to the sounds of the engines and the faces of the gauges.

"Want a SPAM sandwich?" Lt. Goodrich shouted over the growl of the engines.

"No thanks. Not hungry yet."

Even though breakfast had been hours ago, Vernon's stomach rejected the thought of food. He seldom ate anything in the air on the way to a target. Goodrich, on the other hand, seemed to have an iron gut and chowed down both to and from.

Another hour and the vast deltas of the Burma coast floated underneath the wings of the 32-plane formation. Then, the landscape began to slowly rise into the coastal hills and green-covered mountains beyond reached upwards to 3,000 feet. The flight crossed ridge after ridge and emerged into the wide central valley.

"Keep scanning the skies, boys," Vernon announced over the interphone unnecessarily, since everyone knew they were in Japanese fighter territory. "We'll be over the target in 30 minutes."

The fact that 250 other sets of eyes kept watch as well provided a level of comfort. *Safety in numbers,* Vernon thought to himself.

As the flight approached the Japanese held Thedow Airstrip no fighters appeared. Apparently, Command had calculated correctly. The formation had not been detected. The Jap fighters were still on the ground. Sporadic black puffs of exploding ack-ack began to appear but not the barrage they had seen in Rangoon.

"You got it, Froula. Make 'em count," Lt. Goodrich said over the interphone as he flipped the autopilot switch to give the bombardier control of the aircraft.

Thousand-pound bombs rained down from 32 heavies on the wide dirt airstrip below leaving massive holes and rising plumes of smoke and dirt. Fighter aircraft and buildings were destroyed. Their fuel and armament supplies went up in a great ball of fire.

"Woohoo! Look at that," came an excited voice over the interphone.

Another chimed in. "No Jap fighters in the air today, boys."

"Job well done, men. Let's head for home." Lt. Goodrich banked left with three other bombers in formation.

"Keep watching the sky just in case," Lt. Drake warned. Not a single fighter had made it into the air.

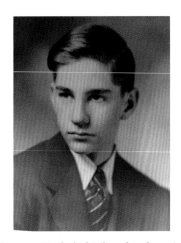

Vernon Drake's high school senior yearbook photo upon graduation from Laurel Senior High in Laurel, Montana.

This commemorative pillowcase was sent by Lt. Drake to his mother during his flight training as a souvenir.

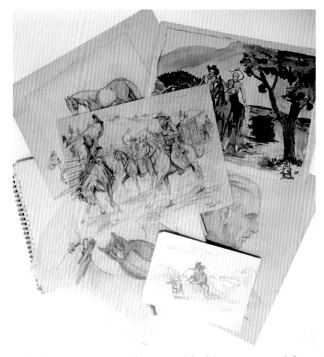

Vernon took up sketching at a very early age and had become a prolific artist by the time he reached his teenage years. This is a small sampling of sketches he made when he was between the ages of twelve and fifteen. His preferred subjects then (and throughout his life) were horses and cowboys.

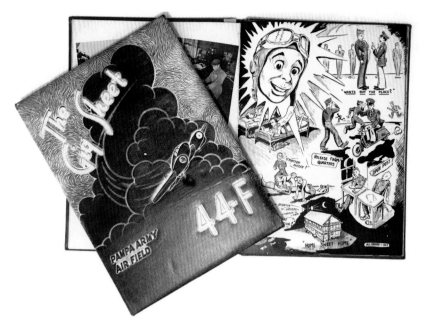

As a cadet in the class of 44-F at Pampa Army Air Field, Vernon worked on the class book staff and contributed many illustrations to said book.

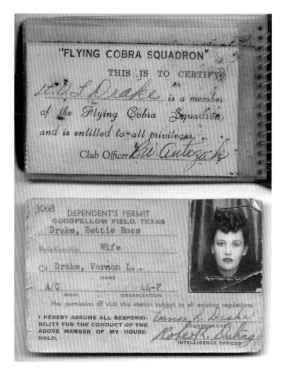

Top image: The 493rd Bomb Squadron was unofficially known as the "Flying Cobra Squadron," operating as a club for camaraderie and moral purposes typical of the Army Air Corps. Bottom image: Lt. Vernon Drake's wife Bettie was issued an ID while he attended flight training at Goodfellow Field in Texas.

The Flying Cobras 493rd Bombardier Squadron patch, as worn on Lt. Drake's leather jacket.

CBI shoulder patch.

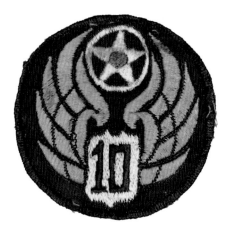

10th Air Force shoulder patch.

The carved ornate jewelry box Lt. Drake purchased in Calcutta for his wife, Bettie.

Lt. Drake departed for India and the CBI Theater on January 22, 1945. After serving there for almost 10 months, he returned to the United States on November 3, 1945, and was discharged from active service on December 22, 1945.

In 1990, Vernon Drake was awarded Wings from the Chinese Air Force in recognition of his participation in the US airlift across the Himalayan Mountains into China during WWII.

The original nose art painted by Lt. Vernon Drake has been restored and is now in the Commemorative Air Force Museum's nose-art collection.

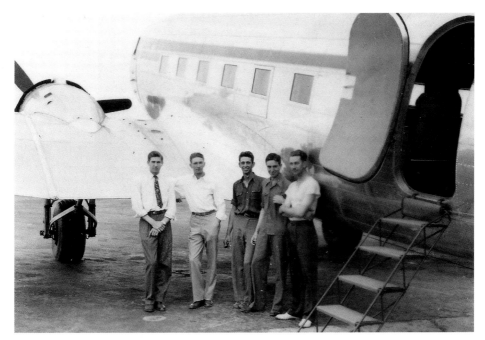

Heralded as the "Flying Drake Brothers" in the *Billings Gazette*, four of the five Drake brothers flew during WWII. Left to right: Vernon Drake (B-24 "Liberator" pilot CBI), Raymond Drake (C-47 "Dakota" pilot over the Hump CBI), David Drake (B-26 "Marauder" radio-gunner in France), Glen Drake (too young but joined the Navy following the war), Norman Drake (ferry pilot-mechanic-inspector for Northwest Airlines).

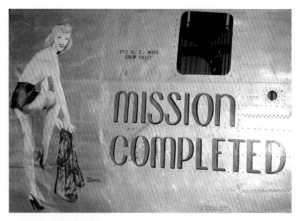

This is the original nose art painted by Lt. Vernon Drake that has been restored and is now in the Commemorative Air Force Museum's nose-art collection.

At age 74, Lt. Vernon Drake was reunited with a Consolidated B-24 Liberator Bomber similar to those he painted nose art on and flew in the CBI Theater during World War II.

The author, Lawrence V. Drake, reproducing one of his father's (Lt. Vernon Drake) nose-art paintings for the National Museum of World War II Aviation in Colorado Springs, Colorado.

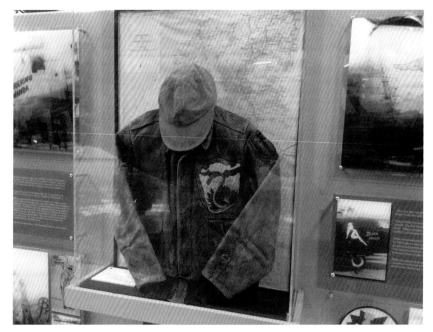

A close up of Lt. Drake's flight jacket and mission hat with hash marks indicating the number of missions flown, both of which are on display in the National Museum of WWII Aviation in Colorado Springs, Colorado.

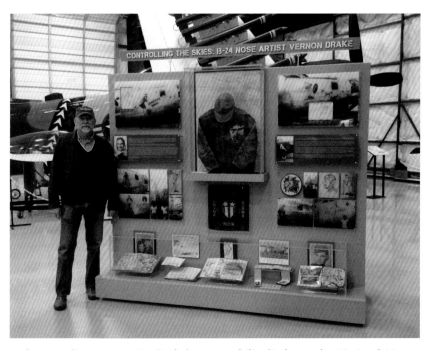

The author standing next to Lt. Drake's memorabilia display at the National Museum of World War II Aviation.

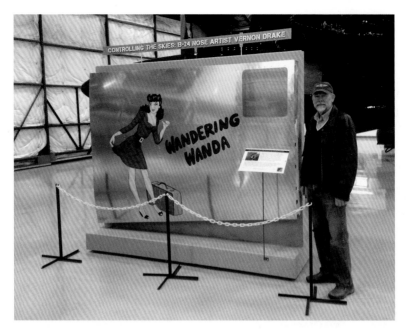

The Museum of World War II Aviation in Colorado Springs, Colorado, allowed the author to reproduce his father's painting of *Wandering Wanda* using the same type of paints and technique used on the original. The museum built a replica of a B-24 section from the original factory drawings for the painting. This reproduction is mounted on the backside of a display of Lt. Vernon Drake's CBI memorabilia.

Lt. Vernon Drake's personal story is included along with hundreds of first-hand accounts and photos in the four volumes of *China Airlift—The Hump*, published by the Hump Pilots Association, a valuable resource for the author.

Once the whole formation crossed the coastal range, they broke up into smaller groups. The 492nd and 426th radioed a farewell and split off to the south. Now, the long ride back to Panda.

"I'll take that SPAM sandwich now," Vernon yelled over to Lt. Goodrich.

"You got it, Drake," Goodrich said as he dug into his flight bag and tossed Vernon a sandwich wrapped in paper. "Take the controls, I gotta pee. Keep 'er steady, I don't wanna miss the bottle."

An uneventful flight back to Pandaveswar ended with Vernon making a smooth touchdown. He and Goodrich were to the point where they shared flying 50:50. At some time in the near future, Lt. Drake would have the opportunity to move into the aircraft commander's seat in his own ship.

Happy to see ol' 246 taxi in, Skipper's crew anxiously awaited news of the mission. Vernon shut down the two remaining engines used for taxi and, once again, sat motionless in the sudden quiet. A calm washed over him as tension drained from his body. Those few moments of silence were precious.

"Well, Drake, we cheated death again," Lt. Goodrich remarked as he undid his seat belt. "It's whiskey time."

Dangerous Drake

"You brought 'er back in one piece, lieutenant." Skipper gave an affectionate pat to the side of his charge. "No holes, no leaks, no squawks. Makes our job easier."

Vernon mimicked Skipper's pat but on his own chest. "She brought me home with no holes, no leaks, and no squawks, too. She deserves a name. You got one?"

"Well, as a matter of fact, the boys and I have been talking. We'd like to name her *Dangerous Drake*. After all, you're the one who got the idea for nose art past Colonel Dodson."

"Yeah, sure. You're kidding, right?"

"Nope. Think about the double enten … entawn … you know—double meaning."

Vernon shifted his cap to the back of his head and scratched his forehead. "Well, I'm not that dangerous. But we did some dangerous stuff over Burma today."

"Sure. And this baby, loaded with 1,000 pounders, makes her dangerous, too. That's a triple enten … entawn … triple meaning."

"If that's what you want, I'll run it by the flight crew and see what they say. I'm not sure how they'll take it."

An image of a Daffy Duck cartoon with bombs strapped to his wings popped into Vernon's head. *That could be fun.*

"Hey, we're all dangerous when it comes to killing Japs."

"Yeah, I guess that's true."

"I've seen you do some fancy sketching. We think you can come up with a saucy dame to match the name."

"Aw, shucks, thanks Sergeant," Vernon said, kicking the dirt with his boot in mock humility. Daisy Duck in a bikini replaced Daffy. "I'll throw the name out there at chow tonight and see if it sticks." He didn't think much of the idea but Skipper seemed pretty fired up about it.

After the mission whiskey and debriefing, Vernon, Goodrich, and Chappy headed for the officer's mess hall.

Chappy arrived at the counter first. "Hey, boys, SOS ['shit-on-a-shingle' or chipped beef on toast] tonight. It's a veritable feast."

The three made their way through the chow line and found a table. After a bit of chitchat about the mission, Vernon figured he would bring up the subject of a name.

"I don't know if you guys have given any more thought to a name for our plane, but Skipper's crew has a suggestion."

"Oh, yeah?" Goodrich asked. "What'a they got?"

"Okay, don't jump on me. Remember, this is their suggestion, not mine." Vernon suddenly felt very self-conscious about the name. "They came up with *Dangerous Drake*."

In the process of taking a big spoonful of the thick white sauce containing chunks of canned beef poured over toast, Chappy about choked. He coughed out, "*Dangerous Drake*? You're kidding, right? That's just ducky … I shoot at drakes and mallards, they don't shoot at me."

Vernon held up his hands, "Hey, I told you, it's their idea—not mine."

Lt. Goodrich twirled his fork and scoffed, "How dangerous is a duck? Can't see Donald dropping bombs on the Japs … though it *is* kinda catchy." He pondered for a minute. "I'd like to see what kinda dame you can come up with … a feathered female of some kind. Let's find out what the rest of the crew thinks."

Surprised at Goodrich's easy acceptance, Vernon focused on his meal sure that Lt. Goodrich was putting him on. "Okay, then."

After another uninspiring dinner, the three stopped by the enlisted men's quarters to get input from the other five flight crew members. Vernon hung back, not wanting to influence any decision. He still felt undeserving of the suggested honor and hoped they would come up with something else. Radio operator Pvt. Coogan suggested, *Bombs Away*.

Sgt. Mandula took a swig of beer. "I'll bet there are a thousand *Bombs Aways* out there. You guys are probably gonna think I'm daffy but I had a dream last night. There was this angel watching over us on our missions. She had a shield and the flak was bouncing off of it."

"She?" Pvt. Coogan piped up.

"Yeah. She. And a fine looking she at that. And she had a sword, too."

"That sounds like one angry angel."

"*Angry Angel*. That's it. We should call her *Angry Angel*! You're not gonna find another one of those in the whole Tenth Air Force."

"*Angry Angel*, now there's a name I can live with," Chappy chuckled.

"We'll put 'er to a vote," Goodrich said, taking charge. "All those in favor of *Angry Angel*?"

Nine bottles of beer were raised in agreement including an enthusiastic one from Vernon.

"*Angry Angel* it is, then," Lt. Goodrich said with the authority of an aircraft commander. "Get that sketchbook out, Lieutenant Drake, and see what you can do."

"Yeah, lieutenant," Sgt. Stinson chimed in. "We wanna see a luscious dame on the side of ol' 246 … so luscious it'll make the other guys sweat."

"Not so fast," Vernon objected. "We need to pass this by Skipper's boys. I'll talk with them in the morning."

That night, Vernon lay on his cot and began sketching ideas for *Angry Angel*. He figured an enticing figure might help sell the name to the ground crew. A 1944 Vargas Girls Calendar hung on the wall opposite his cot. He had used it and other pinup girls for models as he practiced drawing the female form. As much as he enjoyed sketching the smooth, powerful, muscles of a stallion, or the unique features of Indian workers cutting the grass by hand with machetes, he had discovered the curves of a woman brought a feeling no horse or landscape ever could. In an environment that appreciated his art, away from the eyes of the Nazarene church, he felt free to indulge himself.

After all, he reasoned, *look at the art of the great painters of history. The human body is the main focal point of their work. If I want to be a serious artist, I need to be able to draw the human form.* It felt like a reasonable argument.

Miss March, a shapely, long-legged, brunette danced seductively, one leg outstretched, the other bent, with a delicate hand poised above her flowing hair and the other sweeping out in front. Her head, turned to face the artist, bore an innocent smile, seemingly unaware of the dainty, almost invisible frock clinging to her body. A poem went barely noticed in the corner of the calendar picture.

> *March is very breezy*
> *The winds all howl and swirl*
> *But though March is very breezy*
> *It has nothing on this girl!*

Vernon imitated the lines of Miss March on his sketchpad. He followed her curves, careful not to miss the subtle nuances of each limb. He couldn't help imagining the form without the thinly veiled grass skirt she wore. He drew the form naked, intending to clothe it later. His imagination took his thoughts to Bettie and the short, exciting times they spent together learning the intimate experiences of married life.

Miss March slowly became the *Angry Angel*. He added a tight fitting, flowing gown with a skirt that trailed out like Superman's cape. Wings identified her as an angel. She held a shield in her left hand and wielded a sword in the right.

Vernon found her face to be the most difficult to draw. He wanted both beauty and anger. He would draw and erase, draw and erase. Finally, he left his last attempt and put down the pad. It would have to do.

That night, as he slept, the *Angry Angel* haunted his dreams. Her face remained shrouded in haze. Each time he thought he recognized the image he had tried to replicate, it faded away. The next morning, after getting ready for the day, he picked up his tablet once again and studied the face. As the eyes peered back at him, he suddenly realized he had been trying to draw Bettie. That, he could never replicate, and certainly not on an angry pinup girl. Bettie was his personal pinup girl, not to be shared on a bomber or with anyone else. The face on *Angry Angel* would stay the way he had drawn it the night before. He

added the name *Angry Angel* in bold letters, called it good and headed for the mess hall.

Chappy gave a loud wolf-whistle as Vernon previewed his sketch at breakfast. "Now that's what I call a dame!"

"I knew you could come up with a bombshell, Drake," Goodrich said as he ogled the drawing. "Sure gonna' look sweet on the side of ol' 246."

Vernon flipped the cover closed on his sketchpad. "Still got to get it past the ground crew."

"They'll go for it. In fact, I predict they'll flip their lids when they see it."

After morning chow, Lt. Drake hopped a jeep ride out to the revetment where Skipper and his crew were servicing the airplane.

"I've got something to show you, Skipper," Vernon said as he ducked under the wing to join Skipper who pumped grease into a gear joint.

"What ya got, lieutenant? A drawing of *Dangerous Drake*?"

"Well, not exactly. The flight crew liked your idea, but think they came up with an even better one."

"Oh, yeah? Okay—let's see it."

Vernon held out his sketchpad and flipped it open to reveal *Angry Angel*.

The original sketch Lt. Drake did for the nose art on the B-24 named *Angry Angel*. This sketch is now in the collection of the National Museum of WWII Aviation in Colorado Springs.

"Whew ... that's some dish, lieutenant." Skipper reached up, spun his cap around backwards and leaned in to get a better look. "Kinda puts *Dangerous Drake* out of the race, doesn't it. She sure doesn't look like no mallard I've ever seen."

"The guys liked your name until Sergeant Mandula came up with this. He figured we have an angel watching over us. It's not decided though. We want your guys to take a look."

Skipper stepped out from under the wing and yelled, "Hey, boys, come on over here. The lieutenant has somethin' to show you."

The ground crew, in the uniform of the day, shorts and shirtless, gathered around Lt. Drake. He explained the situation to disappointed faces. When he opened his sketchpad, those expressions changed. Cat whistles of appreciation erupted.

"So what do you boys think? Do we call 'er *Angry Angel*?" Skipper asked.

No one hesitated. Ol' 246 officially became *Angry Angel*. Now came the task of reproducing that pencil sketch to a bigger than life painting on the slab side of an aluminum B-24.

Lt. Vernon Drake in the Rocker Club at the Air Base in Tezpur where inspirational pinup pictures lined the walls.

Birth of a Nose Artist

Already 85 degrees and 95 percent relative humidity, Vernon wiped the sweat trickling down his forehead as he stood looking up at the massive forward fuselage of the B-24 in the morning light. With sketchpad in hand, he pondered the challenge of getting his drawing transferred to that huge empty space.

This is going to require scaffolding. That we have but what to use to outline the figure?

Sketching on a pad could be done with a pencil or charcoal. Aluminum presented a new challenge.

"Hey, lieutenant," Skipper's voice from behind startled him. "Would this be of any help?"

He handed Vernon the remaining three inches of a grease pencil. "We use it to mark stuff. Thought you might find a use for it, too."

"Eureka," Vernon exclaimed. "What are you Skipper, a mind reader? This is perfect."

"Just don't use it when the metal is really hot or you'll end up with a mess."

"Got it." Vernon twirled the pencil around with his fingers. "What do we have for paint?"

"The boys dug up some enamel. We have red, black, and white. Got some zinc chromate, too."

"That's it?"

"For now. We can keep scrounging."

"That's a start—how about thinner. Got any of that?"

"We found some linseed oil. Will that work? Of course, good ol' 100 octane aviation fuel will thin anything."

"Guess it will have to do."

Skipper helped Vernon put up a scaffolding next to the right side of the B-24, under the copilot's window. As he touched the tip of the grease pencil to the metal, it melted like butter. Surprisingly, it made the pencil flow more like a pen. He had to be careful and press very lightly; otherwise, the tip would flatten like a mushroom. He found he could easily erase the mark with a rub of a rag if he made an error.

"Hey, this is going to work great," he called down to Skipper.

Vernon began to draw the outline of *Angry Angel's* head. It didn't take long to realize that making such a large drawing up close would require numerous trips down the scaffolding to get a better perspective. As the morning progressed and the sun beat down ever higher in the sky, he stripped down to shorts, boots, and a cap. Up and down the scaffolding he went with every few strokes. A realist and a perfectionist, he determined to avoid any distortions in *Angry Angel's* physique. By mid-morning, he had her outline drawn to his satisfaction.

"I don't know how you boys can work out in this heat all day, sergeant. I'm dying, here."

"I imagine it's a sight better than freezing your ass off at 20,000 feet, sir."

"You got a point there, Skipper."

"Besides, we do most of our work at night when it's cooler."

Vernon climbed down and examined the few paint cans sitting in the shade under the wing.

"Paintbrushes—I'm gonna need a couple of brushes and some rags. I have a small oil-painting kit with a few small brushes my wife sent me but we're gonna need two or three inchers."

"I'll check with the motor pool and base maintenance to see what they have."

When Vernon returned after lunch, Skipper had the brushes he needed.

"Thanks, Skipper. Not the finest bristles, but they'll do."

He popped the top off the half-full quart can of black enamel and mixed it thoroughly with a stick, adding some linseed oil to make it

flow. He figured he would start by painting in the outline he drew with the grease pencil. Using his artist brush, he dipped into the paint can and then began his first brush stroke. The hot skin of the bomber vaporized the thinner so fast that the paint practically dried before it left the end of his brush. After several unsuccessful attempts, he stepped back in frustration.

"Well, this isn't gonna work," he muttered to himself.

He climbed down the scaffold and proceeded to clean his brush when Skipper walked over.

Lifting his hat to wipe his brow on his dark-tan arm, Skipper asked, "How's it goin', lieutenant?"

"Not so good. It's like painting with glue. Looks like I'll be back early in the morning before things heat up too much. With luck, we won't have a mission to fly before we get her painted."

The next morning, Lt. Drake arrived at the plane just as the sky began to lighten. Night had cooled into the high 70s and, without the sun blaring down he figured the paint would flow much better. After mixing the black paint, he climbed the scaffold for another try. This time, the paint smoothly left the tip of his brush as he followed his outline. By the time he had the basic outline finished, Skipper and his crew were ready to get some breakfast.

"Lookin' good, lieutenant," Skipper said as he and his boys gathered around.

A wolf whistle came from one of the crew. "She's gonna be a doll."

The time came to turn the outline into a true painting, skin color being the first challenge. Vernon squatted down next to the paint cans, pushed his cap to the back of his head, and scratched his brow.

"Red, black, white, and green. How do I get a tan skin out of that?"

He picked up a scrap piece of aluminum sheet he used as a pallet and began dropping dabs of paint from each can onto it. With his artist brush, he took small samples from the dabs and swirled them together, searching for a combination that might resemble skin tone. Green zinc chromate and red mixed together became a muddy brown. Adding white gave him various shades of brown.

What do you know—flesh tones.

Armed with a scrap chunk of aluminum, scrounged cans of enamel, and a few brushes of various sizes, Vernon went to work. Right away it became obvious that painting with enamel presented far different challenges than the oils and canvas he had used before. Much more liquid, the enamel paint tended to run, and then dry almost immediately in the heat. Blending and shading on the surface of the bomber proved difficult, if not impossible. A stroke of the brush had one chance of getting it right.

"Hey, Drake. Can we give you a hand?" Chappy and Froula stood at the bottom of the scaffold.

Downtime between missions usually meant card games at the Officers' Club, sack time, or just hanging around shooting the bull. The nose-art project offered a diversion.

"Yeah, grab a brush. Think you can paint inside the lines?"

"You got it."

"I'll mix the paint and you guys can fill in the basic colors."

By 0900 hours, they had the form painted in, ready for Vernon's artistic touch. Up to that point the side of the aircraft had been in the shade, but the sun now crept over the cockpit and onto their side, making work impossible.

"Looks like that's it for today," Vernon said as the sun turned the aircraft into a frying pan. "We'll get an early start in the morning."

Again, *Angry Angel's* face would be the last to get paint. Not the beautiful artwork on the Vargas Calendar, their effort wasn't bad for a bomber in the wilderness of India.

Lt. Drake and his crew spent the rest of the day lounging around the Officers' Club. Vernon reread letters from Bettie and his folks for the umpteenth time. Mail from home came in sporadically, depending on Uncle Sam's urgency. It usually took many weeks for mail to make it halfway around the world. As much as he loved reading them, it bothered him that the events they wrote about happened months before.

Letters first went to an APO (Army Post Office) box at a base in the United States. There, they got sorted, bundled, and sent through a chain of APOs around the world, usually by ship. In fact, the bags of mail had become an increasingly large problem for the army because they took

up valuable space that could be used for military supplies. The army came up with a solution ... V-mail. They photographed each letter onto microfilm and sent the film instead of the original letter. When the microfilm reached its destination, the letter was enlarged, printed, and delivered to its recipient. Rolls of microfilm took up far less space than sacks of paper.

When Vernon first arrived at Pandaveswar he had been appointed assistant postal officer responsible for censoring the enlisted men's outgoing mail. A tedious, unrewarding chore, it revealed those who were intelligent, those who were faithful to their loves back home, and those who were not. Some tried to expose where they were stationed as well as classified mission information. Twice the postal office brought warnings against his own crew for frequently including censored information. Thankfully, he had been relieved of that duty once he began flying missions.

Vernon opened his sketchbook where he kept several blank, single-sheet V-mail forms supplied by the army. With only one page available, he chose his words carefully. Particularly since the army censors would be reading it.

My Dearest Bettie ...

"Too mushy."

Dear Bettie,

Every day seems to be hotter than the last and the nights even hotter. Sure isn't like the cool nights on the farm. I've been thinking about you a lot these days ...

Vernon's mind drifted off to the days he spent with Bettie, driving the back roads to find nice quiet spots to be alone.

Chappy interrupted his daydream. "Hey, Drake, come on. Let's hit some balls."

He and some of the guys were stepping off the porch with the baseball and bat.

"Yeah, okay."

He would finish the letter later.

That night, he found himself dreaming, not of Bettie but *Angry Angel*. That elusive face haunted him. A figment of his imagination, yet she tugged at his heart. She came alive in his dreams and called to him. He wondered how he could be falling for a painting—one that he created.

When morning arrived, he hurried through breakfast to get out to the plane and go to work.

"What's the rush," Froula asked as he downed a glass of lukewarm KLIM.

"I wanna beat the heat and get 'er finished before we lose the shade."

"All right, all right. We're coming." Chappy grabbed a piece of SPAM on toast and followed Vernon and Froula out the door of the mess hall.

At the airplane, Vernon felt inspired. He worked on finishing *Angry Angel's* face while Froula finished filling in her dress. Chappy painted in the letter outlines with black. By mid-morning, a finished *Angry Angel* graced the side of ol' 246. The boys moved back the scaffold and admired their handiwork.

"Pretty damn good if I say so myself," Chappy said satisfied as he wiped paint from his hands with a rag soaked in aviation fuel. "Yep, pretty damn good."

Vernon stared at *Angry Angel's* face. He had been working on it up close. Now that he had a different perspective, she had a look of intensity that took his breath away. He couldn't explain it, but he felt she was more than a painting. She was alive.

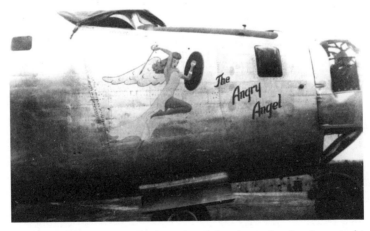

Named by a vote of his crew, Lt. Drake painted the *Angry Angel* early on in his time in Pandaveswar and flew the plane regularly.

AZON

"Hey, Lieutenant Drake, we sure would like some help with nose art on *our* airplane. Do you think you could?" The crew chief from the next revetment cornered Vernon as he lowered himself out of the bomb bay door.

"Yeah, well … I suppose I could. What 'cha got in mind?"

"We want to name her after our commander, Lieutenant Dance. We're calling her *Dangerous Dance*. We figure a dancing dame on the nose would do the trick."

"*Dangerous Dance*, huh?" Now, that was ironic. He wondered if the *Dangerous Drake* idea had somehow leaked over into their revetment. In any event, Vernon had just got his first commission as a nose artist.

It didn't take long for other crews to catch on. There were several would-be artists on the base as well. Nose art began appearing on more airplanes—some good and some displayed a total lack of talent.

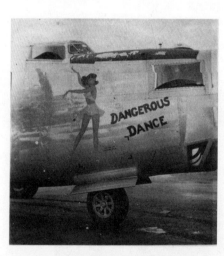

The painting of *Dangerous Dance* on the nose of a B-24 was the first commissioned painting Lt. Drake did after he was recognized as a local artist at Pandaveswar.

Requests for Vernon's artistic skill arrived almost daily. He had become somewhat of an overnight celebrity. Between sketching, planning, and painting, his downtime schedule began to load up. Early mornings were spent painting when he wasn't flying, so long as the subject airplane wasn't on a mission. The next request came from a crew who named their ship *Blind Date*. Vernon painted *Blind Date* as a black-haired beauty with her bare back and bottom towards the viewer as she smoothed her hair in a handheld mirror.

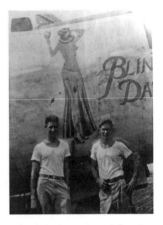

Blind Date painted by Lt. Vernon Drake on a B-24 in Pandaveswar, India, in the 493rd Bomb Squadron, 7th Bomb Group, 10th Air Force.

"I think we're headed for Mandalay in the morning," Vernon said over his plate of creatively fried C-rations. "My guess is a large formation."

"I hope it's high-level. Sure like to stay above the flak," Chappy quipped.

The morning briefing confirmed Vernon's guess. There would be a dozen planes from Pandaveswar joining up with a box of 12 from the 492nd. *Angry Angel* would be in the lead element of three aircraft flying left wing.

"We're playing follow-the-leader this morning, boys," Lt. Goodrich told the crew as they headed for the revetment. "Going in at eight thousand, so you won't need to suit up.

"Eight thousand?" Lt. Froula asked rhetorically. "I'll be sure to keep my flak helmet, vest, and parachute nice and handy."

As Vernon performed his preflight duty of a walk-around inspection, Skipper came up to him.

"Bring 'er back in one piece, lieutenant. You don't wanna mess up that beautiful dame on the nose. I'm gettin' kinda fond of her."

"Me too, sergeant." Vernon gave an affectionate glance toward the painting on the nose where he had spent so much time dreaming, planning, and painting.

Once in the air, *Angry Angel* circled and joined the flight. She pulled into loose formation and settled down for the long ride over

Vernon's sketch of a dancing girl as a possible candidate for nose art on the B-24 *Dangerous Dance*.

Another possible candidate for the nose of the B-24 *Dangerous Dance*.

the Bay of Bengal. The boring hours passed slowly over the endless blue water.

"One hour to target," came the announcement over the headphones from the flight leader, 1st Lieutenant Morrison. "Maintain radio silence from here on in."

As the flight approached the target, the airplanes moved into a tighter formation. Black puffs formed by flak, spotted the horizon over Mandalay as Japanese antiaircraft gunners adjusted their fuses to go off at the altitude of the approaching bombers. The explosions sent shrapnel in all directions, hoping to strike a mortal blow to the oncoming armada.

Lt. Goodrich pulled *Angry Angel* up tight inside *Dangerous Dance's* left wing. He liked to fly close formation—the closer the better. The crew had received a couple of reprimands in flight training for pushing the envelope and flying too close. Goodrich would laugh it off. Those other pilots just didn't appreciate good flying.

Vernon nervously watched the leader as Goodrich tucked *Angry Angel* in even closer. The flight approached Mandalay from the southeast with a planned left turn for a run over the target.

"*Angry Angel*, move it out. You're too close." Upset he had to break radio silence, the flight leader's agitated voice crackled through the headset.

"Roger, moving out," Goodrich answered.

He let *Angry Angel* slide out a short distance but still remained in close.

Turning to Lt. Drake, he yelled over the engine noise, "That guy doesn't know good formation flying."

As they passed the left turn point, the flight leader commenced a right hand turn instead of the anticipated left turn.

"Where's he going? We're supposed to turn left. He's leading us right into more flak."

Vernon didn't say anything, but he had been uncomfortable with the very close formation.

Lt. Goodrich shook his head. "I'll bet he's too damn chicken to turn the formation into a tight wing man."

Angry Angel shook as flak burst all around while the formation made a 270-degree right turn to get back to the target. Bam ... a ragged eight-inch hole ripped open in the right wing three feet from Vernon's seat as shrapnel blasted through its structure.

Once over the target, "Bombs away," came the command from the lead.

Lt. Froula hit the pickle-switch releasing their load of 1,000 pounders to rain down on the Japanese railway yards below. The aircraft lurched upward, free from the tons of weight it had been carrying. Turbulence caused by bomb drops of the previous box formation rocked *Angry Angel's* wings. Vernon watched the mushrooms of dirt, boiling flame, and smoke rising in trail as they passed over the city. Another screen of flak lay ahead as they followed a flight of four planes into the exploding black clouds.

"Looks like one of 'A' flight got hit," Vernon said as he watched a B-24 roll out of formation, trailing smoke.

"She's got two engines on fire." Goodrich leaned forward as though he could get a closer look.

"Come on, boys," Vernon yelled. "Time to get out of there."

The crippled aircraft sank toward the earth. Vernon watched earnestly, hoping to see the small dark silhouettes of men jumping from the plane.

"There's one … two … three … come on, come on … four."

White canopies began to blossom as the B-24 went into a spiral. The doomed aircraft disappeared behind Vernon's wing.

"How many got out?" Goodrich asked.

"I don't know. I couldn't see. At least four, maybe more."

Wham … *Angry Angel* bucked as a shell exploded just below its nose at the one o'clock position.

"Kardell's been hit," Froula yelled over the interphone.

Shrapnel had punched a huge hole in the armor plate of the nose turret and sprayed Sgt. Kardell with Plexiglas fragments leaving his face bloodied. From Lt. Froula's vantage point at his bombardier station behind the nose turret, all he could see was the bloody face of his friend and figured he was a goner.

"I'm okay. I'm okay," Kardell's voice came back over the interphone.

"Check him out, Froula," Vernon commanded.

The Plexiglas made superficial lacerations on Kardell's face that Froula quickly taped up with gauze.

The two pilots sat in silence as *Angry Angel* droned on leaving the flak and some of their comrades behind. Goodrich slid the big machine a little further out from the lead.

The rest of the flight passed routinely. The formation broke up once safely out over the Bay of Bengal with each aircraft making its own way home.

Once on the ground with *Angry Angel* safely back in her nest, the flight crew went to the Ready Room for the debriefing and shot of mission whiskey. Their reception was not friendly.

"What the hell did you think you were doing up there?" Lt. Morrison, the element leader, leered at Goodrich. "I couldn't bank left. You could have got us killed. You forced me to make a two-seventy right turn that kept us over the flak for five extra minutes."

"Hey," Lt. Goodrich's jaw tightened, "I can't help it if you can't fly a tight formation."

"Tight formation?" Lt. Morrison dropped his flight jacket on a chair and stepped-up nose to nose with Goodrich. "I'll show you tight formation."

Just then Col. Dodson stepped through the door as the orderly called, "Attention!" Dodson immediately spotted the tension between the two airmen.

"What's the beef, lieutenants?"

Morrison spoke up. "Well, sir, Lieutenant Goodrich here, crowded so close that I couldn't make the left turn to target as planned so the whole box formation had to make a 270-degree right turn. That put us in jeopardy for almost five extra minutes."

"Is that true, Lt. Goodrich?"

Goodrich spoke confidently. "I was flying regulation tight-formation, sir."

"But I was the lead and told you to move out," Morrison objected.

"And I did move out, lieutenant."

"A foot or two isn't moving out."

Col. Dodson held up his hand to silence them. "Lieutenant Drake, you were copilot. What did you observe?"

Vernon took a quick glance at Goodrich before he answered. "Well, sir, we like to fly tight. We were taught that a close formation was more accurate in concentrating our bombs on the target."

Col. Dodson studied the faces of the men and decided that having not been there, he couldn't determine who was in the wrong. He did, however, know that Goodrich had a reputation of taking things to the edge and had better piloting skills than Lt. Morrison.

"Well, gentlemen, since I wasn't there it's up to you two to make sure it doesn't happen again. I suggest that you decide what 'move out' means and then stick to it."

"Yes, sir," the two lieutenants said in unison.

"You were lucky today. We didn't lose anyone from the 493rd. The 492nd didn't do so well. They did lose one ship."

"Yes, sir," Vernon replied. "We saw her go down. Some of the guys got out. Maybe all of them. I saw four chutes before I lost sight of them."

After the briefing, Col. Dodson asked Goodrich and Vernon to stay behind.

"I don't know what really happened today, but you won't be doing much more formation flying. I'm putting you on AZON bombing."

Lt. Goodrich lit up. "AZON missions, sir?"

The AZON bomb had recently been developed as a solution to the difficult problem of destroying the narrow wooden bridges that supported much of the Burma Railway used by the Japanese. Traditional bombs would glance off the rails or rail beds and explode harmlessly to the side. A spike bombing technique was tried. It consisted of a 15-foot-long spike at the nose of a 100-pound M-60 bomb that was intended to stick in the ground and prevent the bomb from skipping. The new AZON bombs could be radio-controlled to the target by the bombardier. The motorized fins only allowed the bomb to be steered left and right. Lack of pitch control up and down meant that it still had to be accurately released, thus the name AZON for Azimuth Only. The combination of the spike and the steering would make them much more effective. The bombs were dropped from 5,000 feet or lower, which left the bomber susceptible to ground fire making the missions even more dangerous.

These were generally solo missions, seeking and destroying the rapidly erected bridges that were often in canyons and steep valleys. It wasn't dive-bombing, but the thought of the kind of flying he would be doing excited Goodrich. If this were punishment for flying too close in formation, he could take it all day long.

For the next couple of weeks, *Angry Angel's* crew trained on the AZON bomb with several other crews. Lt. Froula got experience with his new toy, a joystick next to the bomb site that he used to guide bombs down by following the smoke trail they left. In the past, he would flip the pickle-switch to release the bombs, the airplane would go into a departing turn, and he seldom got to see the bombs impact their target. Now, Lt. Goodrich had to fly a straight line over the target so Froula could track the bomb all the way down. Of course, that made *Angry Angel* a more predictable target for the enemy on the ground.

Once trained, Vernon's crew drew missions into Burma to bust bridges. The flights were long and grueling but encountered very little flak and

no fighters. Many of the bridges were struck repeatedly after being repaired by the Japanese. Weather and mechanical problems were more challenging. Of course, Navigator Lt. Chapman's workload increased because he was solely responsible for getting to and from the targets. Finding a narrow wooden railroad trestle or bridge in the broad expanse of hills and jungles of Burma wasn't always easy.

Lt. Drake's sketch for a proposed sign over the door of the crew's basha at Pandaveswar.

Wandering Wanda

Requests rolled in for the newly discovered nose-art painter. Chappy walked into the chow hall trailing Lieutenant Lindquist and Lieutenant Noltimier while Vernon sat down with his tray of never-changing fried SPAM and powdered potatoes.

"Hey, Lieutenant Drake, these guys are looking for someone to paint a doll on their airplane, too. You up for it?"

Vernon recognized Lindquist and Noltimier as pilots of one of the other nine crews that went through AZON bomb training.

"I might be. What do you have in mind?"

Since Col. Dodson had bumped him from the flight roster a couple of times to paint nose art, Vernon figured this might be an opportunity to avoid another grueling flight into Burma.

"We already named her *Wandering Wanda* and would like a girl to match."

"*Wandering Wanda*, huh. Why *Wandering Wanda*?"

"That information is on a need-to-know basis, lieutenant," Lt. Lindquist answered with a bit of a sheepish grin.

Chappy cupped his hand to the side of his mouth in a fake whisper. "They may have wandered a bit off target on one of their training runs."

Vernon thought for a minute. "Well, that all depends. I'll do it if you can get me enough time off. I don't want to be painting until midnight and up at 0400 hours heading across the pond."

"Right. I think that can be arranged."

"Okay, then. I'll sketch something up and see if you like it."

That evening, Vernon sat on the basha porch with his sketchpad. Slowly an image emerged. With jet-black hair, the blue-eyed beauty with a perfect figure stood slightly pigeon-toed next to a suitcase with her thumb outstretched in a typical hitchhiker's stance. Dressed in a short red dress, tight in all the right places, she wore a sweet, almost innocent look. No man could possibly pass by without stopping to give her a ride wherever she wanted to go. As a finishing touch, Vernon added luggage stickers from his school at Nampa to the suitcase and his signature in the corner. As he sat back and admired his creation, he couldn't help but fall a little in love with her.

Another mission would be flown before Vernon had the chance to show his drawing to Lt. Lindquist's crew but when he did, they approved with a resounding round of wolf whistles.

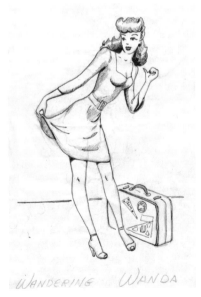

The original sketch by Lt. Drake of *Wandering Wanda* that includes a suitcase with travel stickers for his college, Northwest Nazarene College, in Nampa, Idaho.

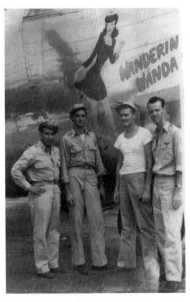

Wandering Wanda was painted by Lt. Vernon Drake on a B-24 in Pandaveswar, India, in the 493rd Bomb Squadron, 7th Bomb Group, 10th Air Force.

Lt. Lindquist managed to acquire Col. Dodson's approval of a day off for Vernon as well. When the aircraft became available, Vernon set to work. He spent the night painting while the maintenance crew prepared the ship for its next mission. That mission turned out to be slated for the morning he finished the last brush stroke. The crew arrived with more wolf whistles.

"Nicely done, Lieutenant Drake," Lt. Lindquist complimented as he slapped Vernon on the back. "She's a knockout. We'll bring her back in one piece. Got a bridge to blow today."

Vernon stood back and took in the finished art. Like the others, she had come alive in the process. He didn't imagine the crew had the same feeling toward her. To them, she became a part of the aircraft. They had a love-hate relationship with the bomber. It could kill them or bring them home safely. More than a painting, Wanda became the personality, the soul of the machine and the crew that flew her.

His cot felt good after a long night of work. Vernon drifted off to sleep easily. The sounds of Pratt & Whitney R-1830s rumbling en masse along with screeching brakes as the bombers paraded to the end of the runway and then roaring overhead had become a soothing sound. The best part … he wasn't in one of them.

As late afternoon arrived, so did *Wandering Wanda*. The bombers trailed in and landed, one after another, and taxied to their revetments. It wasn't long before a jeep pulled up to Vernon's quarters where he sat on the porch writing a letter. Lt. Lindquist jumped out.

"Hey, Lieutenant Drake, we have a slight problem. Hop in and I'll run you out to the airplane."

"Slight problem?"

"Yeah, come on. I'll show you."

As the jeep pulled up to *Wandering Wanda*, Vernon could see streaks of paint down the side of the aircraft. The suitcase beside Wanda, which he painted last, had turned into a smeared blur in its effort to withstand a full day of the 180 mph slipstream.

"Can you fix it? I think we're going out again tomorrow."

Vernon's heart sank. No doubt he would have a mission in the morning as well. If it was to be fixed before the next flight, it meant working in

the heat of the day so the paint would have time to fully dry before the 0600 departure.

"Yeah, I guess I can. But I'll need some help. Can you spare some crew to help clean up the mess?"

"You got it."

With rags, aviation fuel, and some mineral spirits, the crew went to work erasing the wind-blown remnants of Wanda's suitcase. Once done, Vernon redrew the suitcase with his grease pencil and began painting. This time he didn't add the luggage stickers from Northwest Nazarene College. The base suitcase needed to dry before he could paint the stickers over it. There just wasn't enough time and the oppressive heat of the day wore him down.

On April 5, 1945, morning came too soon as the orderly made his rounds shining his flashlight and waking Vernon's crew. At the briefing, they learned that they were assigned another bridge-busting mission. *Angry Angel* would be in a flight of three along with Lt. Lindquist's crew in *Wandering Wanda*, and a B-24 named *Double Trouble*. They would hit the By-Pass Bridge at Kanchanaburi over the Mae Kong River in southern Burma. The wooden structure crossed the river where a more permanent concrete and steel bridge was under construction using the slave labor of prisoners of war. Flying in trail, bombs would be dropped from 6,000 feet. The good news … only light antiaircraft fire was expected. The bad news … *Angry Angel* would be flying tail-end Charlie, meaning the gunners would be well dialed in by the time Vernon's crew reached the bridge.

Vernon glanced over at Lt. Lindquist. "Looks like we will be on your tail. I hope paint doesn't end up on our windshield."

"That's not the only thing I hope isn't all over your windshield," Lt. Lindquist replied.

The ride to the revetment had become routine along with the preflight, taxi, and take off. With Lt. Goodrich at the controls, *Angry Angel* nuzzled off to the side and behind *Wandering Wanda* in loose formation. Once at altitude, the three aircraft crews settled in for the five-hour ride to the target. That meant a long time over enemy territory. Being so far south, the chance of enemy fighters seemed likely but hopefully avoidable. After

crossing the Bay of Bengal, they skirted north of Rangoon and down the coast of the Andaman Sea. Dropping down to 6,000 feet, the flight went into trail formation in a beeline for the target. As predicted, they encountered very little ground fire and dropped their AZON bombs.

"Piece of cake," Lt. Froula called out over the interphone as he watched the bombs from the two aircraft ahead explode on target. Lt. Goodrich put the big Liberator in a steep turn so they could all see the results. A whoop went up over the interphone by the rest of the crew.

"Nice job Froula," Vernon quipped into his microphone.

On the way home, Lt. Drake maneuvered *Angry Angel* up beside *Wandering Wanda*.

"Looks like you still have all your paint and parts, Wanda," he chided over the radio to Lt. Lindquist.

"Good to know," Lt. Lindquist answered while his copilot Lt. Noltimier gave a thumbs up at the window.

An uneventful trip home culminated in Lt. Drake's soft landing and routine taxi back to the revetment. At the debriefing, aerial reconnaissance photos showed that their flight had knocked out 60 feet of bridge on both approach ends, which pleased the 10th Air Force Command and Col. Dodson.*

* Some have claimed this mission is depicted in the book *Bridge over the River Kwai*, although the location of the bridge depicted in the story, as well as the plot, is fictional. (There were no bridges built across the River Kwai during World War II. The Mae Kong River was renamed Khwae Yai in the 1960s as a result of the film. Ref: *The Colonel of Tamarkan: Philip Toosey and the Bridge on the River Kwai* by Julie Summers.)

The Last Liberator

Steamy, thick air enveloped another typical morning at the 10th Air Force Base in Pandaveswar. The kind that causes shirts to soak with sweat just walking from the basha huts to the chow hall. Out on the flight line, an excited crew warmed up the engines of a very special bomber. Four huge propellers swirled hot dust against the earth-banked revetment designed to capture at least some of the turbulence created by the big beast.

On this morning, Lt. Drake's crew had been assigned a significant mission to fly a truly unique airplane. They were an unlikely choice since they had earned an unsavory reputation. The crew getting busted at the Port of Embarkation in Miami, their escapades in Brazil along with their too-close formation flying didn't help either. But today, the gunners, Sgts. Kardell, Mandula, Barry, and bombardier Lt. Froula, wouldn't be needed. This mission wasn't flying into Burma to attack Rangoon or take out bridges behind enemy lines that the 493rd Bomb Squadron was known for. Those 12- to 15-hour missions were brutal. This detail would be a cakewalk.

The airplane, a B-24J Liberator Bomber, differed from its squadron mates. What appeared from a distance to be special camouflage paint was, in fact, the signatures and nicknames of the hundreds of aircraft workers at the Consolidated Aircraft plant in Fort Worth, Texas. They built this last of the 2,745 B-24s assembled there. The bomber had been christened the *Spirit of Fort Worth*. General "Hap" Arnold had issued orders requiring reports of its combat actions to be sent back to Fort

Worth for employee morale purposes. The events would also be useful PR for the general population stateside.

Jeeps soon arrived in the early morning sunlight with their loads of VIP "Brass." The mission—fly the group commander and tactical officers to Calcutta for a high-level conference. A return trip would be made in the evening … an easy assignment. The VIP passengers were soon boarded in the waist compartment, strapped in, and anxious to find cooler air aloft.

The event provided a heady moment for the young 2nd Lt. Goodrich as ship's commander. Advancing the throttles, the large bird lumbered out of the revetment and down the taxiway to the end of the narrow asphalt strip.

To demonstrate his skill, Goodrich announced to Vernon and engineer, Sgt. Stinson, "We're doing an engine check on the roll."

A quick check for incoming aircraft preceded a non-stop turn onto the runway, squealing the tires as the plane swung around. Four muscular engines roared to life sending the lightly loaded bird rumbling down the tarmac, slowly gaining speed until it gracefully lifted into the air for a picture-perfect takeoff.

Goodrich beamed with satisfaction. "And that's how it's done."

Smooth air and good weather cooperated to make the flight uneventful. The huge aircraft sailed gracefully over green landscape as its valuable cargo traded military strategies back in the bay. At the end of the 45-minute flight, Goodrich made an equally satisfying landing at Calcutta. As the bomber taxied onto the ramp, film crews and reporters awaited its arrival.

Following a post-flight checklist, the two pilots shut down the engines while the VIP officers clamored out of the bomb bay doors. Photographers gathered around and clicked away at the "Brass" posing beside the special airplane, making sure the painted signatures all over the aircraft got their proper due. Lt. Drake and the rest of the enthusiastic crew crowded onto the flight deck where they smiled and waved from the windows, hopeful that their wives and sweethearts might get a glimpse of them on *Tinkertown News*. The trip had gone well with each crew member performing their part flawlessly. They felt proud.

With their mission a success, they were assigned to fly the *Spirit of Fort Worth* down to Dudhkundi, an almost vacant ex-B-29 base, for another

load of "Brass" attending the conference. Never shy about demonstrating his prowess at handling an aircraft, Lt. Goodrich quickly forgot the two reprimands he received for reckless formation flying in combat. But that was then … this was Lt. Goodrich's show now.

The sun had grown hot and the flight crew soaked with sweat as they awaited their passengers on the huge concrete apron at Dudhkundi where rows of B-29 bombers formerly sat preparing to attack Japanese targets in the Pacific Rim, even Japan itself. A single officer arrived for boarding. Lt. Goodrich recognized him as the tactical officer who had been training the 493rd crew for low-level bridge bombing using the radio-controlled AZON bombs. That program convinced Lt. Goodrich low-level bombing was his kind of flying.

As the Liberator headed down the runway, the thermometer projecting through the windshield read 135 degrees Fahrenheit. They took off in the opposite direction from the previous landing, but that didn't matter since the windsock hung lifeless on its pole. More than double the length of runway the crew was accustomed to, takeoff presented little challenge. Maybe it was the oppressive heat, or the hurry to get in the air, or the desire to impress the passenger … whatever, the enthusiastic commander pulled back on the control wheel as soon as he felt the ship getting light. Instead of the normal "Gear up" signal to Vernon, Lt. Goodrich reached over and pulled up the gear handle himself and immediately braked to stop wheel rotation before they fully retracted.

Vernon had a sickening sense as he felt the plane, not quite ready to fly, settle back toward the pavement. He threw the gear handle down—but too late. The gear lock had released and the big wheels were heading for the wells. Screeching rubber and bending metal drowned out the roar of the engines as the ship returned to earth. The nose wheel buckled and the tires on the main gear exploded as the proud bird skidded down the pavement. Powdered concrete dust and smoke poured into the cockpit obscuring all vision as the aircraft hulk careened out of control down the runway.

Blinded by the debris, Vernon's emergency procedure training took over. He rapidly searched for switches, flipping them off as he went. Once through, he reached out to recheck what he had done and felt Lt. Goodrich's hand turning switches back on. He, too, had performed the checklist blindly not knowing Vernon had already accomplished the

task. After what seemed like several minutes, the terrific grinding and screeching subsided as the big plane jolted to a stop. A quiet calm came over the cockpit. The crew sat in disbelief for a brief moment, letting the event sink in before springing into action.

Chappy, Pvt. Coogan, and Sgt. Stinson exited by the top hatch, slid off the wing, and sprinted for the edge of the runway. Lt. Goodrich went out the left side window and dropped 10 feet to the ground. Clouded by the subsiding dust, Vernon could see through his window the propeller on number three engine still spinning. He decided to follow Goodrich out the left-side window as the best alternative. Hitting the ground hard, Vernon jumped up and ran for safety.

The two pilots lay out of breath in the dirt beside the runway with faces and clothes so caked with dust, only their eyes were visible. Getting to their feet, they scrambled to join their crew at the side of the runway where they looked back at the pride of the Consolidated Aircraft workers, lying helpless on its belly, propellers curled back, engulfed in dust and smoke.

"What the hell happened?" Goodrich muttered. He knew what he had done.

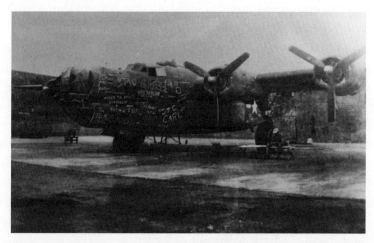

This is the ill-fated last B-24 off the Fort Worth Plant assembly line. It was to be used for public relations by order of General "Hap" Arnold. Lt. Drake's crew crashed this aircraft on takeoff resulting in their being grounded and eventually transferred to Tezpur, India, to haul gas over the Himalayan Mountains.

Gathering his wits, he took a quick assessment of his crew. All personnel were safe and accounted for.

"Where's our passenger?" Goodrich yelled out as he searched the surrounding area.

As the great cloud of dust settled, the tactical commander appeared in the waist window and called out, "Did anyone disconnect the batteries?"

Sgt. Stinson looked at Lt. Goodrich. "I'm not going back in there."

Lt. Drake stood up and wiped the dust from his face. "I got it."

He climbed back into the crippled hulk, hoping there wouldn't be a fire, found the battery packs, and disconnected them. By the time the fire apparatus arrived, he had the job done.

The crew members, after being flown to a hospital for physical checkout, were returned to base the same day. Word had reached the base before them and friends who had assumed the worst when they heard that the *Spirit of Fort Worth* had crashed, greeted them. The embarrassed crew drank more than the usual number of beers and took a lot of ribbing.

The next morning, Lt. Drake and Lt. Goodrich were called into the squadron commander's office.

"What the hell were you thinking, lieutenants?"

Vernon had seen Col. Dodson angry before but this event had struck a new chord. His eyes burned with anger.

"If you were trying to impress Command, you certainly succeeded. They were impressed all right. Impressed enough to ground you pending a full investigation of the incident." Col. Dodson brought his fist down hard on his desk. "You have marred our whole squadron. I had to answer to General Arnold himself because of you two."

Even though Lt. Goodrich had pulled up the gear, he and Vernon were a team. Vernon stood at rigid attention with his left seat pilot and shared the responsibility.

"We don't need a couple of hotshot pilots in this command. We need levelheaded, reliable aviators. You two would be washing dishes in the cook shack from now on if I had my way."

"Yes, sir." There wasn't anything left to say.

"I'm disgusted with you. You're confined to quarters for now. Dismissed."

Grounded

The incident did not impress Command, which directed Col. Dodson to ground the crew pending an official investigation. Vernon didn't see that as necessarily a bad thing. Being grounded meant less time over enemy territory and more time to work on nose art for other crews.

"What are you gonna tell the review board?" Chappy asked Vernon as they sat in the shade of the basha porch. "You know it wasn't your fault Goodrich pulled up the gear too soon. Goodrich was aircraft commander so even if he had called for gear up and you flip the switch, it is still on him."

"I'll go along with whatever Goodrich says but I believe he will come clean and admit that he screwed up."

"What do you think the board will do?"

"Who knows? Guess we'll find out."

Vernon tried to sound nonchalant about the whole thing, but his stomach rolled as he thought about all the possible implications. The last thing he wanted to do was write home that he had been grounded, busted, or worse.

In the meantime, a couple of nose-art projects kept him from spending too much time worrying about the inquiry. The crew of an all-black radar-equipped B-24 named their ship *Black Magic*. Vernon painted a Vargas pinup for them, a blonde in a swimsuit. On another, he painted one named *Bar Made*, not "Maid," with the obvious altered meaning. He

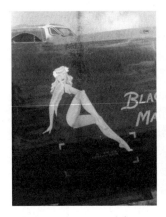 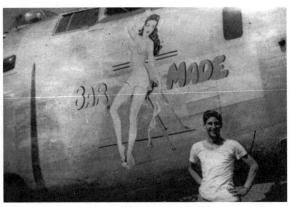

Black Magic painted by Lt. Vernon Drake on a B-24 in Pandaveswar, India, in the 493rd Bomb Squadron, 7th Bomb Group, 10th Air Force.

Bar Made painted by Lt. Vernon Drake on a B-24 in Pandaveswar, India, in the 493rd Bomb Squadron, 7th Bomb Group, 10th Air Force.

used his imagination to create his own version of a Vargas pinup. The crew wanted a girl more risqué than he had previously painted. With their prompting, he came up with a topless gal sitting on a bar stool, dangling her bikini bra. He felt a pang of exciting guilt in painting these girls. What would the folks back home think … all his church friends, and particularly, Bettie? Of course, they were half a world away and would never know. At the same time, his art brought smiles to men that faced death almost every day. His growing collection of nose art had become known on the base at Pandaveswar as the Panda Girls. What could be wrong with that?

Again, he could only work in the mornings and evenings when temperatures weren't sweltering in the blaring sun. During the day he would sketch ideas for other nose-art paintings or draw the Indians at work. Much of building and maintaining the base had to be done by hand labor. With Pandaveswar being at the far end of the line, supplies and equipment were hard to come by. Dozens of workers pulled huge rollers to pack the earth hard enough to handle the weight of the bombers. Workers squatted in their baggy white diapers and turbans, cutting grass with machetes, or pulling weeds. Plenty of subjects were available to fill Vernon's sketchbook.

The Board of Inquiry met a week later and spent only 20 minutes interviewing the crew. Lt. Goodrich accepted the blame, but the board made it clear that responsibility lay with the entire flight crew. They were dismissed while the board deliberated its decision. After minutes that seemed like hours, Lt. Drake and Lt. Goodrich were called into Col. Dodson's office. Vernon felt his knees go slightly weak as he marched smartly into the room. Col. Dodson rose from his desk and looked sternly at the two young pilots.

"I don't have to tell you how disappointed I am in you two. At least you had the decency to admit your mistake although it cost the army a perfectly good airplane and put a black mark on the 493rd. I don't know why but Command is going to let you fly again."

Vernon felt a sigh of relief rise in his chest.

"But," Col. Dodson continued, "you are being transferred out of my squadron to the 9th Bomb Squadron, which is being moved to Tezpur in the Assam Valley. Your ship will be converted to a tanker and you will be flying gas hauls over the Himalayan Mountains to northern China bases."

Lt. Goodrich stiffened. "Yes, sir. Thank you, sir."

"Pick up your transfer papers on the way out. Dismissed."

The two got their orders from the clerk and called the crew together in the dayroom. Everyone anxiously waited to hear of their fate.

Sgt. Stinson spoke up. "Come on, lieutenant, give us the scoop. What's going to happen to us?"

Goodrich, with a foot on a chair, leaned on his knee. "Well, boys, we stay together and get to fly again."

"All right!" Lt. Froula cheered.

"That's the good news. The bad news is that we are being transferred to the 9th Bomb Squadron."

Froula looked puzzled. "Didn't the 9th just leave for Tezpur?"

"Yep, they're in Tezpur alright. That's where we're going. We're going to haul gas over the Himalayas into China."

The crew looked at each other in disbelief.

Pvt. Coogan spoke up. "We're gonna fly tankers?"

"Not just any tanker, Coogan. We're gonna outfit *Angry Angel* with gas tanks in the bomb bays."

"We'll be a flying gas tank! One spark and we'll be goners."

Chappy had been sitting quietly and finally jumped in. "Say goodbye to the Panda good life. I hear Tezpur is a dump."

"But, we will stay together and we will be flying," Lt. Drake added.

"Well," Lt. Goodrich shifted nervously, "not everybody. We'll be flying unarmed. That means no bombardier or gunners. Sorry, Froula, that means you, too. You and the boys will be assigned to other crews here at the 493rd." Goodrich stood up and lifted a folder he had on the table. "Drake, Chappy, Stinson, and Coogan, I have our transfer orders here. The rest of you report to the orderly for your assignments."

"When do we leave?" Stinson asked.

"We pack up today and fly over tomorrow morning. It's 400 miles. Skipper is coming with us and we'll get a new ground crew in Tezpur."

"That's the pits." Froula shook his head. "We're gonna miss you guys."

Vernon slapped him on the back. "We're gonna miss you, too. I wish the very best for you boys. It's been great to serve with you."

Emotions ran high in the room. The crew had been together since Pueblo, Colorado. They had trained together, played together, and faced death together. They had become more than a crew; they had become family.

That afternoon, Lt. Froula sat on his cot as he watched Vernon, Goodrich, and Chappy pack their things into their B-4 garment bags. Vernon carefully wrapped the jewelry box he had bought for Bettie in a shirt and stuffed it into the center of his bag. The reality of the split slowly sank in as things that had made the basha home for the last six months disappeared into luggage.

The next morning, the whole crew assembled at the revetment.

"Well, boys," Lt. Goodrich said sadly, "here's where we part company. You've been a great crew. All I can say is that I wish you good luck and hope you get assigned to the best of the best."

Vernon added, "If God is willing, we'll meet up after this damn war is over and have one final mission whiskey."

The flight crew stowed their gear and climbed onto the flight deck.

"You take care of our *Angry Angel*," Froula called out as Vernon waved from his window, "and she'll take care of you."

"Bust a few Jap bridges for her," Vernon called back.

"Switches off?" Sgt. Stinson yelled from his position on the ground.

"Switches off," Vernon called back.

The ground crew pulled the propeller blades of each engine through several rotations to make sure the cylinders were clear before starting. Sgt. Stinson stood ready with a portable fire extinguisher just in case of a fire from a flooded engine.

"All clear?" Lt. Drake called out.

"All clear," Stinson answered.

Vernon primed the No. 3 engine, pressed the meshing switch, and began cranking the engine with the starter. With a few pops and puffs of smoke, the engine came alive. After it reached a steady idle, he started engines 4, 2, and 1, in that order. That allowed Stinson to walk from one engine to the next with his extinguisher while avoiding spinning props.

As the idling engines rocked the ship, the realization came over him that this chapter of his life had ended. How strange it seemed that this airbase that created such fear and anxiety in him for months now felt like leaving home. It had become familiar, a safe haven after long, suspenseful bombing missions. He had made and lost friends here. He had established an identity. No longer a bomber pilot, he would be a tanker pilot in an unknown world.

The big bird taxied out to the run-up area and stopped where the usual preflight checks were made. Lt. Goodrich guided the lightly loaded aircraft onto the runway, this time without the checks-on-the-roll or the squealing tires. He held the nose down on the takeoff run, making sure the plane had plenty of speed before liftoff.

Vernon paused to watch Pandaveswar shrink below his wing before they banked north. Next stop, Tezpur, the Assam Valley, the Himalayas, China, and whatever future they might hold.

The Himalayas

Tezpur

Approaching Tezpur from the south, Pvt. Coogan dialed in the traffic controller. The radio waves buzzed with activity. After a few minutes, Lt. Drake found a lull in the communications.

"Tezpur tower, heavy two-forty-six, 10 miles southeast at 5,000, inbound for landing."

"Heavy two-four-six, winds two-five-zero at 12. Plan runway zero five. Hold five miles south on one-niner-zero at 2,000."

"Roger, hold on one-niner-zero."

"You got that?" Vernon asked Goodrich.

"Got it," came the reply.

Lt. Goodrich put *Angry Angel* into a holding pattern as they watched aircraft in the distance lift off and land in a steady stream.

Eventually, they got the call, "Heavy two-four-six, cleared to land."

The wide Brahmaputra River, filled with broad sandbars left by the monsoon season, slipped beneath Vernon's wing. Beyond, lay the airfield boarded on the east by the Kameng River. To the northeast, snow-capped Himalayas rose menacingly toward the sky, forming a wall between India, Tibet, and China. A dirt runway greeted them as they touched down and rolled to a turnoff where a jeep with a red flag flapping from a pole mounted to the rear bumper, directed them to parking. As they taxied into the revetment, the thermometer in the windshield indicated 105 degrees.

"Looks like we won't get a break from the heat here," Vernon commented to Goodrich as they ran through their shutdown procedures.

The "Follow Me" jeep left and another jeep pulled up in a cloud of dust as Lt. Drake and crew dropped out of the bomb bay doors onto the dusty ground.

A sergeant hopped out of the jeep and saluted. "Welcome to Tezpur, gentlemen. I'll take you to Operations."

The mid-afternoon sun beat down like a blast furnace as the crew threw their bags in the back of the jeep and crawled aboard.

"So, this is Tezpur," Chappy said as the jeep bounced over a rutted road toward a cluster of thatched buildings. "And I thought things were tough at Panda."

As they passed the control tower, a grass shack on stilts, Vernon commented, "How do you suppose they know who's who and what's what from *that* bird's nest?"

The Operations Building wasn't much better … a long, low, thatched building with a covered veranda providing little relief from the heat. A clerk quickly processed the crew's paperwork and then back in the jeep and onto their quarters—rows of basha huts similar to those they had left.

"Home sweet home," Chappy remarked as he jumped off the jeep. "You think they would stop putting us up in these four-star hotels."

"Showers are over there." The sergeant pointed to a wooden platform with a half-dozen pipes sticking out of the floor like galvanized candy canes. Shower days are Wednesdays and Saturdays.

It looks like shyness is not the order of the day, Vernon thought as he eyed the wide-open shower facility.

"The house boys will bring water buckets to your basha every morning. The officers' mess is over there." He pointed at another thatched building. "Your orientation briefing is at Operations at 0900. Welcome to Tezpur."

Vernon claimed a cot, stowed his B-4 bag and sank into a rattan chair on the basha porch. Rising above the trees, the Himalayan mountain peaks 50 miles away shimmered in the late heat of the day. The sight brought memories of the Rocky Mountains, the same distance from his ranch on the hills south of Billings. He often sat on the back porch

of his Montana farm home gazing across the broad Clarks Fork River Valley as the sunset behind those granite towers.

The mountain view brought back a memory of a time with Bettie.

"Aren't they beautiful?" Bettie asked as she clutched his arm.

The couple sat on a log next to Rock Creek outside Red Lodge. They had driven up from Billings for a church picnic. Clear, ice-cold water rushed down from the Bear Tooth Range of the Rockies, creating more of a rushing river than a creek. Sun warmed the fresh, cool mountain air. Vernon breathed it in deeply.

"Yeah, they're great. I love living so close to the mountains."

"We barely had hills in Nebraska," Bettie answered in a sweet, small voice.

A chilling breeze momentarily rustled through the pine trees.

Bettie snuggled closer. "It's so peaceful up here. It's hard to imagine there is a war going on."

The two sat in silence, listening to the sound of water tumbling over its rock-lined bed. They surveyed the green pine forests rising up steep mountain slopes to meet granite summits topped with caps of white.

"It can't get any better than this," Bettie murmured.

With Bettie's warmth against his chest, Vernon felt a sense of complete contentment wash over him. A contentment he wished would last forever.

Lt. Goodrich jolted him from his memories. "Come on Drake, let's get some chow."

Chappy followed close behind. "I can't wait to dig my teeth into some canned beef and dehydrated potatoes."

"Yeah—right. Back to reality," Vernon grumbled as Chappy playfully knocked his hat off. He gazed back at those rocky sentinels as he stepped off the porch. "Are we really going to fly over those things?" he asked himself loud enough that Chappy heard.

"Well, we sure as hell ain't flying through 'em."

The trio shared a table with a couple of other pilots.

"Name's Anderson," the blonde, blue-eyed pilot spoke up as he extended a hand. Vernon thought he looked fresh out of high school. "You fellas new here?"

"Yeah. Just flew in today."

"Ah. *Angry Angel*. Saw your nose art. Quite a gal."

Chappy spoke up. "Lieutenant Drake here is the artist."

"Really? Not bad." Lieutenant Anderson waved a fork toward his tablemate. "This is Clarkson. We're flying *Ice Queen*. She's a C-87 tanker. You know, a B-24 that got pregnant at the factory before they could make a bomber out of her. Got her name from all the ice she carried on her wings on our very first trip over the Hump. Never thought we'd make it back."

"Rough trip?" Vernon asked, trying to sound matter-of-fact.

"They're mostly all rough trips. You boys will find out. They don't call it the Aluminum Highway for nothin'."

"Aluminum Highway?"

"Yep. Just follow the smashed-up birds all the way to China. You can't get lost."

The corners of Lieutenant Clarkson's mouth rose slightly as he hid a chuckle with a bite of potatoes. Vernon didn't know if Anderson was pulling his leg or not. In any case, a trip over the rock pile didn't sound like a pleasant experience.

"So," Anderson queried, "you fellas been flying bombers. I guess you've seen some action?"

"Mostly bridge busting. We've seen our share of combat."

"Flying the Hump will be a piece of cake, then."

Vernon caught another muffled chuckle coming from Lt. Clarkson.

"Guess we'll find out."

Lt. Anderson stirred his coffee. "If you get bored, we could use a fancy lady painted on our ship, too."

The next morning, Vernon and crew reported to the Operations Building where Lieutenant Lang, the squadron commander's aid, met them. Friendly enough, Lt. Lang gave a rundown on living in Tezpur and then turned to flight duties.

"Each of you will be assigned to fly with experienced crews while your aircraft is being converted to a C-109." He pulled down a rolled-up schematic cutaway of a B-24. "We will be removing all the armament and installing tanks. Two 400-gallon self-sealing tanks go here in the forward bomb bay." He directed his long wooden pointer to the location on the schematic. "Two more 425-gallon tanks go in the aft bomb bay.

A 100-gallon tank will be fitted into the bombardier's compartment and three tanks with a total of 470 gallons above the bomb bay. That's a total of 2,220 gallons."

Vernon tried to do some quick math in his head. *Let's see. Aviation fuel weighs about six pounds per gallon. Two thousand times six ...*

"That's a 13,320-pound load you'll be hauling," Lt. Lang stated before Vernon had a chance to make the tally. "Plus, your aircraft tanks will be topped off as well. At your destination, all but enough gas to return to base will be off-loaded."

Whoa, Vernon gasped. *That's twice the weight we carried on long-range missions ... and we'll be a flying gas tank with no defense.*

"Every effort is being made to avoid any static buildup or spark. Fumes are vented overboard. You can understand the 'No Smoking' order in and around the aircraft."

Lt. Goodrich and Chappy seemed equally stunned based on the looks on their faces. No doubt, Lt. Lang had gotten used to the reaction because he continued without a stutter.

Chappy looked over Lt. Drake's shoulder. "Hear they call the C-109, 'C-one-oh-boom' around here."

"Thanks a lot. Just what I wanted to hear."

Lt. Lang continued, "We're flying maximum effort here. Our forces rely on our getting gas and supplies to them. We fly every day and every night, no matter the weather." His tone softened a bit. "Consider yourselves lucky. Your bird can fly over the rocks. The C-47 drivers have to pick their way through the passes."

Chappy whispered to Lt. Drake, "Bridge bustin' looks pretty good now, don't ya think?"

"Check the posted roster daily for your flight assignments. You'll get your first look at the Hump tomorrow. Good luck."

The rest of the day consisted of classes on the routes, destinations, and facilities that made up the flights over the Himalayas into China.

The crew joined the lineup checking the roster sheet tacked to the bulletin board on the veranda outside Operations. Vernon scanned the list and found his name noted as copilot next to aircraft 788, a C-87. The pilot—Lt. Anderson.

"Looks like I'm flying the *Ice Queen*," he remarked to Goodrich who scanned the list for his name.

That evening, Vernon sat again in his rattan chair gazing at the towering silhouettes with peaks hidden in a crown of clouds and wondered what tomorrow would bring. At least he wouldn't be flying north over those giants, he would be flying east to China.

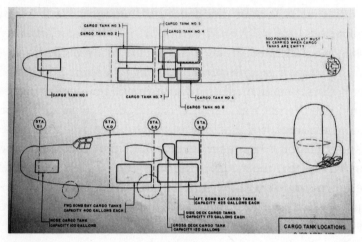

This illustration is from the original WWII Conversion Manual for the C-109 Tanker.

In the Clouds

"How are your instrument flying skills?" Lt. Anderson asked as he and Lt. Drake settled into the seats on the flight deck of the *Ice Queen*.

Vernon felt a slight weakness in his knees, a combination of anticipation and fear while he hoped the pancakes and powdered eggs he had for breakfast stayed put. He always got a little queasy on a flight before the engines started but settled down once the wheels began to roll. He often wondered whether Goodrich or Chappy felt the same. If they did, they never let on.

He looked over at his youthful aircraft commander, wavy blonde hair in bad need of a trim sticking out like straw beneath his flight cap. *How can this kid be old enough to make lieutenant, let alone pilot this tub?*

"We've spent some time in the clouds," Vernon answered as confidently as he could.

And that they had … cloudbanks and tropical storms were a routine part of bombing Burma. It seemed layers of clouds thrived over the Bay of Bengal and loved to pile up against the coastal hills. Most of Vernon's instrument time consisted of climbing up or letting down through overcast skies. *Angry Angel* could usually get above the weather or dodge around thunder-bumpers. Often, they wouldn't see the ground until they reached inland Burma. Chappy had become efficient at navigating to targets with few landmarks.

"Well, you'll get your chance to show off today. Take a good look at the ground because that is the last you'll see of it until we land at Kunming."

Vernon had been watching the overcast sky through the thin ground fog since he got up that morning. It hadn't risen an inch. At the preflight weather briefing, they were informed that returning pilots reported most of Route Fox had low-level clouds and towering cumulus. There might be a clear layer in between.

Lt. Drake had met Lieutenant Dodge, the *Ice Queen*'s navigator, earlier that morning. It would be his job to provide headings and keep them on course. Today, that would be done mostly by dead reckoning—basically a clock, a chart, and a compass. Lt. Dodge sat in his compact compartment one level below the flight deck. He hunched over his small desk figuring the effects of winds aloft, density altitude, true airspeed, ground speed, and a host of other factors to provide the pilots with the proper course to fly. Some air bases had towers that broadcast a radio beam to assist in navigation, but they were far and few between. The weather could disrupt or interfere with transmission, often making them unreliable.

Lt. Drake and Lt. Anderson stepped methodically through the start-up procedures as they called out each move. Once all engines vibrated through the beast, Lt. Anderson had Vernon taxi out to the run-up area. With checks completed, they took to the runway.

"Takeoff power," Anderson called out.

Vernon obliged by moving the throttles forward, beginning the slow noisy roll down the dirt runway. The takeoff run seemed to go on and on. He wondered if it would ever make it into the air. When they finally broke ground, the runway and its surroundings disappeared into a grey mist. Lt. Anderson carefully scanned his instruments in a rhythmic pattern, holding the wings level in a slow but steady climb.

"Gear up."

"Gear coming up," Lt. Drake responded as he moved the gear lever to its up position and watched the light indicators until he heard the familiar clunk and saw the lights turn green. "Gear up and locked."

He glanced over at Lt. Anderson who had transformed from a boy pilot into a serious professional. His movements were slow and fluent. He

held the big hulking aircraft precisely on course. The airspeed indicator hardly faltered. With nothing but a white windshield ahead, Lt. Anderson flew as though he could see the world.

"Take up heading one-thirty-one," came Lt. Dodge's instruction over the headphones.

"On it, Duggy."

Lt. Anderson had already banked to that heading. He had made this trip many times before, the course known as Fox Route. It would take the heavy tanker southeasterly, across the Assam Valley, over the jungle mountains of Naga Land that marked the border between India and northernmost Burma, passing north of Indawgyi Lake and then over a second range of mountains that dumped into the headwaters of the great Irrawaddy River Basin. Next, the towering wall of the Himalayans marked the border between Burma and China. The final and most challenging hurdle to be crossed before reaching Kunming.

For now, Vernon could only imagine what lay beneath the white shroud outside his window. No sensation of climbing, turning, or descending entered the cockpit as the *Ice Queen* climbed smoothly through the morning air. Other than the drone of the four powerful engines, it felt as though the large beast hung motionless in the center of a monstrous cotton ball.

They had left a valley floor only 150 feet above sea level and, by the indications on the altimeter, were a mile and a half over the earth when their white universe faded. The *Ice Queen* rose above a wispy snow-like carpet into clear air. Far above, another layer of thick clouds blocked out the sun as the air cooled 5.4 degrees Fahrenheit with each 1,000-foot gain in altitude.

"Some peaks in the first mountain range are around 8,000," Lt. Dodge explained. "We'll cruise at 10 until we get to the Rock Pile."

Vernon welcomed the chilly air at 10,000 feet. At 45 degrees, he needed his B-10 fleece-lined jacket to keep warm, but the cool temperatures provided great relief from the sweltering heat of the Assam Valley floor. The *Ice Queen* cruised eastward for hours in that vacant space between the unseen worlds below blanketed in mist and the heavens beyond the ragged grey ceiling. There wasn't much to do but monitor the engines

and keep the big ship on a heading. The autopilot did that. Smooth air, the drone of the engines, and the nondescript world outside produced an almost hypnotic state.

"Samsaw," Lt. Dodge announced after an hour of boredom. "Heading one-zero-five degrees corrected for a northeast quartering tailwind. Next point—Mangshih.

Vernon checked his chart. *Samsaw. That puts us over the Ledo road.*

Vernon searched the blanket of white, hoping for a small opening to catch a glimpse of the underworld. Somewhere, below that floor of clouds, US Army engineers working with Allied soldiers were building an impossible road through the mountain jungles to allow supply trucks to reach China. No view today, the clouds remained solid.

I'm sure glad I'm flying an airplane and not driving a bulldozer.

Another hour of monotony passed. Vernon had time to dream of home and long for Bettie's touch and news of his little daughter he hardly knew. He hadn't received a letter since leaving Pandaveswar. Time seemed to stand still.

"Thirty minutes to Mangshih," Lt. Dodge announced.

"Climb power," Lt. Anderson called out to Vernon as he switched off the autopilot. "Time to put some space between us and the rocks. We'll take her up to 15,000."

Vernon advanced the throttles. Far ahead he could see the fleecy floor boiling up to meet a grey ceiling. No doubt they would soon be in the soup again.

Occasional radio chatter would come across his headphones as other pilots called out position reports and weather observations from the various routes to and from China. Today they were almost all punching holes in the clouds. Since he had no ground references to go by, Lt. Dodge would adjust course headings based on these reports. He would never really know how close to or far away they actually were from Fox until he had a visual reference point. Today, those didn't exist.

Lt. Anderson squirmed some in his seat and cinched his seat belt just a little tighter. "There are some 10 to 12 thousand footers between here and Kunming. I would prefer not to enter any cumulus granitus clouds."

"That could ruin our whole day," Vernon chuckled.

The temperature in the cockpit dropped below freezing as the *Ice Queen* ascended into the murky grey above and said goodbye to the mind-numbing, silky-smooth air she had enjoyed for hours. She began to bounce like Vernon's worn-out Oldsmobile driving over the rutted dirt road to the ranch. Lt. Anderson grabbed firm control of the wheel with both hands where once they had simply rested on the yoke.

"Welcome to the Hump, Lt. Drake."

Vernon busied himself with managing the rpm and manifold pressures of the four brutish engines clawing at the ever-increasingly angry sky. The white sheet over the windows began to darken. Both pilots continuously scanned their instruments with rhythmic regularity—Lt. Anderson the flight instruments and Vernon the engine and system instruments.

Vernon began to sense a right turn as the plane bucked and bounced its way through space. He glanced at the gyrocompass. No, the heading remained correct. Back to scanning the dials, the right-turn feeling became stronger. He looked back at the compass again—still no change.

Vertigo. Trust your instruments, not your feelings. How many times had he said that to himself? Pounded into his head during instrument training, that phrase had saved his bacon many times. He remembered spinning in a swivel chair blindfolded during a Basic Training exercise to demonstrate the effects of vertigo. His body now falsely told him the aircraft had entered a turn when it hadn't. All the instruments confirmed that.

Flash! The flight deck filled with a blinding light for a millisecond followed by a boom like a bomb had exploded in the bay.

"Crap!" Lt. Anderson grumbled loudly. "Duggy, can you get us around this stuff?"

"I can try, lieutenant. Give me a sec." Lt. Dodge, plotter on his chart and E-6B slide calculator in hand, worked rapidly to plot a new course. "Steer one-fifty-two, sir. Let's hope the cell is to the north."

Flash—flash! Boom!

Lt. Anderson banked hard right to the new heading. Vernon's internal gyro rolled and his head told him they were going inverted.

Trust your instruments, not your feelings.

Trust your instruments, not your feelings.

Another flash. He didn't need to be reminded that aviation fuel filled the bulk of the aircraft. His heart began to race. *One spark. That's all it takes.*

More flashes but further away. The jarring of the *Ice Queen* lessened although still a rough ride. Duggy's gamble seemed to have paid off—for now.

Vernon found himself leaning hard to the left; his brain still convinced they were in a turn. Lt. Anderson looked over at him.

"You okay, lieutenant?"

Vernon fought the urge and sat up straight. "Yeah, I'm fine. Never did like thunderstorms."

"Better get used to 'em. It's daily routine in this outfit."

CHAPTER 29

Kunming

The *Ice Queen* bounced and jarred its way across mountain ranges that were hidden somewhere in the murky mist. With nothing to see outside the windows but white and grey, the pilots continued to religiously scan their instruments, making the corrections needed to keep their charge right-side-up and on course. Lt. Drake's mind fought hard with his erroneous sensation. In time, his vertigo slowly righted itself.

"You take it for a while, Drake," Lt. Anderson called over to Vernon as he stretched out his arms to relieve some tension. He had been flying straight for almost two hours.

"Got it." Vernon grabbed the yoke with both fists in a firm grip—his first chance to fly since arriving at Tezpur. The wheel danced in his hands in response to the invisible forces buffeting the aircraft. He focused on the gyro horizon instrument. It told him his wings and nose were level. Next, the turn indicator confirmed he wasn't in a turn. His controls were coordinated according to the turn and bank Indicator. The compass bobbed and swung but he held his course. The rate of climb instrument would go crazy from time to time as the ship jolted through up and down drafts caused by the hidden monsters below. He fought to keep the altimeter needle somewhere close to his assigned altitude. Round and round he went, from one instrument to the next, making control input corrections as needed. His thoughts had no room for anything

other than keeping the *Ice Queen* headed for Kunming. Time crawled slowly as miles of dangerous terrain passed unseen below.

"Thompson picked up the radio beacon, sir," came Duggy's voice over the headset. Sergeant Thompson served as the fourth on the crew as Radio Operator. "I think we got blown south. Take up a heading of seven-zero degrees."

Lt. Dodge could hear the dit-dah-dit … dah-dah-dit-dah of the broadcasting tower. If it got stronger as they flew, he would know he made the right call. As minutes passed, that comforting sound *did* increase. Duggy knew his job.

The bouncing buckboard settled down some as they neared Kunming. Vernon could hear the other traffic communicating with the tower.

"It's usually pretty busy here." Lt. Anderson reached into the side pouch for his approach chart, pulled it out and set it on his lap. "I hope we don't get stacked too high."

Duggy broke in, "Kunming is reporting a thousand overcast and four miles visibility."

"The good news is," Lt. Anderson added, "Jap fighters don't fly in this weather."

Kunming control tower put the *Ice Queen* in a holding pattern with three other aircraft stacked 1,000 feet apart. Round and round they went. As the aircraft on the bottom received permission to land, the others would descend to the next level of holding. After 20 minutes of holding, Lt. Drake heard the welcome words, "Start your approach."

"You take 'er in," Lt. Anderson directed. "I'll be here with you."

Even with the cold temperatures at 11,000 feet, Vernon's palms were sweating in his flight gloves. An instrument approach at an unfamiliar field in hazardous terrain located almost a mile and a half up would make most pilots sweat. He hadn't done an approach like this since pilot training in Pueblo, Colorado.

Crossing the radio station at 11,000 feet, Lt. Drake steered the *Ice Queen* outbound on a heading of 360 degrees while starting a 500-foot-per-minute descent.

"I've got the clock," Lt. Anderson reassured. "Out for two minutes."

Vernon watched the altimeter wind down as the seconds ticked away.

"Two minutes," Lt. Anderson called out. "Start your turn."

Vernon banked the plane to the right, watching the compass swing, heading for 200 degrees that would take them back over the marker beacon while staying above the mountains to the north. The instruments told him he had initiated a turn, but his equilibrium told him otherwise.

Trust your instruments, not your feelings.

"Two hundred degrees—I've got the throttles—900 feet per minute." Lt. Anderson reduced the power while Vernon held a steady heading.

With the windshield still plowing through a grey mist, Lt. Drake concentrated on the dials before him. The marker beacon beeped away as the *Ice Queen* crossed over, now 7,800 feet. Somewhere ahead, under that grey blanket, lay the Kunming airbase.

"Heading one-ninety, airspeed one-fifty, gear coming down."

Small hints of color began to interrupt the grey mist, then as though being spat out of the muck, the *Ice Queen* dropped below a ragged overcast revealing a flat valley floor with an airstrip ahead to the left and a lake beyond.

"Flaps coming down."

All the landings he had done in a B-24 were after the bomb loads had been dropped and gas tanks near empty. Now, all Lt. Drake had to do was land a heavily loaded flying gas tank on a gravel landing strip in a mountain valley in China.

Piece of cake.

The landing turned out to be the easiest thing he had done all day. He rolled the wheels on without a bounce and with plenty of runway to spare.

"Nicely done, Lt. Drake," came unexpected praise from Lt. Anderson.

After he parked the airplane on the transport ramp where ground crews were ready to off-load the tons of aviation fuel, the crew turned in their paperwork at Air Traffic Command Operations. A sign behind the desk read "China Is Not For The Timid."

As if we have a choice!

Vernon began to feel the pangs of hunger that had gone unnoticed for the last few hours. It had been eight hours since he had eaten.

"You're in for a treat," Lt. Anderson said as they walked out of the building. "How about some chow?"

"That, I could go for." He looked around and out toward the ramp where the *Ice Queen* sat surrounded by trucks with umbilical cords draining precious cargo from her holds.

"Where's Sergeant Thompson?"

"He's staying with the plane. Gotta watch out for Chinese saboteurs. They get paid by the Japs to booby-trap our birds if they get a chance. Some guys have had sugar put in their gas tanks. Not a good thing to find out when you're somewhere over the rock and your engines give up the ghost. A few times they set explosives in the landing gear."

"Does Thompson get a break?"

"Dodge will go out and relieve him when we're done eating."

Vernon followed Lt. Anderson and Lt. Dodge around the building and into the chow hall.

There, he saw something he wasn't expecting. "Real, honest to goodness eggs!" Vernon exclaimed. His eyes grew large as he watched the cook crack open the oval beauties. "I haven't had real eggs since we left Calcutta."

"One of the few benefits of Hump life," Duggy pointed out. "And here's another." The cook spooned a slab of meat onto his plate. "Don't know what kind of critter it is, and we never ask *but*—it's not from a can."

The crew sat down to a real meal and hot strong coffee. Vernon closed his eyes and drank in the smell. For a few seconds, he found himself back in the kitchen at the ranch with his mother frying eggs on the stove. To Lt. Drake, it seemed like a fitting reward for a morning of drilling holes through the clouds.

It took an hour for the ground crew to drain the *Ice Queen* of its liquid cargo leaving just enough fuel for the trip back to Tezpur. Vernon took a short stroll around the base. Teams of two dozen Chinese coolies,* each harnessed to massive stone rollers and supervised by Chinese soldiers, dragged the heavy cylinders across the gravel to smooth out the ruts from taxiing aircraft. Numerous others bent over, picking up larger stones,

* This now-offensive term is in keeping with the vernacular of the times, and so has been kept in the text.

their saucer-shaped, grass-woven hats providing some shade from the sun. Old trucks, barely operational, hauled gravel to shovel-equipped coolies dressed in tattered clothes and woven-straw sandals. Airplanes came and went, divulging their cargo of all shapes and sizes from jeeps to crates. Groups of poorly equipped Chinese soldiers, having never flown before, awaited their transport to India where they would be trained to fight the Japanese.

"We've lost a few planes to those boys," remarked Lt. Anderson over his shoulder as he nodded toward the soldiers. "They're scared to death of flying. On takeoff they can panic and all rush to the back door at once trying to get out. Next stop—stall, spin, and splat."

Vernon could imagine 30 Chinese soldiers piled on top of each other at the rear of a C-47 making it tail heavy to the point of losing control.

"Then there's those darn crazy coolies," Lt. Dodge added. "They'll run right out in front of you on takeoff. Seems they believe that the propeller can cut off the evil spirit following 'em."

"No kidding?" Vernon had a hard time swallowing that one. Being the new guy, he figured they were toying with him.

"Don't believe me?" Dodge shrugged. "Check the regs. We're under strict orders not to abort to avoid hitting 'em. It's a court-martial offense."

"Yeah," Lt. Anderson continued. "The Chinese even build crooked footbridges so they can make a quick jog and leave the dragon spirit in the drink." He shook his head. "This is a different world, Drake. Takes some getting used to."

The sign in the Operations Building began to make sense to Vernon—"China is not for the timid."

The crew made one last stop, a check with Operations for a weather report.

"You're going back to Tezpur by Route Charlie," the weather officer stated. "Looks like you'll get some breaks according to en route pilots. They are reporting tops at 18,000 over Yunnanyi, with building cumulous. You should be able to get on top and find clear air."

With the weather briefing in hand, such as it was for the unpredictable Hump, the crew boarded the *Ice Queen* and prepared for the trip home to Tezpur.

Floating Mountains

Within minutes of takeoff, the *Ice Queen* entered the soup once again. With Lt. Anderson at the controls following the departure procedure, he made a climbing 180-degree turn back toward the safety of Lake Tien Ch'Ih (currently Dian Lake) where he could climb to altitude before striking out over the mountains. An empty aircraft, the *Ice Queen* climbed like a fighter. Being so lightweight, she also got bounced and buffeted in the strong up and down drafts. At 18,000 feet, the aircraft popped out of the overcast into clear blue skies. Lt. Anderson continued to climb and leveled off in smooth air at 20,000 feet.

Vernon drank in the view from above a fairyland-like white carpet that stretched as far as he could see in all directions. Occasional hills of white billowed up like sheep on a snow-covered prairie. Off in the distance, faint blue mountain peaks floated effortlessly, seemingly detached from anything earthly.

Lt. Anderson took up a heading for the radio beacon at Yunnanyi 150 miles away and switched on the autopilot. "Keep an eye on her," was all he said as he slouched back in his seat and tilted his cap down over his eyes.

According to the charts, which weren't very accurate, there wouldn't be any mountains higher than 12,000 feet between Kunming and Yunnanyi ... if they stayed on Route Charlie. After Yunnanyi, peaks could poke up into the heavens. For the time being, cruising along in

the smooth frigid air felt like an unreal carpet ride—a very noisy carpet ride. The drone of four 1,200 horsepower Pratt & Whitney engines could lull a person into Neverland … half in a dream world and half in the real world. It became easy for Vernon's mind to drift off.

The tanker suddenly took a hard bounce from unstable air and jolted Vernon back to reality. He had been flying on his internal autopilot while daydreaming. The hazy blue mountaintops in the distance had become distinct hard rock piles topped with glaciers of ice and snow. The Himalayas were showing their treacherous spine above the white carpet of boiling clouds. Sgt. Thompson had picked up a strong signal from the Yunnanyi radio beacon giving Lt. Drake a reliable beam to follow. It would be the last navigation aid before heading over the rugged granite spires that made up the backbone of the tallest mountain range on earth. At least they were above the clouds with brilliant blue skies overhead. He tried not to think about what hid beneath the pillowy soft whiteness that stretched out as far as the eye could see.

"Pick up a heading of two-nine-five," came Duggy's instructions through Lt. Drake's earphones. "Looks like we have about a 70-mile-an-hour headwind up here."

Heavy easterly headwinds were common. Those winds piled clouds against the western slopes, often turning into ferocious storms. As they flew west, Vernon could see columns of billowing cumulus in the distance—teenagers rapidly growing into full-blown thunderheads.

Lt. Anderson glanced over at Vernon. "Just another day of running the gauntlet." He sat up a little straighter in his seat. "The trick is to stay out of the white stuff and the grey stuff. Both can contain hard stuff that is murder on airplanes."

Nearing his 900-hour transfer requirement, Lt. Anderson had played this game of *dodge-the-gotchas* many times. He had friends that had lost, and nearly lost the game himself more often than he would like to admit. A few more hops over "The Rock," and he would be heading for home.

By the time the *Ice Queen* reached checkpoint Yunlung, Vernon felt like they were flying through a surreal coliseum, weaving around towering cloud columns and avoiding pinnacles of hard rock. All this time, Lt.

Douglas hunched over his charts plotting their wandering route with little more than a watch and a compass, guessing at ground speed and location.

How easy it would be to get lost up here, Vernon thought. *I wish Chappy were here. Duggy seems okay but I would feel a whole lot more confident if Chappy was at the chart table.*

Chappy had successfully guided *Angry Angel* to and from the bowels of war-torn Burma 19 times through tropical storms, solid overcasts, enemy flak, sometimes returning in the dark of night. Vernon had come to trust Chappy explicitly. His whole crew had.

Bouncing and jarring, the *Ice Queen* picked her way through the aerial minefield until she emerged over the eastern foothills where a low broken overcast covered the jungle below. Lt. Anderson relieved Lt. Drake at the controls and dropped down to 12,000 feet with its warmer air. Oxygen masks came off requiring only an occasional inhaling of the life-sustaining gas.

Flying westward toward home in the Assam Valley, Vernon watched the clouds part, revealing a dense green canopy that blanketed the landscape from mountains to deep gorges. Little evidence of human life showed itself for mile after mile. He shuddered at the thought of bailing out over the jungle, or worse, crashing into it. Either way, he doubted the outcome would be anything but fatal.

Finally, the Assam Valley with its winding rivers, villages, farm fields, and open spaces glided under the wings of the *Ice Queen*. Only a few more miles to go and his introduction to the Hump would be complete … and, none too soon. Maybe there would be letters from home waiting for him?

No News

"No letter again today." Vernon walked out of the Mail Room deflated, shaking his head. He had come to rely on Bettie's daily letters. Sometimes a week would go by leaving an ache for news from home, and then a stack would show up. The army mail service wasn't too reliable. He would spend hours reading and re-reading her words. Sure, his mother's letters had news, too, about the farm and the family. He cherished those but they didn't fill the void in his soul that Bettie's words did.

Lost in his thoughts, he almost stumbled off the porch. Three weeks since her last post. *Has she stopped writing? Naw, the last letter I got was in Pandaveswar. The mail probably hasn't caught up with me ... could she be seeing Cal or Ed again? She could be sick ... or worse ...*

"Hey Drake, why so glum?" Chappy slapped Vernon on the back after catching up to him. "Here, have a slightly damaged cookie." He pulled out a crumpled, semi-round lump of oatmeal raisin from a small squashed box. "My mom makes the best."

"You got those today?" Vernon looked puzzled.

"Yep. Uncle Sam did his best to seek and destroy but they got through enemy lines."

"I haven't heard from my wife in weeks. In fact, I haven't had a letter from anyone since we got to Tezpur."

"Gee, that's tough. It's probably an army SNAFU, you know, situation normal, all fouled up."

"Yeah, I guess." Vernon stuffed the stale crumbs in his mouth and mumbled, "Hmmm, not bad."

"At least Lt. Lang is keeping you busy painting a lady on the squadron leader's plane. You missed out on two rides over the Hump already. You gotta admit that's a sweet deal."

"Painting *Lassie I'm Home* is keeping me out of the mountains for a few days at least."

"She's a looker. You got 'er about finished?"

"I better have. It's going out in the morning from what I hear."

"You heard right, and I'm the navigator."

"No kidding. Well, I guess you'll have a good crew. At least that's the scuttlebutt."

"Yeah, but I'm looking forward to getting our guys back together again on *Angry Angel*. I figure it could happen any day now. We all got a good taste of the Hump and I think we could handle it."

"Where's Goodrich today?"

"He drew *Lucky Lady*. He's probably chowin' down at the Egg Shack in Yunnanyi about now."

"Speaking of chow, I'm headed there. You coming?"

Vernon, empty-handed, and Chappy with his box of crumbs, strolled across the grounds in the Indian heat toward the smell of frying SPAM. After lunch, he would write a few more letters … maybe make some sketches. It was too hot to paint.

Later that afternoon, a bunch of the guys planned a bicycle race with captured Japanese bikes. Someone had brought a dozen of them on a back-haul from China. Chappy snagged a couple for Vernon and himself. It seemed half the base turned out for the event. Guys of all ranks in shorts, boots, and caps lined up across from the chow hall on a menagerie of bikes in all stages of disrepair, ready for the start.

"Okay, guys," the starter yelled. "You race down past the Ops building, out to revetment Charlie, back by the Motor Pool, around the rear of the chow hall, and back here."

Vernon squatted down over the handlebars one foot on a raised pedal, poised to charge ahead. This wasn't his first race. He and his brothers spent a lot of hours chasing each other over the dirt roads in

the South Hills. "Eat my dust, Chappy," he called over to his friend who had his cap on backward showing a determined face ready to take on all comers.

"We'll see about that!"

"Ready—set—go!" The starter shot his pistol in the air and a dozen bike riders were off to start the race.

The Jap bikes were small, flimsy, and certainly not meant for tall American soldiers. Some riders got off to a wobbly start. Others took several attempts to get going. Vernon and Chappy were both at home on any bicycle and captured an early lead. Spectators lined the dirt road and cheered on their favored rider. Vernon pumped the pedals hard with Chappy right off his elbow matching him stroke for stroke. By the time they had reached the Ops building, they were two lengths ahead of the next riders. Rounding Charlie, two other riders made it a four-man race. Vernon dug down and pumped harder, sweat now pouring down his forehead and into his eyes.

Chappy began to pull ahead, body and bike wildly swaying back and forth with each rapid stroke of the pedals. "See you back at the chow hall, sucker," he called, looking back over his shoulder.

Chappy didn't see the rut coming that grabbed his front wheel and sent him, head and tail, over the handlebars and into the dirt. Vernon had no time to avert the coming disaster and followed in a spectacular two-bike pile-up. They both lay sprawled out on the dirt in a slight daze as the rest of the pack whizzed by with various jeers and jabs.

Vernon sat up and dusted off his cap. "I'm glad you navigate better than you ride."

"Hey, I didn't put that rut there."

After checking for cuts and bruises, the two untangled the bicycles, which appeared to have escaped any serious damage as well.

"Look on the bright side," Chappy said as he swung a rather sore leg over the seat. "We have bikes to get around the base on. No more begging Ops for a jeep ride."

Vernon turned his bike toward the basha. "Well, I'm going to find a nice cozy spot to take a snooze. I'm not getting much sleep lately."

"Yeah, it must be tough painting girlies all night long," Chappy jabbed.

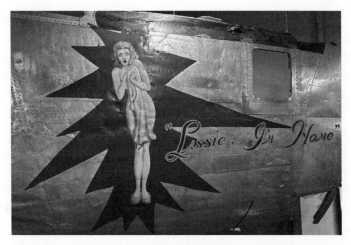

Lassie, I'm Home painted by Lt. Vernon Drake on a B-24 in Pandaveswar, India, in the 493rd Bomb Squadron, 7th Bomb Group, 10th Air Force. The original painting is now in the Commemorative Air Force collection.

Later that evening, as the sun set, Vernon packed up his painting supplies in a parachute bag and rode his newly acquired bike the mile out to the revetment where *Lassie I'm Home* was awaiting her finishing touches. The ground crew had a scaffold and a couple of work lights set up, ready for the artist when he arrived.

"She's going out in the morning, ya know," Sergeant Hanson commented as Lt. Drake unpacked his brushes. "Are you gonna have her finished?"

"No problem, sergeant. She'll be ready to travel in a couple of hours."

With blond hair, the blue-eyed beauty stood surprised and embarrassed with nothing but fuzzy slippers and a towel clenched modestly in front of her naked body.

By the time he had finished, cleaned up, and got back to the basha, midnight had come and gone. He left his bike and bag on the porch, crept into the basha to his cot, kicked off his boots, and sank into the straw mattress. Moonlight streaming through the window illuminated the room. Chappy snored away as usual, but Goodrich's cot sat empty and undisturbed. He should have been back and snoring away with the rest of them. Too late to wake Chappy, Vernon decided to wait until morning to get the story.

He lay in his cot imagining all the different scenarios. It wasn't uncommon for a mission to divert to another base due to any number of reasons. Sometimes weather or a mechanical problem grounded a plane

in China. It could have landed at Chauba or Jorhat or a half-dozen other places if fuel ran low. Eventually, Vernon drifted off to sleep.

Five in the morning came early as Vernon, in a fuzzy dream state, heard Chappy rustling around in the dark getting his things together. Vernon had forgotten that Chappy had been assigned to *Lassie I'm Home* this morning as their navigator. Too sleepy to think straight, he decided not to ask him about Goodrich. He would check with Operations when he got up.

With a few more hours of shut-eye, Vernon awoke rested. A quick glance toward Goodrich's cot answered his immediate question. Goodrich had not returned. After getting dressed, Vernon rode to the Operations shack and asked if there was any word on Goodrich's plane.

"No, we haven't received any reports. All we know is that they didn't land here. Check back later, we should know something in a couple of hours. It takes a while for dailies to reach us."

Later that morning, he got notice to report to Operations. Thinking it would be news of Goodrich, he headed over there hoping for the best.

"No news of 263 but you need to see the scheduling officer," the clerk replied to his inquiry.

Vernon reported to the scheduling officer at Ops.

"Lieutenant Drake reporting in. You have something for me?"

"Lieutenant Drake." The clerk ran his finger down his clipboard. "Here you are. You've been assigned as aircraft commander of 264 ... copilot, Lieutenant Stephenson ... navigator, Lieutenant Chapman ... radio operator, a Private Coogan ... and your engineer is Sergeant Stinson."

Vernon couldn't believe it, his crew back together again on Angry Angel—except for Lt. Goodrich. Where was Lt. Goodrich?

"You're scheduled for a Kunming run in the morning. Lieutenant Stephenson is a high-timer. He'll be your check-pilot. Keep you out of trouble."

Vernon's emotions were mixed as he rode toward breakfast at the chow hall. He had been awarded aircraft commander status—both an honor and achievement but also a heavy responsibility. He had his airplane and his crew back but Goodrich was missing. And, he had to perform for a complete stranger who was an old hat at flying the Hump. The next 48 hours were going to be hard ones.

Aircraft Commander

"Look what they've done to her." Vernon patted *Angry Angel*, a once-proud bomber, now stripped of her armament and bloated with gas tanks.

"I know." Skipper shook his head. "It was hard to watch. Kinda wished they'd left me back at Pandaveswar so I didn't have to see this. But, as they say, orders is orders."

"Well, bomber or tanker, I know you'll keep her in top shape so she can do her job."

"It's good to have you back in the cockpit, lieutenant—and congratulations on the promotion. Haven't heard from Lt. Goodrich have you?"

"Nothing yet. He's probably bending elbows at an Officers' Club bar someplace between here and Kunming. I'm sure we'll hear something soon."

Skipper followed Lt. Drake around the airplane as he did his preflight inspection.

"Where ya heading this morning?"

"We're flying Able Route to the Chengtu area. Never been there. I just know there is a 20,000-foot floor for instrument flying over the rocks, and there are peaks a bunch higher than that."

"That's what ya get for flying a lady that can cruise at those altitudes."

"Lieutenant Stephenson ..." Vernon nodded toward the short stocky officer throwing his flight gear up into the open bomb bay doors, "... is

sitting right seat. He's flown Able a bunch of times. He should keep us out of trouble. Besides, we've got Chappy back on the charts."

"*Angry Angel* will get you there and back if you treat her right, sir. Have a safe trip." Skipper gave a friendly salute as he ducked under the fuselage.

Lt. Drake returned the salute. "Thanks, sergeant. It's RON [remain overnight] so see you tomorrow."

Skipper took up his position with the fire extinguisher as Vernon, Chappy, Sgt. Stinson, Pvt. Coogan and Lt. Stephenson settled into their places on the flight deck. In the heat of the morning, cockpit windows open, the odor of aviation fuel permeated the air as a stark reminder of the cargo they carried.

Lt. Stephenson, a veteran Hump pilot in his mid-twenties, didn't say much other than responding to the procedural request from Lt. Drake. The crew stepped through their startup checklists as *Angry Angel* came alive. It took extra effort to get her moving from the revetment as her tires bulged from the heavy load. Once rolling, she joined the procession of tankers jockeying their way to the end of the runway. One by one, each aircraft got the green light from the tower and lumbered into the air heading to their various destinations.

Angry Angel struggled to lift her 58,000 pounds into the air. Vernon still hadn't gotten used to using up every inch of the runway to break ground. No room for error remained. Every takeoff with a full load left his heart pounding after holding his breath in prayer the last third of the takeoff run. His mind's eye could still see the fiery crash he had to follow at Pandaveswar.

The climb to altitude proceeded long and slow. The Assam valley passed below in almost clear skies. Hills and jungle rose toward the Hpungan Pass where peaks topped out at over 13,000 feet—a small introduction to the spires to come. After an hour-and-a-half in the air, Coogan picked up the radio signal from Fort Hertz providing a beam to home in on. The needle on the radio compass indicated when they were on the beam or left or right. The signal came in loud and clear when on course. Using the heading needed to stay on the beam and the time between checkpoints, Chappy could calculate the

direction and intensity of the winds aloft—crucial information when out of radio range.

Once over Fort Hertz, they would use the outbound beam to put them on the route to Likiang, the next checkpoint 178 miles away. To get there, *Angry Angel* would have to climb to 20,000 feet and stay on the route. Any deviation could end up finding vertical rock in the way.

Cloud cover had been spotty so far but as they climbed eastward, clouds filled in below and above. Soon the lone aircraft cruised between layers.

As the outbound signal from Fort Hertz faded away, Chappy's navigation would have to get them to a point where they could pick up Likiang. Time ticked by as *Angry Angel* cruised that invisible highway between cloud layers.

"How we coming, Chappy?" Vernon asked over the interphone.

"No signal yet. I can't take any solar readings because of the overcast."

A sextant had been used for hundreds of years as a navigation aid for sailors. By taking a fix on the location of the sun, moon, or stars, the navigator could locate his position on the earth. A modification in the 1920s made it useful for aeronautical navigation. Every Army Air Corps navigator learned the art of its use. Of course, it became useless under an obscured sky.

More time passed.

"Are you picking up Likiang yet, private?" Lt. Stephenson asked. "We should have it by now."

"I got a weak signal, sir. Not enough to find the inbound beam."

"Keep at it, private."

Chappy broke in. "We may have a stronger wind than forecast, commander." Addressing Lt. Drake, he wanted to acknowledge Vernon as the commander of *Angry Angel*, not the check pilot. "I suggest you take up a heading of six-zero degrees and see if we can intercept the beam."

"Roger."

Vernon banked left to the new heading as Pvt. Coogan continued to fine-tune his dials, searching for the elusive signal.

After 10 minutes of flying, Coogan called back, "The signal is getting fainter, sir."

"We must be tracking away, commander," Chappy called. "Turn to a heading of one-six-zero for 10 minutes. That should take us back to the beam."

Vernon again banked the aircraft, this time to the right to the southeast.

"I've lost the signal, sir," Pvt. Coogan reported.

"We're too far out for the radio compass to work," Lt. Stephenson said stiffly.

Chappy fed Vernon more course corrections in his effort to find the elusive radio signal. Keenly aware of the rocky spires that stretched for hundreds of miles below the grey layer of clouds, Vernon became more concerned about the uncertainty of their location for two reasons. One, he didn't want to have a close encounter with granite and, two, Lt. Stephenson sat silently grading his every move.

Each course correction failed to produce the desired signal. It became obvious that they were now lost. Lt. Drake did know one thing for certain, the Chinese highlands lay somewhere in the general direction they were heading. They would eventually leave the Himalayan Mountains behind.

Vernon turned to Lt. Stephenson, "Looks like we may have been blown off course."

Lt. Stephenson came back glibly, "The good news is you have lots of fuel onboard."

"True." Vernon felt the coldness of the lieutenant's voice. They would be in deep trouble if this happened on the return flight with only enough fuel to make it home.

"I heard a couple of days ago a C-109 returning from Kunming on Charlie Route got lost and ran out of fuel. The last anyone heard from them was a radio call saying they were bailing out."

The words stung Vernon's brain. *Goodrich?*

"Do you know who it was?"

"Nope. Didn't hear but let's not let that happen to us."

Angry Angel lumbered on eastward where the mountains lowered and civilization emerged again. Now in range of several bases, Vernon swallowed some pride and called for a radio fix. By triangulation, Chappy reported they were 130 miles southwest of their goal. He knew that

winds alone could not have put them that far off course. All of his course corrections chasing the beam had taken them further afield.

The weakness in Chappy's voice came through Vernon's headphones. "My mistake lieutenant. I messed up. No excuse, sir."

Vernon felt the total humiliation and disappointment in his navigator's voice. Mistakes happen but Chappy had put everyone's life at risk and he knew it. Vernon would talk with him later about what and how it happened but for now—complete the mission.

"Give me a heading to Ipin. Let's get this thing on the ground."

"Yes, sir."

The clouds parted on the way to the Ipin checkpoint. Rugged hills with deep gorges hid small villages where farmers eked out small plots of land to grow food for a sparse population. Eventually, the terrain gave way and towns began to appear until the broad Yangtze River came into view. From Ipin to Lushien took less than 30 minutes.*

Lt. Drake was cleared straight in—no stack of airplanes today. The landing checklist went smoothly, as did his landing. He couldn't afford any more screw-ups. Lt. Stephenson continued his quiet observation. Vernon found it difficult to read his stern manner but sure that he didn't rate very high on his confidence scale.

They had burned more fuel than normal due to the diversions so their off-load didn't impress either. The war in China needed every drop of fuel it could get. Wandering around over the mountains wasting fuel didn't sit well with anyone.

A late trip to the chow hall for real eggs, meat, and potatoes took some of the sting out of the day's events. Vernon learned that this was to be Lt. Stephenson's last trip over the Hump before he rotated back to the States. Anxious to get out of India, he didn't want anything to prevent that from happening—certainly not a bailout over The Rock because of a green pilot and navigator.

The day had been way too long and the cot in the Transient Officers Quarters felt good. Morning would come early for the trip back. If lucky, his dream world would return him home to Bettie.

* Checkpoint names have been referred to in the format indicated on the relevant routing chart.

Ups and Downs

Lt. Drake stood in the dim early morning light looking up at the image of *Angry Angel* he had created. Overcast skies added a sense of gloom to the start of day. *Angry Angel's* face seemed somehow more real this morning.

Is that Bettie looking down on me or is it Angry Angel? *Her face is so familiar. Is it because she reminds me of Bettie or because I created her?*

Either way, Vernon felt a warm attraction to the blonde-haired beauty—as though she had a soul. He glanced toward the grey clouds overhead.

I'm glad you're with me today, he said silently to the lady on the side of his B-24/C-109, as though she had some supernatural ability to keep him safe.

The morning briefing indicated the flight back to home base at Tezpur would most likely be rough. Heavy weather had moved in during the night and pilots were reporting storms building along the way. This would not be a pleasant flight.

"Looks like you have your work cut out for you," Vernon told Chappy earlier. "No more sightseeing."

Lt. Chapman wore a grim smile without the usual clever comeback. He knew he had screwed up and wasn't about to let it happen again.

Thirty seconds after lift-off, *Angry Angel* entered the soup. Pvt. Coogan had the outbound beam dialed in and Lt. Drake kept the radio compass needle centered as they climbed out to the west ... next stop, Tezpur,

800 miles to the west over the most rugged and tallest mountains in the world. At least the Himalayas were over an hour away. He would deal with them when they got there. For now, keeping *Angry Angel* climbing on course took Vernon's full attention.

The routine climb to altitude went fairly smoothly. Constant instrument flying demanded concentration. Only a light chop in the air made following the outbound beam to Ipin relatively easy. When *Angry Angel* reached the assigned 22,000-foot cruising altitude, Vernon leveled off and set course for the Likiang waypoint.

"Switch to autopilot," Lt. Drake directed Lt. Stephenson.

"Switching to autopilot," came the response.

Still in the clouds, the autopilot took much of the stress out of flying the gauges. Things still had to be monitored because the autopilot's reliability record wasn't the greatest but it did relieve some of the tension.

Chappy poured over his charts, listening to the outbound radio beam as it faded. He knew he had to have the course corrections made to compensate for wind direction and ground speed before he lost contact. Just north of Able Route lay some of China's tallest mountains stretching far above 27,000 feet. Determined to stay on course, he checked and rechecked his figures.

Wham—an invisible giant fist sucker-punched *Angry Angel* and sent her reeling, catching her pilots by complete surprise.

Wham—again jolted into a steep bank in the opposite direction, both pilots grabbed the controls. Lt. Drake reached for the autopilot switch but before he could flip it, the plane vaulted once more knocking his arm away. He tried again. This time he made it and slammed the toggle to the off position. He and his copilot struggled to right the airplane. Again, the airplane felt like a wrecking ball rammed it from above and in an instant, they were dropping 6,000 feet per minute.

"Full power!" Lt. Drake called to Lt. Stephenson who already had the throttles moving forward.

Angry Angel struggled in vain to gain back the altitude lost in the fierce downdraft when the pilots were driven into their seats by vicious vertical winds that sent them rocketing up into blackness.

"Power back. Get the power off!"

With the nose pointed toward the earth in a dive and rapidly approaching Maximum Rough Air Speed, the plane continued its elevator ride upward. Dark grey matter outside lit up with lightning as the aircraft pitched wildly. Both pilots put all their strength into the controls in combat against the forces nature had brought against them.

Crack—lightning struck the trailing antenna sending a powerful surge of electricity into the radios burning wires and vacuum tubes as it went. The flight deck filled with the smell of ozone and smoke from the radio meltdown.

In an aircraft carrying bladders filled with aviation fuel fumes, electrical sparks could easily turn it into a fireball.

Vernon managed to call out over the interphone, "You okay, Coogan?" It still worked.

"Yes, sir. I'm okay but the radios are gone."

Angry rain attacked the windscreen with a vengeance as blinding lightning exploded all around. The highly charged drops burst in violet electrostatic sparks with each impact, turning the glass into a terrifying light show. Saint Elmo's fire danced over *Angry Angel*, leaving 50-foot-long lavender spiral cylinders streaking out from the propellers of each engine.

Struggling with the giant trying to rip the control wheel from his hands, the thought of thousands of gallons of fuel carried to get home on and the empty bladders containing explosive gas fumes invaded Vernon's brain. For a brief second he pondered which was worse, the threat of death from outside the aircraft or the deadly cargo inside. He felt a perverse chuckle well up at the absurdity of the question.

Dead is dead, he said silently.

More violent jolts hit *Angry Angel* hard, each one more powerful than the last as if the clouds were trying to rip the wings from this gangly bird that dared enter their domain.

"Hang in there, lieutenant," Lt. Stephenson called over to Vernon as they struggled to right the aircraft once again. "I'm not going to end my tour this way."

Vernon gave a knowing nod as the control tried to wrench its way out of his grip. He keyed his mic, "Hey, Chappy, how are you doing down there?"

The navigator's station lay below Vernon's floorboards. The initial jolt had sent charts and instruments flying off Chappy's small desk, and his head into the superstructure. Not having a seat belt on his swivel stool, the bucking aircraft sent him careening into the nearest bulkhead. Slightly dazed with blood running down his face and clinging to his desk, he answered, "How about missing a few of those potholes, commander."

Leave it to Chappy to joke around in a serious situation, Vernon thought.

"Right," was all Vernon could respond before hitting another huge "pothole."

He had often felt fearful on bombing runs, over open water, or crossing jungles but he had never felt the intensity brought on by this angry sky. Chappy's humor helped damp down the fear just a bit.

The buffeting, being thrown up and just as fast, shoved down, continued for what seemed hours. Vernon thought *Angry Angel* should have been torn apart long ago. His muscles ached from fighting the control wheel. No longer surprised by the fury of the storm, it became a wrestling match. One he vowed to win. He would make it back. He had to. He wouldn't let *Angry Angel* or Bettie down.

Just when he thought he could fight no more, there would be moments of calm, almost as though the storm allowed a short rest between rounds. With each extreme lurch, Vernon watched the gyro instruments more closely. They were the only things in his bizarre world that confirmed *Angry Angel* remained right side up. If they tumbled, all hope of coming out the other side of the storm would be lost. The struggle went on and on until, almost as suddenly as it began, *Angry Angel* sailed out into smooth air. Still in the soup but the controls had gone quiet.

The two pilots sat motionless, still clinging to the control wheels waiting for the next round but it didn't come. *Angry Angel* had brought them through ... but to where?

"Hey, Chappy, any idea where we are?"

Lt. Chapman had the first-aid kit open on his desk and a bandage wrapped around his forehead. "Somewhere over China or Tibet, I imagine."

With no radio, no visuals, hours of bouncing every which way through storms, and still in the clouds, all of Chappy's skills couldn't locate them. This time it wasn't his fault.

"Go west, young man, go west."

For now, that is all they could do. Head in the general direction of India and hope for a break in the clouds, and that their fuel would last.

"Goodrich," Vernon almost whispered into the interphone. He had a vision of Lt. Goodrich lost in the clouds and running out of fuel although he hoped that wasn't his fate.

"What's that?" Lt. Chapman asked.

"Oh, nothing," Vernon answered. "Just thinking out loud."

Angry Angel plunged ahead under heavy instrument flying conditions. The work kept Vernon busy without much time to think. They were safe as long as the aircraft kept flying. Both pilots eyed the fuel gauges frequently, making mental calculations as to how much time remained before things got really quiet.

"We ought to be near Fort Hertz in Burma, commander," Chappy announced after pondering over the possible scenarios and assuming they were somewhat on course.

Even though they were uncertain of their actual location, the thought that they might be only one last mountain range away from India and the Assam Valley brought hope. With luck, the clouds would part and they could identify a river, valley, or mountains. Once they knew their location, there would be airbases in India where they could land if fuel became an issue.

"Boy," Chappy quipped over the interphone, "sure miss those nice, quiet bombing runs into Burma."

All eyes strained for a color other than white outside *Angry Angel's* windows. They needed a visual reference before the fuel gauges reached the empty mark.

Lost

Skipper and his ground crew lounged under a makeshift tent made from camouflaged tarp hung over scaffolding. The broken clouds and passing rain showers had not cooled the day. In fact, the rain felt as hot as the air—only wet. Puddles of water flooded the revetment where a B-24 should be, making the place a steamy mess.

The sergeant wiped oil from his wrenches with a rag. After carefully inspecting each tool, he laid them side-by-side in order of size in the top tray of his toolbox.

"Shouldn't they be back by now, sarge?" Private Conners asked as he looked up from a handful of playing cards. He shuffled the deck and began dealing cards to three other mechanics sitting on tipped over-buckets around a wooden crate.

Skipper gestured up at the sky with a wrench. "Hard telling with this muck. They could be doin' the jig dodging thunder-bumpers."

Time continued to tick by as the crew waited patiently for *Angry Angel* to arrive. A few more rounds of cards, more tools cleaned, talk of the world back home, and still no sign of 264.

"We might as well pack 'er in boys," Skipper said as he closed his tool chest. "Ops will let us know if they hear anything."

Each man knew what that meant. Chances were good that *Angry Angel* wouldn't return today, if at all. Skipper walked slowly to the jeep, hoping to hear the growl of an approaching airplane. He had lost Lt. Goodrich, and now it's possible Lt. Drake and the flight crew had met the same fate.

The jeep pulled up to the Operations shack.

"I'll be back in a minute," Skipper said over his shoulder to the soldiers remaining as he piled off from behind the steering wheel. He went inside to ask the orderly if he had heard anything from *Angry Angel*.

"No, nothin' yet, sarge. They probably set down at another base. There's been a lot of heavy weather reported over the Rock."

"How about the *Ice Queen*? She's been gone for a couple of days now."

"No word there either. I'm sure they'll be sending out a search plane when the weather breaks."

Those were not comforting words. Millions of acres of jungle and formidable mountains practically guaranteed a downed airplane wouldn't be found unless it went down en route in an open space. Even then, the jungle or a mountain can swallow an airplane. A plane that wandered off course could be anywhere.

Dinner for *Angry Angel*'s ground crew took a solemn turn that evening. No one spoke about the missing aircraft or anything else. The extra effort the cooks had made to spice up the corned beef hash went unnoticed. Back at their tents, writing letters home, reading, or even saying a silent prayer for their missing comrades, made the evening go slowly.

Morning dawned to a blue, empty sky disturbed by the rumbling of tankers taking off to the east. A far cry from the previous day, hot steamy sunshine had returned. Skipper and his crew spent the day lounging, occasionally tossing a baseball around, and playing cards. They all looked up when a returning aircraft rumbled overhead, hopeful to see a familiar silhouette—as if one B-24/C-109 could be discerned from another at altitude. Skipper said he knew the sound of *Angry Angel*'s engines. The others doubted him.

The wait for news made time creep by. Had *Angry Angel* gone down? Had they turned back? Did they land at another base? Skipper's crew wouldn't be the first to lose an airplane but that didn't make it any easier. Losing friends in this war happened often but no one ever got used to it.

The day wore on. Lunchtime came and went. The afternoon ball game took place as usual. There wasn't much to do for the ground crews when their airplanes were flying into China. They waited.

Skipper perked up as he strained to hear the rumbling of an approaching aircraft off in the distance.

"She's back," he whispered.

Pvt. Conners sat next to him on the steps, whittling on a piece of wood. "What was that, sarge?"

"Quiet. Listen." He cocked his ear toward the approaching sound. "She's back," he said louder.

"Who's back?"

"*Angry Angel*. I'd recognize those eighteen-thirty Pratt and Whitneys any day."

"Oh, come on, sarge. You can't tell the difference. They all sound the same."

Skipper stood up and searched the sky. "You bet I can. I've lived with those ladies for a year."

Now both soldiers stood straining in the direction of the sound.

"There … there she is." Skipper pointed at a small bomber profile in the east growing larger by the minute.

"You sure?"

"Damn right, I'm sure. Round up the guys. We're going to meet them."

As impossible as it seemed that his sergeant could identify the sound of one aircraft over another, Pvt. Conners jumped to and spread the news.

"Sarge says *Angry Angel* is back. Grab your gear. We're headed for the revetment."

With Skipper at the wheel, the jeep bounced over the rutted road on the way to *Angry Angel's* resting place as a B-24 lined up on final approach. Still too far away to read the tail number, he had the crew convinced *Angry Angel* had made it back.

By the time they made it to the revetment, the bomber, now tanker, rolled to the end of the runway and turned off on the taxiway. The crew erupted in cheers. Sure enough, 264 could be seen, boldly displayed on the vertical fin of the twin tail.

The big bird rumbled down the taxiway to the revetment. Lt. Drake followed Skipper's arm signals as he guided the aircraft into its parking place. Skipper made an "X" with his arms as Vernon brought *Angry Angel* to a halt. The rumble of the two remaining engines ceased and their massive three-bladed propellers slowly spun down to a stop. Two ground crew members ducked in under the wings and set wheel chalks around each tire. *Angry Angel* was home.

"Good to have you back, lieutenant," Skipper said casually as Lt. Drake ducked out from the bomb bay doors.

"Hope we didn't worry you too much, Skipper," Vernon answered just as casually. "We ran into a bit of weather and had to set down at Chabua. Lightning took out the radios."

"I knew *Angry Angel* wouldn't let you down."

Vernon glanced up at the beauty on the side of the airplane. She seemed to have a smile. Just another day flying the Hump on the surface of things but each man knew how fortunate they were.

At the debriefing, Lt. Drake explained the severe weather and lightning strikes. "Without a radio for navigation and in the soup, we held our best guess heading until we figured we had cleared the mountains and were over the Assam Valley. Fuel was getting low so I figured we could let down and hopefully get under the clouds. We set a minimum altitude to descend to. If we didn't break out and ran out of fuel, we could bail out."

Lt. Stephenson sat silently as Vernon continued.

"We did break out at 1,500 feet in rain and found we were over the Luhit River. We followed it south, got a green light from Chabua, and landed. They fixed us up with a replacement communication radio."

The debriefing officer, Captain Nelson, reached out to shake Lt. Drake's hand. "Well, we're glad to have you back, lieutenant. Others weren't so lucky. We lost a number of planes in that storm. It was the worst we've seen since we've been here." He handed out glasses and lifted a bottle. "I believe that deserves another round of mission whiskey."

After the briefing, the flight crew walked to the mess hall for a much-needed meal. On the way, Lt. Stephenson lagged back with Vernon. He cleared his throat and said, "I want to let you know, lieutenant, that you flew a good mission. You'll do all right as aircraft commander. I just hope you continue to be as lucky as you were this time."

"Thanks," Vernon said humbly. "I'm glad you were with us and we got you back home."

"Speaking of home, I ship out tomorrow. I would have been more than a little upset if I would have missed my flight."

At the mess hall, Lt. Stephenson broke off to sit with some of his friends. Evidently, Lt. Drake had passed his review. The question now remained, who would be his copilot?

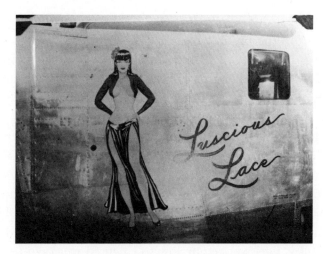

Luscious Lace painted by Lt. Vernon Drake on a B-24 in Pandaveswar, India, in the 493rd Bomb Squadron, 7th Bomb Group, 10th Air Force.

The following day, Skipper informed him that repairs to *Angry Angel* would take a day or two. A friend of his wanted to ask if Vernon would paint a lady on the side of their C-109. They wanted the Miss Lace character from the "Mail Call" comic strip in military newspapers. The statuesque Miss Lace, known for her voluptuous curves barely covered by flowing gowns, had become a favorite morale booster for GIs all over the world. The sexy, sophisticated, brunette mixed with servicemen in all sorts of circumstances, from the trenches to the airfield. The crew wanted to name their ship *Luscious Lace*.

Another painting would keep him out of the air for a few more days. Vernon welcomed the opportunity—a win-win for everyone. He enjoyed the painting, even with the heat, and he wouldn't face those formidable rocks for a while. That meant sleeping at night and a calmer stomach after meals. Although he didn't show it, every trip took a toll on his body.

News from Home

Luscious Lace took three days to paint, working early in the morning and late at night to avoid the unbearable sun. Vernon could have done it in two, but the crew flew a mission after he had almost finished the morning of the second day. When the tanker came back that evening, much of the paint had streaked down the side of the aircraft creating a real mess.

Each day, Vernon made a trip to the mailroom, each time coming away empty-handed. He flew *Angry Angel* on a few more trips following Able Route, each time with a new green copilot in the right seat. Luckily, the weather wasn't too bad. The trips always involved some instrument flying but were manageable. Vernon couldn't decide if he preferred flying instruments through the unknown or in clear air over the craggy spires that stretched for hundreds of miles. As awesome as they were, the thought of being forced down terrified him. At least if he hit rock in the clouds, he wouldn't see it coming.

"I've finally got something for you, lieutenant," the postal clerk said as he handed over a V-mail.

"That's it?" Vernon fingered the thin folded and sealed paper.

"Sorry. At least it's something."

Before he got to the door, Vernon had it open.

"Dear Son," it read.

Darn, it's not from Bettie. He felt a pang of hurt and excitement at the same time. He had hoped for news from home and here it was. His heart

longed to see Bettie's handwriting but a letter from his mother would do. She might tell him something about the love of his life.

Vernon read through the short letter. V-mail didn't allow much space. His mother wrote about the farm. The harvest had been good and his father resumed building the addition on the house. Everyone at church prayed for their service boys every day.

Finally, news of Bettie.

"Dan and Clara Ross have moved back to Billings. Dan purchased an unfinished house out on Custer Avenue. Bettie and your daughter, Lana, have moved in with them."

That's it? That is all there is about Bettie?

Back at the basha, Vernon sat on his cot, his lap filled with old letters from Bettie. At least he knew where she was and that she and the baby were okay. If they weren't, surely his mother would have written something

"Hey, Drake," Chappy poked his head into the basha. "We're on the board for tomorrow again." He saw Vernon sitting with his head in his hand staring at the pile of letters. "What's up? Did you finally get mail?"

Without looking up, Vernon answered in a low, quiet voice. "I did, but still nothing from my wife. I got a letter from my mom. Not much news though."

"Man, that's the pits. Hey, come on. Let me buy you a drink at the Rocker Club."

Vernon stuffed his letters into his bag and threw it on the cot. "You know, that sounds like a good idea."

The two mounted their bicycles and rode the half mile to a thatched building that had become the Officers' Club named the Rocker Club for the row of rocking chairs on the veranda.

Vernon wasn't a complete teetotaler, but his alcohol intake had been limited to a shot of mission whiskey and a very occasional beer. He needed to hear from Bettie. The thought of her had kept him going. When fear welled up, he would picture her face. That gave him the confidence to push ahead, a goal, a reason to live when others were dying.

The next morning, as the runner announced the wake-up call, Vernon's head pounded. He rolled over, slowly sat up, and slipped his feet into his shoes.

Chappy looked at his suffering friend. "How are you feeling this morning, sport?"

"Ohhh ..." Vernon cupped his head in both hands. "Not so great. Why did you let me drink so much last night?"

"It wasn't that much. You just can't handle your liquor."

"Well, I don't have much practice. And if this is the way I'm gonna feel the next morning, I doubt I'll be doing much practicing."

The business of preparing for the flight to China kept him from thinking too much about the previous day's letter—a quick breakfast, assembling his gear, the morning briefing. Before long, his jeep pulled up to the revetment where *Angry Angel* sat waiting. Skipper and his crew were buttoning up the last cowling after a night's maintenance. The fuel trucks had their hoses wrapped back on their racks, their job done for the day. Bulging aircraft tires groaned under the weight of 4,500 gallons of explosive liquid cargo.

Vernon began his walk-around preflight check and looked up at the lady on the side of his plane. No smile today. She seemed distant, angry—lifeless.

Not you too, Vernon heard himself thinking.

"I hear you painted her," the nameless new copilot said from behind. "Gee, she's swell."

"Yeah, thanks," Vernon answered in monotone. Another time he might have told the young pilot how she had brought them through dangerous bombing runs and ferocious weather over the Rock the day 13 planes were lost—but today he didn't feel like saying much of anything. He would do his duty and hopefully get back alive.

The trip to Lushien had become routine, as routine as any flight over the Himalayas could be when crossing beautifully terrifying terrain. *Angry Angel* dodged a few thunderheads, bounced through mountain turbulence, sailed high over endless stretches of impenetrable jungle, and squeezed through towering passes.

Vernon let the new guy do much of the flying while he monitored and tried not to think about the letter. Unfortunately, on a fairly uneventful trip over the Hump, there was a lot of time for thinking. He busied himself with reviewing charts and procedures but the lack of any letters from Bettie pushed its way in.

Fresh eggs and meat in China didn't perk him up nor did the green copilot's reaction to the rare delicacy. He took over guarding the airplane early just to get away from the typical mission chatter. From under the wing, he watched a gang of coolies struggle under the weight of a two-ton roller as they dragged it across fresh taxiway gravel. Gravel made by hand and a hammer.

What do those poor souls think of war? he wondered. The whole thing didn't make a lot of sense.

Flying back over Able Route on a fairly clear day, Vernon felt small—flea-size small. The mountains towered, the miles stretched on forever, the empty sky above grew a darker blue the higher they climbed. It all seemed so unreal. *Angry Angel* could be swallowed up whole and no one would ever find her. Her crew would be missed and then forgotten. Thirteen planes disappeared in that severe storm he went through. Goodrich went missing only days before. Life went on. The war went on. Only by some miracle had *Angry Angel* survived.

Family and sweethearts gave the men hope. Hope suffered when they were no longer there.

The copilot did a decent job of landing at Tezpur. After taxiing to the revetment and shutting down, Lt. Drake made a point of complimenting him, remembering how stressed he, himself, had been on his first flight over the Hump. He could see the relief cross the young pilot's face.

Young pilot? That's funny. He's probably no younger than I am. Age here is determined by hours in the air, not years on the ground.

After a quick debriefing, the flight crew went to drop their gear off at the basha before going to the chow hall for dinner. As Vernon ducked into the basha, he could see someone sitting on Goodrich's cot in the dim light.

Forgotten and replaced, Vernon thought. *As if someone could replace Goodrich.*

The dark figure turned and spoke, "Hey, Drake. How was your trip?"

"Goodrich?" Vernon was shocked. "It's you ... where did you ... how the heck ... where have you been?"

Miracles

Lt. Goodrich looked thinner and browner in the dim light of the basha but his wide grin hadn't changed.

"Back from the dead," he said to his crewmates as he spread his arms out wide. "You know you can't get rid of me that easily."

Vernon stuttered, "What happened? Where have you been? We never heard anything."

"Well, I know what the Burmese jungle looks like from the ground up and I wouldn't recommend it."

"Come on," Chappy chimed in. "Spill it. Don't keep us in suspense. What happened?"

"Okay, okay." Goodrich sat on his cot, elbows on his knees. "Well, boys, it's like this. We were coming back on Charlie Route when we hit the soup around Shingbwiyang. Twenty minutes into the clouds we lost the number three engine and electrical power. The radios went down so we were flying blind. The ol' *Ice Queen* did a good job of staying in the air and the biggest rocks were behind us so we kept heading west and hoped for a break in the clouds."

"I've been there—done that," Vernon said absentmindedly, thinking about his struggles with the storm weeks before.

"Fuel was getting low and we figured that the off-loaders had shorted us. We probably had enough to make a base in the Assam … if we had known where we were. We tried to get under the stuff but weren't sure if we'd cleared the last mountain range."

Vernon and Chappy sat riveted as they listened. Vernon pictured himself in the cockpit right along with Goodrich.

"Finally, the commander gave the order to bail out. We put her on autopilot and hit the silk."

"Boy, I can't even imagine how that must have felt," Chappy said.

"Yeah. I can tell you it scared the hell out of me. I didn't know what we were getting into. I only knew I'd probably be better off floating down than crashing into whatever."

"So, what happened? Where did you land?" Vernon asked impatiently.

"There's nothing like hanging under a chute in the clouds." Goodrich reached up like he had grabbed the harness straps above his head.

"All of a sudden it was perfectly quiet except for the *Ice Queen* sputtering off in the distance. You can't tell you're falling. You're just sitting there in a swing in the mist. Then I heard the commander calling somewhere off in the white stuff. I yelled back I was okay. I heard a couple of the other guys calling back too. It seemed like I hung there for a long time until, finally, the jungle opened up about 100 feet below. I crashed down through some branches and ended up dangling 10 feet from the ground. I swung over to the trunk and got myself and my survival kit to the ground."

Goodrich went on to tell of his ordeal while Vernon and Chappy sat, entranced, on their cots.

"Between the rain, the mist, and hacking through the jungle, it took all day to find the other crewmembers. Corporal Ritter, our radio operator, broke his ankle when he landed on some rocks. We managed to splint it up so he could hobble. The rest of us were okay except for cuts and bruises from coming down through the trees.

"We weren't sure where we were except we figured we were on the western slope of the last mountain range. That meant that any streams or rivers would lead down into the Assam Valley.

"I gotta tell ya, sleeping on a jungle floor in the rain is mighty spooky. You wouldn't believe how dark it is. Plus, I think every creepy-crawly thing around found me. Anyway, we discovered this overgrown footpath that made going a bit easier and followed it down to a stream. We heard that the people in that area were pretty primitive, so we weren't looking forward to running into any. For two days we never saw a soul, we just stayed on the path and followed the stream.

"By the third day, we were all getting pretty tired of hiking. I was getting hungry. The chocolate bars, dehydrated cheese, and K-biscuits in my survival pack didn't exactly make for a filling meal."

Chappy butted in, "Nothing in the jungle you could eat like maybe some fruit or a rabbit?"

"Nope. At least nothing we felt safe trying. A couple of snakes started to look tasty, though.

"Anyway, about mid-day our stream connected with a small river and a wider path. As we came around a bend, this painted-up native guy stood in the path looking at me. Naked as a jaybird, he carried a long spear. I don't know who was more surprised, him or me. Anyway, he took off down the trail and disappeared. A little while later he showed up with a half-dozen more of his tribe. I don't think they had ever seen anything like us before. They checked us out pretty good. I was glad I strapped on my Colt before I jumped. Those spears looked pretty lethal.

"As it turned out, they were more curious than anything. Lieutenant Jefferies tried to explain to them through hand signals that we had fallen from the sky. I don't know what they thought but they flashed big grins and signaled us to follow 'em. Those guys could travel. We couldn't keep up, especially with Corporal Ritter's ankle. We made him a crutch and took turns helping him, but we moved slow. Our new friends would show up every now and then and signal us to keep following. By late afternoon, they led us into their tiny village. The whole tribe turned out from a dozen huts to look us over."

Lt. Drake shuffled to find a comfortable spot on his straw mattress. "I hear there are headhunters in those Burma jungles."

"You heard right, and these guys probably were, too. We didn't know if they planned on us being their next trophy or what. They seemed friendly enough, offered us food and a place to sleep. I recognized the fish but I'm not sure what the other stuff we ate was.

"The next morning they had made a stretcher for Ritter and had us follow them again. We followed the river the whole day and came to a larger village. There, they took us to meet a French missionary named Father Francis. He spoke some English and took us in. We gave some

of our survival gear to the natives who brought us. You would have thought we were giving them gold.

"Turns out we were on the Turang River and Father Francis had come up from a small town a few miles downstream called Ngaiung Ga where he had a mission. The next day we made the hike and Father Francis put us up there for the night. He wrote a letter and sent a runner down to Shwangni Ga where they had a radio. The next day an L-2 circled overhead dropping supplies to us. Inside we found a note telling us to make our way to Shwangni where a search party would pick us up.

"The cart path to Shwangni sure beat the trails we had been on. In fact, we put Ritter on a two-wheeled cart and pulled him along. That little trip took almost two days. By the time we got to Shwangni, I didn't think I could walk another step. I've never been so happy to see a Tommy in all my life. A British soldier sat in his truck, waiting to pick us up.

"We handed out the last of our supplies to the locals and bounced our way down what I would barely call a jeep trail, to another small village. The next day got us to Ledo where the Royal Air Force flew us to Jorat for a medical checkup and a few days of R&R. You'll never guess who I ran into there?"

"Who?" Vernon and Chappy said in unison.

"Lieutenant Parker," he answered with a wink.

"Lieutenant who?" Vernon raised his eyebrows in confusion.

"You remember—Emily Parker—the dolls we met at the Casanova Restaurant."

"You're kidding me," Chappy sputtered.

"Yep. She kept me rested and relaxed for two days," Goodrich said with a satisfied look.

"Whew!" Vernon sighed. "That's amazing. All I can say is, you're one lucky son of a gun. If anyone could escape the Burmese jungle and end up in the arms of a dame, it'd be you. I'm glad you're back."

"Me, too," Chappy chimed in. "I think that deserves a drink. How about a trip to the Rocker Club? I want to hear more about this R&R. I'm buying."

It didn't take any persuading. The three headed out the door to celebrate Goodrich's return.

Goodrich's amazing adventure picked Vernon's spirits up. It made him appreciate even more his good luck the day he survived that terrible storm. If Lt. Goodrich could jump into the jungle and come out alive, miracles were possible. He could outlive the war and return home.

Two days later, Lt. Goodrich's name showed up on the daily roster as Vernon's copilot. The crew would be back together again, Lt. Goodrich, Lt. Chapman, Sgt. Stinson, Pvt. Coogan, with Lt. Drake as aircraft commander. Vernon and Goodrich had shared flying duties in the past, but the question never arose as to the final say. That role fell to Lt. Goodrich, the aircraft commander who always sat in the left seat. How Goodrich would take this new role reversal, Lt. Drake didn't know.

CHAPTER 37

The Stack

Lt. Goodrich looked up at the side of the bomber-turned-tanker to see *Angry Angel* as resolute as ever. "It's good to be back," he said to Vernon. "If I have to go to China, *Angry Angel* and her crew are the ones I want to make the trip with. And, just so you know, I've got no problem with you as aircraft commander."

"Thanks, pardner," Vernon said as he gave Goodrich an "ah shucks" fist thump on his shoulder. "We're a team regardless of who's in the left seat."

"I've had plenty of right-seat time since we scraped the tarmac and I've almost gotten used to it," Goodrich replied with a "yeah, right" grin.

The trip to Lushien contained typical thunderstorms to skirt, mountains to dodge, and turbulence to battle. When the clouds cleared over the Himalayas, no more awe-inspiring sight could be found anywhere on earth. Terrifying in their ruggedness, yet majestic in their immenseness, Lt. Drake never lost the feeling of insignificance in their presence.

In Lushien, Lt. Goodrich entertained the crew over fresh eggs and mystery meat with his tales of survival and his encounter with Lt. Emily Parker. As the lieutenant bragged about his romantic adventure, Vernon's mind drifted off to Bettie.

"Sorry you haven't heard from your wife," Goodrich butted into his thoughts. "Chappy told me you're not getting your mail."

"Yeah, well, I really don't know what's going on. I haven't heard from her for months."

"That's tough … but hey … Uncle Sam is bound to get their SNAFU fixed up eventually. Everything will be just fine when you get back."

Getting back presented the real challenge. It took 600 hours of flight time to earn rotation back to the States. Vernon and his crew were only halfway there. The odds of making it kept decreasing with Command's "No weather" policy. "No weather" meant ignoring the weather. No matter what, they flew. More planes and crews were lost flying the Hump than bombing in Burma.

Angry Angel climbed out into the Chinese sky and headed west toward India. Back across western China, the mighty Himalayan Mountains, the jungles of northern Burma, the farmland of the Assam Valley, and touchdown once again at Tezpur 10 hours later. Weary and hungry, the chow hall became the next destination but not before a stop at the mailroom.

"This is your lucky day lieutenant," the clerk said as he pulled a bundle of letters from the wall of pigeonholes. "Here you go. Looks like Uncle Sam finally got his mail glitch figured out." He handed Vernon the stack of V-mail several inches thick.

Vernon let his flight gear slide to the floor as he reached for the package. He cradled the paper bundle as if it could disintegrate in his hands. All thoughts of weariness and food flew from his mind. He had letters … lots of letters. He grabbed up his gear and charged out the door to the waiting jeep.

"Hey, boys—look what I got," he yelled, waving the stack of mail high above his head. "Get me back to the basha, I've got some serious reading to do."

At the basha, Vernon sat on the edge of the porch, a pile of new V-mail letters next to him. He sorted through them, making a small pile for the family, one for friends and relatives, and one for Bettie. Once done, he stared at the pile of letters from Bettie. He fanned them out on the porch deck and arranged them by date.

Should I open the oldest one or the most recent one first? Maybe I should just get it over with and open the most recent one.

Picking up the top letter, he carefully opened it. Bettie's neat, flowing handwriting, even at a third the original size, plucked a heartstring.

"My Dearest Darling,"

That's a good start!

"I know you haven't been getting my letters, but I have been getting yours. You sound so sad. I only hope you will get this one. I wish there were something more I could do but I can only keep sending them."

Good, she got my letters.

"Dad's been working hard on the house. I'm still in the attic sleeping on a mattress laid over the open beams with Lana's pram next to me on a piece of plywood. It's okay for now. We are getting along just fine. I wish you could see her, Vernon. She is getting so big so fast.

"I got a job as a parts picker and shipper with Mopar Auto Parts. It's a good job and mom takes care of Lana when I'm at work."

The rest of the letter told of her mother, father, and how much Fern missed Ed who had been called up. It ended, "With love, Bettie."

Vernon tore into the oldest letter.

"My Dearest Darling, how I miss you so. I hope you are okay. I can't imagine how hard it must be for you.

"I started a second job today cleaning spark plugs for Mulvaney Motor Company. It doesn't pay much but I feel like I'm doing my part to help the war effort. I can't be there with you but at least I'm contributing something. It really hurts to see some of our boys coming back in a bad way. I pray every day that you will be safe."

More local news followed and then ...

"My Dearest Darling, I have some bad news. It's about Cal. At Basic Training in Fort Benning, he had a terrible accident that absolutely crushed his leg. He has been in the Fitzsimmons Army Hospital in Denver for months now."

Wait ... what?

"The doctors had him in the operating room for hours. We thought they might have to amputate his leg. Can you imagine that? Instead, they put in a steel pin. He's flat on his back with a huge cast suspended from a rack at the end of the bed. He looks so sad in pictures even though he is smiling."

Poor Cal ... but ... Vernon felt bad for Cal. He also felt a little guilty for not trusting Bettie. Even though Cal lay injured, he had the advantage of being there while Vernon remained on the other side of the world.

"My Dearest Darling, you sounded so sad in your last letter. I don't know why you aren't getting mine. I wish I knew where you are stationed. It's so hard not knowing. You are so far away.

"I have been very busy between my two jobs, house chores, and looking after Lana. Cal is still in the hospital. Shirley and I volunteered to help out at the Williamsons. I'm happy to contribute where I can. He seems to be in better spirits although the doctors told him that his leg would never be the same. We're not sure exactly what that means. I guess the silver lining is that he won't have to go to war.

"The congregation prays for all you boys overseas at every serv …"

Vernon didn't hear Chappy come up behind him. Chappy sat down on the porch edge and looked at the piles. "What's the verdict? You still married or do we make another trip to the Rocker Club?"

"Still married and wishing I was there and not here."

"Well, cowboy, I'm glad to hear you're not on the outs. Sure don't like seeing you mope around here. If you want to keep your strength up, you better get over to the chow hall before it closes. You know, we've got a run to Kunming in the morning."

Vernon gathered up his letters and put them in his locker. He did have to eat. He would finish reading the others when he got back. Maybe he would find more clues in those from friends and family. If nothing else, he knew Bettie hadn't abandoned him. That's something.

An evening rainstorm unleashed its warm liquid as Vernon jogged to the chow hall. Nearing the end of the monsoon season, rain had become an expected event several times a day—part of life in the Assam. Tomorrow he would be doing battle once again with those forces of nature that had become his war.

USS *Missouri*

The next few weeks were filled with trips back to Kunming and Lushien. With the monsoon season coming to a close, there were actually a few days where *Angry Angel* encountered little instrument flying. A few approaches to Kunming meant letting down in the stack of airplanes while flying blind, always a harrowing experience, but Lt. Drake and Lt. Goodrich had come to expect it. Now old pros, they enjoyed playing the role of hardened, experienced Humpers. They didn't have to embellish their tales of terror in the skies—they were real enough. The hardest part came when they had to say goodbye to friends and squadron mates that didn't come back.

"Did you hear the news about your buddy, Harris?" Chappy asked Vernon over a plate of hash.

"No. What?"

"They went in somewhere east of Fort Likiang. Probably hit rocks because they didn't radio they were having trouble. They just never reported crossing Hsinching."

Vernon sat slightly stunned. Although he hadn't seen much of Lt. Harris since Calcutta, he sure didn't want to hear that news. Learning about other flights crashing took its toll but when someone he knew disappeared, his soul mourned.

"Boy, I hate to hear that. He was a great guy. We had some good times."

Vernon didn't want to spend too much time thinking about Harris or the others. That brought on depression. He had a difficult enough time holding it together without contemplating that he might be next.

The following day, *Angry Angel* made another haul into Kunming. The weather remained clear with only cirrus clouds and a few buildups. A high-altitude tailwind shortened their trip by nearly an hour. When they called into Kunming for landing clearance, the voice on the other end sounded almost giddy.

"Welcome to Kunming boys. You're just in time for the party."

"Party?" Lt. Goodrich answered back.

"Haven't you heard? It's official. The Japs surrendered. The war is over!"

"You're kidding?"

"Not kidding. Cleared to land straight in on two-six. Over."

"Roger, Kunming."

Vernon looked at Goodrich. Goodrich looked at Vernon. Both locked in shock for a few seconds, not believing what they just heard.

Lt. Goodrich breathed out. "Do you suppose that's really true? They wouldn't joke about a thing like that, would they?"

"Whoopie!" Vernon tossed his chart in the air. "It'd better be. Let's get this gal on the ground and find out."

After landing, loading crews confirmed that the war had, indeed, ended—at least for most of the Japanese. The bases would stay on alert with business as usual for a while.

"We dropped some kind of super bomb on a couple of Japanese cities and that did the trick," the Operations officer answered Lt. Drake's inquiry. "President Truman announced it on the radio. He said all Allied armed forces have been ordered to suspend offensive action. Looks like you boys will be out of a job soon."

"Can't be soon enough," Chappy added.

Vernon, Goodrich, and Chappy found a celebration going on in the chow hall. Beer flowed freely, the Andrew Sisters belted out Boogie Woogie Bugle Boy over the loudspeakers, and soldiers danced around, ecstatic at the news.

"Go easy on the beer, guys," Vernon warned. "We still have to get back to Tezpur." He might as well have been telling them to quietly sit

in the corner—it wasn't going to happen. By the time the ground crew had off-loaded their 2,300 gallons of liquid cargo, *Angry Angel's* flight crew could have flown without the airplane—all except for Lt. Drake. He went out to the flight line and found the crew chief.

"Check her over real good. You might find a problem with one of the engines and ground this bird for the night." He gave a wink.

"No, she's good to …" The chief realized what Lt. Drake wanted. "Now that you mention it, lieutenant, I am a bit concerned about a magneto on number two. I'd like to pull it off and check it out. I'll let Operations know. Should have her fixed and ready to go first thing in the morning."

"Thank you, sergeant."

With a sharp salute, Vernon left *Angry Angel* in the mechanic's hands and rejoined his crew in the festivities.

The next morning, with heads feeling the results of the night before, they prepared for the flight back to Tezpur. Kunming remained on alert, not only because of potential renegade Japanese attacks but also Chinese Communists who saw an opportunity with the war ending. China's war with Japan may have ended but the civil war within China continued. The coolies still struggled with their rollers, shovels, and buckets. Aircraft still came and went. Activity hadn't changed but, somehow, the air seemed lighter.

As the flight crew boarded *Angry Angel*, Lt. Drake remarked, "It won't break my heart if I never see this place again."

For all they knew, this wasn't their last trip to China but it felt like it.

As the sun followed the growling, four-engine tanker westward, Vernon dreamt of his homecoming, his parents meeting him at the station, that first glimpse of Bettie, his little girl, and a warm greeting embrace. The thoughts were wonderful but the 8,000-mile barrier between here and there left an empty pit in his stomach.

Ragged, snow-covered peaks drifted by and gave way to jungle-covered mountains. The radio compass guided the way. Chappy fed headings to the flight deck. Pvt. Coogan kept the radios humming; Sgt. Stinson monitored the engine gauges from his station behind Lt. Goodrich. They had become an efficient team, each doing his job knowing they could fully rely on the others to do theirs.

The wide Assam Valley came into view as northern Burma fell away. A slow let down toward Tezpur and they would be home.

Home, Vernon thought. *How strange that sounded ... Tezpur as home ... this place where he felt safe until the next flight over the Hump.*

As *Angry Angel* taxied into the revetment, nothing seemed to have changed, that is until they swung out of the bomb bay door to be greeted by a grinning Skipper.

"Did you hear the news? The Japs surrendered!"

With that, the celebration started all over again. Everywhere they went on the base, spirits were high with smiles and the two-fingered victory sign being flashed at every meeting.

Weeks went by as the tankers and cargo planes continued to fly but the converted B-24s sat idle. Vernon and his crew lounged around trying to keep occupied in anticipation of what would come. On September 2, 1945, Armed Forces Radio announced the formal signing of the Instrument of Surrender aboard the battleship USS *Missouri* in Japan's Tokyo Bay.

On Monday, September 10, Lt. Drake burst into the basha. "I got our orders, boys. We're being sent back to the 493rd at Pandaveswar. Skipper's crew has to remove the fuel bladders before we can go. That'll take a week or so. In the meantime, we're on our own."

Chappy grabbed a towel from the laundry line stretched across the room and swung it over his head. "Yahoo! That means no more Hump! Goodbye rocks!"

"And no more flying gas tank," Lt. Goodrich added.

For the next few days, the flight crew spent much of their time at the revetment helping the mechanics remove the rubber bladder tanks and plumbing. Skipper's maintenance crew also received orders to report to the 493rd along with Vernon's flight crew. Everyone loaded their bags onto *Angry Angel* and headed for Pandaveswar.

Bombing of Burma had ceased as well so bombers sat idle in their revetments on the Pandaveswar airfield. Crews did odd chores, played baseball and cards, or hung out at the Officers' Club. Each day they listened to Armed Forces Radio and checked the bulletin board for news that would determine their fate. Rumors flew about being reassigned

to pockets of resistance or other bases. Fighting had erupted in China between the Chinese Communists and the Nationalists party of Chiang Kai-shek. The US Airlift Command continued to fly thousands of Nationalist Chinese troops into Japanese-controlled territory to accept the Japanese surrender. Lt. Drake and his crew feared they would be pulled into that role as experienced Hump fliers. The war may have been over, but the flying didn't stop for many pilots. As days went by, aircraft began leaving Pandaveswar, not to return.

"Sir, you're to report to the commanding officer of the 9th Bomb Group at 1400 hours," the runner informed Lt. Drake.

"What's it about, corporal?"

"I don't know, sir."

"Could be good news or bad news," Chappy said while slapping his baseball glove with a ball. "Let's hope it's good news."

With legs weak in anticipation, Lt. Drake marched into the Col. Dodson's office hoping he didn't still hold a grudge over the crashing of the *Spirit of Fort Worth*.

"At ease, lieutenant. I've seen the paintings you've done on the aircraft. Very impressive. I'd like you to do one for me. I've been rotated to the States and will be flying one of the planes back. I'd like you to paint nose art on that plane."

Vernon felt the tension flow out of his body. He didn't get the news he wanted but it wasn't bad either. "Yes, sir. I could do that."

"Great. My idea is a gal stepping into her skirt with the title, *Mission Completed*."

How ironic, Vernon thought. Less than a year ago this same commander had to look the other way while crews painted the banned images on their planes.

"Oh, and by the way, lieutenant, you and your crew have your choice of aircraft to fly back, too."

Vernon had to make sure he heard right. "What was that, sir?"

"Pick up your orders on the way out. You're going home."

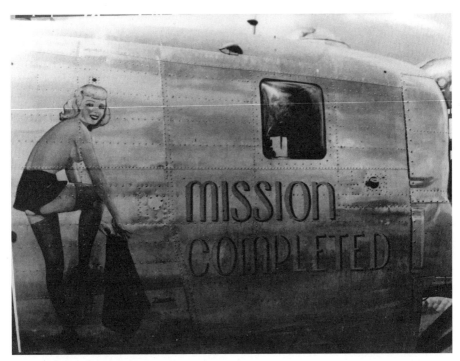

Mission Completed painted by Lt. Vernon Drake on a B-24 in Pandaveswar, India, in the 9th Bomb Squadron, 7th Bomb Group, 10th Air Force. This is the aircraft that Lt. Drake's commander flew home at the end of the war. The original painting is now in the Commemorative Air Force collection.

Going Home

Vernon spent early mornings and late evenings painting *Mission Completed* on the group commander's aircraft. He, Lt. Goodrich, and Chappy, filled their days planning their trip to semi-circumnavigate the globe. It seemed unreal. Sure, they had flown into Burma, crossed the Himalayas, landed in China but now they would be flying over three continents, two seas, and the Atlantic Ocean.

"It's just a bunch of hops all strung together," Goodrich would say. "We've flown a lot farther than that, just not all at one time."

Their orders reassembled the original crew including Lt. Froula and the gunners. No one questioned *Angry Angel* as their choice of aircraft. Twenty bombing missions into Burma and 29 over the Hump, she had brought them home safely each time.

Skipper and his maintenance crew would be on board, along with other passengers being transported back to the States. All-in-all, 28 war-weary souls would be winging their way west. But that wasn't to be.

"Sorry, lieutenant, she's grounded." Skipper's head sagged to his chest as he held his rumpled cap in his hand. "I found a crack in the main spar. It's a wonder she didn't come apart flying over the rocks with all that weight. There's no way it's going to make it all the way to the states. You'll have to find us another ride."

The news came as a real blow to the crew. It seemed like a real betrayal to leave *Angry Angel* behind after all they had been through together.

Back at Ops, Lt. Drake checked the roster of available planes. Scrolling down the list he stopped at *Cute Lil' Lass*. Her nose had one of his best paintings on it and he had flown her on several trips. She handled the best of all the ships he had flown ... an easy choice.

At 0730 on November 5, *Cute Lil' Lass* broke ground for the last time from Pandaveswar with Lt. Drake and Lt. Goodrich as co-commanders.

Lt. Goodrich took the first turn in the left seat. "Let's give these boys a real farewell," he said as he made a steep bank back toward the field. Dropping down to treetop level, *Cute Lil' Lass* roared over the basha area in a low pass that Vernon was sure blew the thatched roofs off the huts. The wannabe fighter pilot in Lt. Goodrich had returned. If he could have done a victory roll in a B-24 bomber, he would have. Next stop—across Northern India to Karachi on the Arabian Sea.

The miles passed slowly over the monotonous farmlands of India—a never-ending carpet of small villages and tiny fields where life hadn't changed in a thousand years. Vernon broke the monotony with a low pass over the Taj Mahal at New Delhi, one of the few cities of size they encountered. Cameras clicked from every portal on the plane. For hours, the bomber bounced her way west. Without oxygen for her passengers, she had to make her way at lower altitudes below the clouds where heated air boiled upward guaranteeing a rough ride. No one complained. They were heading home.

Eventually, after a long day, the aircraft wheels squeaked on Karachi pavement. The airport buzzed with activity, as did every part of the city. Karachi had become the port for embarking personnel of the CBI Theater under a plan code-named *Operation Magic Carpet*. Troops were shipped in by train and air to be put on transport ships bound for home.

More interested in heading home than seeing the sights, the crew had their first real decent meal at the American Red Cross Club. They had seen enough of India to last a lifetime. A good night's sleep and they were off again the next morning.

In the early light, Lt. Drake hugged the coastline of the Gulf of Oman. He had never gotten used to crossing open water. Eventually, he had to span the Persian Gulf to the Arabian Peninsula. Once over dry land again, the earth was indeed very dry. Hours passed as they droned on

above the trackless emptiness of forbidding desert with not a soul, road, or village for 700 miles.

"What do you think would be worse, going down at sea or in the desert?" Goodrich asked Vernon.

"Well, I would rather be walking than swimming and the desert doesn't have too many sharks."

"Either way, your goose would most likely be cooked. It would just take longer in the desert."

Finally, a stark mountain range appeared, signaling the end of the desert and a descent into the Jordan valley.

"I've got the airplane," Lt. Goodrich announced. He took the controls, pulled back the power, and began rapidly losing altitude.

"What are you doing?" Vernon asked.

"I want to tell our kids someday that we flew an airplane below sea level."

True to his fighter pilot ego, Goodrich dove down to a few hundred feet above the shores of the Dead Sea, the lowest land-based elevation on Earth. At that point, *Cute Lil' Lass* cruised out over the salty brine at a thousand feet below sea level. She popped up over the Judean Hills for a rooftop pass over Jerusalem.

From there, Goodrich banked southwest over the Sinai Peninsula, the Mediterranean Sea on the right, and the desert once crossed by escaping Israelites of biblical times. Once again, the awe of being so close to the land where the Bible stories of his youth took place left Vernon speechless.

"This time we're going to get a good look at those pyramids," Lt. Goodrich announced as they crossed the Suez Canal into the fertile Nile Delta. "Tell the boys to get their cameras ready. They'll be looking up at those things."

By the time they reached the outskirts of Cairo, Goodrich held the bomber just off the deck heading straight for the tallest pyramid. Any camel riders were sure to get dumped as their animals scrambled for safety. True to his word, Goodrich zoomed between two ancient structures and pulled up in a climbing, arching turn while cameras continued to snap pictures.

"That'll be one for the albums back home," Vernon said as he clicked a few shots for himself.

Once on the ground at the Royal Air Force Base west of Cairo, the crew decided they needed a break from two days of traveling and spent the next day sightseeing in the city. Vernon found a nicely tooled leather purse to add to the inlaid box he had purchased in Calcutta for Bettie. In a few days, he would be watching her face as she opened his gifts. He hoped she would be pleased.

The following day would be the longest yet—from Cairo across the whole of northern Africa to Marrakesh in Morocco. Again, miles and miles of uninhabitable desert bumping up against the deep blue of the Mediterranean Sea with the last half from Tunisia to Morocco nothing but barren rock and sand.

At Marrakesh, Lt. Drake and Lt. Goodrich were called into the base commander's office.

"Seems you men have gained quite a reputation. I have here reports of some crazy stunts you've been pulling, not only endangering your crew and passengers but people on the ground, too. I know you're anxious to get home and may think you're not in the army anymore but you are still wearing the uniform and representing America. By all rights, I should throw the book at you."

The two aircraft commanders shifted uncomfortably. Lt. Drake figured they would probably be taking a boat the rest of the way home.

"I'm pulling your passengers. You and your crew will carry on … without another incident … you understand? Any other time, you would be in the brig. If you want to see an honorable discharge, you'll keep it clean from here on out."

"Yes, sir. We understand. Thank you, sir."

With that narrow escape, *Cute Lil' Lass* lifted off for Dakar, lighter by 18 passengers than she arrived with. Only the original crew stayed on board, Lt. Drake figured those other poor souls would be taking the slow boat home.

A stop in Dakar overnight, gas tanks topped off, ocean survival gear checked and rechecked, and the lightly loaded, four-engine machine launched off over the broad, endless stretch of water known as the

Atlantic Ocean. Vernon's heart beat a little faster as the African Continent disappeared behind him and nothing but blue seas met blue sky ahead.

Hours of water and waves passed beneath with only the shadows of clouds breaking the monotony. The uneasiness of being over the ocean never left Vernon as his eyes became strained from continuously scanning the instruments for anything out of the ordinary. Unknowingly, he drifted off to sleep while Goodrich flew on.

What was that? He thought he heard an engine cough. *There ... there it is again.*

Without warning, the oil pressure on the number two engine dove to zero ... the engine had quit. A few seconds later, number three went silent. His hands shot to the controls, flipped switches, and his eyes searched the gauges for the cause. Number four quit. By this time, all the crew had jumped into action. Then, everything went quiet. *Cute Lil' Lass* had become a glider with nothing but ocean in all directions.

While he scrambled to bring the engines alive again, other crewmembers hurriedly got into their life preservers and rounded up the rescue gear. Ditching would be inevitable if the engines could not be restarted.

The bomber rapidly lost precious altitude as she descended toward the growing waves below. No matter what he did, he could find no explanation for the failures. Every attempt to restart the engines failed. Time was running out.

"Get your vest on, Goodrich," he yelled. "I'll hold her until you're ready."

The greenish-blue ocean came up fast. He lowered the flaps and worked at slowing the airplane to just above a stall. If he were lucky, she wouldn't flip when they hit and they would have time to get out.

What a way to end. All this way. Bettie ... I'll never get to see you again.

He felt Goodrich shaking him and saying. "I've got it ... get your vest on ... we're not going to get killed ... we're not going to get killed ... we're not getting to Brazil ... we're coming to Brazil ..."

Huh? What did he say?

"Hey, Drake." Goodrich shook Vernon again. "Wake up lieutenant, we have Natal in sight."

Vernon shook his head and opened his eyes. Instead of water frothing over the windshield, he saw a thin ribbon of land stretching across the horizon. It had been a dream. He had dozed off. They had made it across. They would be on American soil in less than an hour—South America but American just the same.

A day in Natal, another great meal and a quick visit to the Wonder Bar, the crew made an early night of it. Tomorrow they would set foot in the good ol' US of A.

The trip to Florida meant more hours over open water. This time, Vernon stayed awake. They followed the coast as far as Trinidad, then struck out over the Caribbean Sea for Cuba and finally touched down at West Palm Beach. A jeep with a large "Follow Me" sign met them as they pulled off the runway and led them through row upon row of bombers to an empty spot at the end. Each man kissed the pavement as he deplaned. The United States had never felt so good.

"So, what happens to our aircraft?" Vernon asked the jeep driver.

"It'll probably go to the salvage yard along with the rest of 'em, sir. Without a war we don't need them."

Vernon looked up at the image he had painted and imagined a tear rolling down her cheek. He had built a bond with this hunk of metal. She had brought him home safe from the other side of the globe. It didn't seem right to simply walk away.

"Hey, Skipper—you have a screwdriver I can borrow?"

"Sure, lieutenant." Skipper dug into his tool bag and handed the tool to Vernon. "Anything I can help with?"

"No. I just want to take home a little souvenir from this lady."

Vernon climbed back up onto the flight deck and sat, scanning the instruments. Only three screws held the 8-days clock in its hole. Two-and-a-half inches in diameter, it had kept track of the hundreds of hours they had flown together.

A fitting memory.

A few minutes' work and the timepiece found its way into Lt. Drake's flight bag.

As the crew boarded jeeps to take them to Operations, Vernon took one last look at *Cute Lil' Lass* and thought of *Angry Angel* and the other

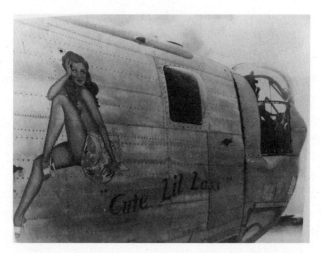

Cute Lil' Lass painted by Lt. Vernon Drake on a B-24 in Pandaveswar, India, in the 493rd Bomb Squadron, 7th Bomb Group, 10th Air Force. This is the aircraft that Lt. Drake flew back to the United States at the end of the war.

Panda Girls he had grown so fond of. He felt a tug at his heart. Elated at going home, he also had a foreboding sensation of sadness for abandoning the friends he would never see again. As they drove away, *Cute Lil' Lass* melted into the endless sea of bombers.

After two days of paperwork and making the rounds to satisfy the army, Vernon received his discharge papers, back pay, and a ticket home. A transport plane took him as far as Chicago where he boarded a train for Montana. As he stepped off the train in Billings along with hundreds of other uniformed soldiers, he scanned the crowd for familiar faces. His gaze came to rest on a weather-beaten, wide-brimmed hat. He'd know that hat anywhere. Pushing through the throng, he found his way to a strong bear hug from his father and a warm embrace from his mother.

Looking over his mother's shoulder through tears of joy in his eyes, he found Bettie's wide, beautiful smile and their young daughter in her arms. His heart melted. In that instant, he knew they belonged together.

"Go to her, son," his mother whispered in his ear.

The Panda Girls Live On

"I've often said those Panda girls I painted saved my life.

"They represent the missions I didn't have to fly because I was allowed to paint instead."

LT. VERNON DRAKE

Approximately 18,500 Consolidated B-24 Liberators were manufactured during World War II. Some were used to bring our troops home. Most were destroyed in combat or cut up for scrap after the war. In 1946, Minot Pratt, the general manager of an aviation salvage company in Walnut Ridge, Arkansas, took a liking to the artwork painted on the nose of thousands of aircraft he cut into scrap. He ordered his favorites removed using a fire axe with the intention of making a unique fence. The fence was never built but 33 panels were saved and stored in a garage. In the mid-sixties his son Tully donated them to the Confederate Air Force, now the Commemorative Air Force, which displays them at various venues when not in the CAF Museum. As of this writing, they are on exhibit at the Henry B. Tippie National Aviation Education Center in Dallas, Texas. *Mission Completed* and *Lassie I'm Home* painted by Lt. Drake, are in that collection.

An exhibit of Lt. Drake's memorabilia is on display at the National Museum of World War II Aviation in Colorado Springs, Colorado. The display includes many original nose-art sketches, class books

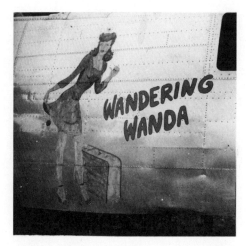

This old photo appears to be the original *Wandering Wanda* cut from the B-24 and mounted on a fence, indicating that the aircraft may have made it back to the States after the war. (Author's collection, photo origin unknown)

with Lt. Drake's artwork, original photos, logbooks, flight jacket, mission hat, patches, and more. The exhibit also features a full-size reproduction of *Wandering Wanda* painted by his son, the author.

Recently, the author discovered a photo of unknown origin showing *Wandering Wanda* cut from the side of the aircraft and apparently mounted as part of a fence. Since Minot Pratt is noted for having salvaged many panels, it is possible that *Wandering Wanda* made it back to the States and he added this panel to his collection.

During the war, Lt. Drake and his four brothers attained local notoriety as the "Flying Drake Brothers." Norman Drake flew as a civilian test pilot for an aircraft manufacturer. Raymond Drake flew C-47 cargo planes over the Hump. The C-47 didn't have the altitude capabilities of the B-24/C-109 and C-46, making the flights through the Himalayas far more treacherous. Ray was the highest-time Hump pilot when he left the CBI and was awarded the Distinguished Flying Cross and the Air Medal. A humble man, he declined to be honored along with Vernon in the National Museum of World War II Aviation. He and Vernon never crossed paths while based in India. David Drake flew as a tail gunner in a Martin B-26 Marauder in Europe. The youngest of the five brothers, Glen Drake, wasn't old enough to enlist but joined the navy following the war.

Vernon and Bettie returned to Billings, Montana, after Vernon earned his degree in architecture at Montana State University in Bozeman. He established a successful architectural firm and became a well-respected professional, designing schools, churches, and commercial buildings. He

and Bettie raised five children. Vernon continued to paint well into his final years. A collection of his watercolors can be seen at drakeip.com/vld-art/

Vernon left behind a treasure trove of written and recorded accounts of his World War II experience along with letters from crew members. His sketchbooks and class books are full of images from that period, many of which are reproduced in this work.

Nose Art by Lt. Vernon Drake

Wandering Wanda, 493rd Bomb Squadron, 7th Bomb Group, 10th Air Force
Angry Angel, 493rd Bomb Squadron, 7th Bomb Group, 10th Air Force
Luscious Lace, 493rd Bomb Squadron, 7th Bomb Group, 10th Air Force
Black Magic, 493rd Bomb Squadron, 7th Bomb Group, 10th Air Force
Bar Made, 493rd Bomb Squadron, 7th Bomb Group, 10th Air Force
Blind Date, 493rd Bomb Squadron, 7th Bomb Group, 10th Air Force
Dangerous Dance, 493rd Bomb Squadron, 7th Bomb Group, 10th Air Force
Mission Completed, 9th Bomb Squadron, 7th Bomb Group, 10th Air Force
Cute Lil' Lass, 493rd Bomb Squadron, 7th Bomb Group, 10th Air Force
Lassie I'm Home, 493rd Bomb Squadron, 7th Bomb Group, 10th Air Force

By Lt. Vernon Drake 1922–2004

Never learned to roll Bull Durham
Never learned to spit and chew
Couldn't drink beer or liquor
Couldn't cuss like other boys do
Mom and Dad taught by example
Gave us lessons and a creed
Taught us lessons that were useful
Reinforced if there was need
Stand up straight and square your shoulders
Look the speaker in the eye
It is manly to be sober
It is manly not to cry
Study hard to learn your lessons
Reason, think in all you do
Striving hard to reach perfection
Moving forward to something new
Direct your efforts to helping others
The aged, the weak, and those in pain
Keep in mind—"Love one another"
Eternal life will be your gain
Never lie or cheat another
You are loser if you do
There's no way you can cover
Speak you only what is true
To women and girls be kind and tender
Open doors, your hat remove

They are "special," respect the gender
Speak politely, your worth you'll prove
Life is like a flowing river
Always passing, no return
Make each moment count forever
Give full measure for what you earn
Grandchild, now it is your treasure
Take and keep it safe until
You are the parent of another
There include it in your will

Bibliography of Further Reading

B-24 Veterans. *Hump Pilots Association Volume 1*. Dallas: Taylor Publishing Co., Dallas, 1980.

B-24 Veterans. *Hump Pilots Association Volume 2*. Dallas: Taylor Publishing Co., 1983.

B-24 Veterans. *Hump Pilots Association Volume 3*. Paducah: Turner Publishing Co., 1992.

B-24 Veterans. *Hump Pilots Association Volume 4*. Paducah: Turner Publishing Co., 1997.

Birdsall, Steve. *Log of the Liberators*. New York: Doubleday & Company, 1973.

Dorr, Robert F. *7th Bombardment Group/Wing*. Paducah: Turner Publishing Co., 1996.

Ethell, Jeff, and Don Downie. *Flying the Hump*. Osceola: Motorbooks International, 1995.

Feuer, A. B. *The B-24 In China*. Mechanicsburg: Stackpole Books, 2006.

Henderson, Lt. Col. W. *From China Burma India to the Kwai*. Waco: Texas Press, 1991.

St. John, Philip A., PhD. *The Liberator Legend*. Paducah: Turner Publishing Co., 1990.

Summers, Julie. *The Colonel of Tamarkan*. London: Simon & Schuster UK Ltd, 2005.

Valant, Gary M. *Vintage Aircraft Nose Art*. Osceola: Motorbooks International, 1987.